SCULPTURE
AS EXPERIENCE

EXPANDED WITH NEW CHAPTERS

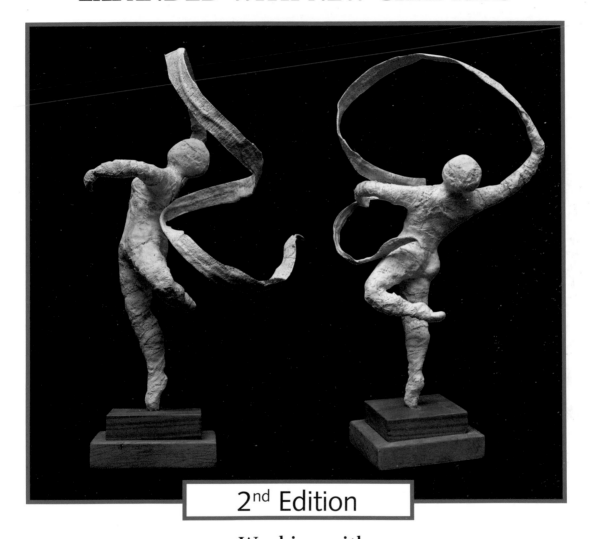

2nd Edition

Working with
CLAY, WIRE, WAX, PLASTER and FOUND OBJECTS
- NOW
PAPER, FOAM CORE, WOOD and SAND
and
METHODS FOR MOUNTING and PROJECT PRESERVATION

JUDITH PECK

Published by

kp krause publications

An Imprint of F+W Publications

700 East State Street • Iola, WI 54990-0001
715-445-2214 • 888-457-2873
www.krausebooks.com

Our toll-free number to place an order or obtain
a free catalog is (800) 258-0929.

The following registered trademark terms, publications and companies appear in
this publication:

Architectural Digest
Bondo®
Carborundum
5 Minute Epoxy®
Formica®
Hydrocal®
Kiwi® Shoe Polish

Micarta®
National Geographic
Magazine
Plexiglas®
Sculpmetal
Ziplock®

Cover art: "Ribbon Dancer," Arlene Beckman. Photo by Lee Vold.

Library of Congress Catalog Number: 2006935549
ISBN 978-0-89689-453-2

Designed by Katrina Newby
Edited by Erica Swanson

Printed in China

DEDICATED TO MY
RAMAPO COLLEGE OF NEW JERSEY STUDENTS.

TABLE OF CONTENTS

PREFACE

INTEREST in sculpture has grown steadily among Americans. More exhibitions of sculpture appear locally, nationally and internationally than ever before, and experimentation combining sculpture with painting, graphic processes and any manner of mixed media is now common. In addition, new technology has further advanced the complexity of sculptural expression. Because of all this, it is not unusual to find that individuals who respond to the direct physical engagement of sculpture-making are somewhat hesitant to enter the vast arena in which sculpture now functions. This book, in its de-emphasis of technical and mechanical methodology, is an invitation to visitors and potential dwellers to enter that arena.

Sculpture as Experience is designed both for students in school who have access to working facilities and for out-of-school adults who will be making space for their creative work at home. The goals of this expanded 2nd Edition of Sculpture as Experience are:

1. To introduce students to aesthetic concepts of sculptural form and space;

2. To offer instructional guidelines in those specially selected three-dimensional media that will best help students find their personal artistic direction;

3. To expose students to tools, techniques and methods of sculptural processes that are executed by hand and do not require a fully equipped shop or studio;

4. To provide students with the means to find delight and achievement in sculptural expression.

ACKNOWLEDGMENTS

APPRECIATION is first and foremost extended to my students in the School of Contemporary Arts at Ramapo College of New Jersey, whose enthusiasm and energy for creative expression in sculpture are a continuing source of personal delight and inspiration. All of the illustrations of artwork in this text, with few exceptions, are by students who have been enrolled in my course, Basic Sculpture.

Because I have been teaching this course for decades, a large body of art work has been produced, and although students in years long gone described their work for me on paper and gave permission to use it if ever I wanted to include it in a book, some of the written descriptions are unidentifiable. Every possible effort was expended to correspond those descriptions to the illustrations used in this text, but unfortunately, some excellent works remain unidentified. Should individual works illustrated in the text become identified in the future, new editions will reflect the updated information.

The photographer responsible for most of the illustrations in this 2nd Edition is Jose Hernandez, graphic artist for Ramapo College of New Jersey. Most illustrations from the original text were provided by Lee Vold of Mahwah, New Jersey. I am grateful to Jose Hernandez and Lee Vold for their professionalism and perfectionism. Reproduced from the 1st Edition are photographs by Frank Cavallo, Erik Unhjem and Jules Pinsley. All line drawings and other project photography are by the author.

Tibor Csokasi provided technical assistance in helping to restore the lost files of the 1st Edition and for digitally (and magically) restoring illustrations when originals were lost.

My deep appreciation is extended to Ramapo College of New Jersey for providing release time credits toward preparation of this book, and to my colleagues in the School of Contemporary Arts for their support.

I acknowledge, always, the continuing inspiration of my children, Sabrina, Joel, Jennifer and Sarah, and their spouses and children, collectively, Soledad, Jack, Dan, Jonathan, Rebecca, Ben, Andrew, Joshua, Samantha, Aleeza, Rachel and Ariel. Finally, I am grateful to David Piltzer for the help and moral support I receive in all earthly matters.

INTRODUCTION

IT is sobering to list the range of methods and materials used to create contemporary sculpture. The sheer number of words employed to describe the scope of sculptural activity is impressive. Although the list is long, you will discover that you are doing and using many of these things in the course of your own work.

SCULPTURE CAN BE:

- carved in wood, stone, cement and plaster
- modeled in clay, wax and plaster
- fabricated out of found objects
- constructed with wood, foam core, wire and rods
- welded in steel
- laminated in plastics
- formed out of rope and fabric
- beaten out of lead and copper
- cast in plaster, clay, bronze, stainless steel, iron, aluminum and plastics
- pressed in sand
- dug into the earth
- conceived on paper, in words and in action.
- nailed • screwed
- filed • tacked
- tied • hung
- wrapped • sewn
- assembled • balanced
- painted
- taped • floated
- cut • drilled • sawed
- twisted
- soldered
- bent • arranged
- sprayed
- waxed
- glued
- stapled • mounted

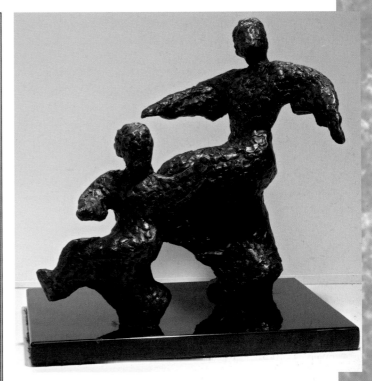

Figure Intro-1. "Dancing Mother and Child," bronze, Judith Peck. Photo by Hernandez.

THE SCOPE AND METHODS OF SCULPTURE

Making sculpture is technical in process because you deal with so many physical things at every stage, from the preparation of materials and supporting structures, through construction, to final finishing and mounting. Yet, in spite of all its earthbound tribulations, there are few means of creative expression as potentially free in spirit as sculpture. Learning the nature of sculpture's physicality is the key to finding and enjoying that freedom.

Sculpture is experience, for much of what we use to make sculpture we have experienced already and, in fact, are intimately familiar with: the muscles of our body; our senses of touch, sight and even sound; our sense of scope in terms of monumentality and detail; and our sense of self in the context of the physical and psychological environment as we confront both the profound and the ordinary. Moreover, the world is three-dimensional, and so are we. Sculpture will come as no surprise.

OBJECTIVES OF THE BOOK

This book is presented as experience, not theory. As you work, practical solutions will begin to interest you, because sculptural problems will appear when you first pick up papers to arrange in a composition, or combine wood shapes, or press a handful of clay between your hands. But problems in art are different than other problems because they are positive in direction. In other words, you are starting from the norm and going upwards, striving for a clearer statement, a greater understanding, a keener awareness, and solving those problems brings you to a higher level of experience.

The primary goal, then, is to provide you with enough information so that you can experience sculpture. A second goal is to provide you with some insight into seeing. What you see will directly affect what you make in sculpture. You may think you are seeing when in actuality you are just passing through. For example, you can see the doorway to your home many times a day and never see its physicality — you simply pass through it. You can see your face in the mirror many times a day and never see its planes and structure.

Beyond the techniques of sculptural observation which you can learn is the quality of how you see, what you perceive. And this is not technique. How you see is intimately connected to who you are: what kind of person you are. Are you interested in

Figure Intro-2. Problems in art should be looked at as choices. Face them as challenges that will ultimately heighten the bar on your level of experience. Xiang Ye. Photo by Hernandez.

people, in society, in beauty, in ugliness, in truth? Are you honest in ascertaining what you see and what you feel, and if so, do you have the courage to project that honesty in your art? If not, do you have the constitution to acquire courage? These are not academic questions, nor are they off the track. The person behind the eyes is ultimately the only one who can determine what is finally seen.

SUGGESTED SCHEDULE: A 17-WEEK PROGRAM

Completing the sculpture projects described in this book roughly approximates a school semester. The school program would consist of about ten hours of studio work per week over a span of four to five months, one hour each weekday in or after school, and four hours evenings or weekend, working at home.

For out-of-school work, the total program should have you engaged for about the same time. You will, of course, vary your working sessions to meet personal needs: if employed, you may plan on devoting a portion of the weekend and some evenings for studio work; if you have children home, you may have to reduce working time to 20-minute periods, whenever they can be managed (keeping a small work space for kids with a supply of clay is a great idea). You may find that long, concentrated sessions work best for you, or that short, half-hour sessions stolen from chores are preferable.

Finding the time to work will probably be your first creative challenge, for self-motivated, internally-mandated hours do not appear on their own; they must be fabricated. Whether such time is found through the discipline of a regular routine or by salvaging bits and pieces from other sources is a matter of individual style.

An approximate breakdown of the 17-week program is given below, but your own adjustments to this schedule will be made according to your productions:

The Dynamics of Sculpture (Exercises in Seeing and Drawing)	1 week
Paper Productions	1 week
Foam Core Fabrications	1 week
Wood Constructions	1 week
Found Object Sculpture	1 week
Modeling in Clay	2 weeks
The Figure in Foil and Pariscraft	2 weeks
Wire Sculpture	1 week
Wax Sculpture	1 week
Carving in Plaster and Cement & Vermiculite	4 weeks
Lamination and Patina	1 week
Mounting	1 week
Sand Sculpture	1 day
Total	17 weeks and a day

THE PROJECTS

You will observe, as you move from chapter to chapter, that there are variations in the nature and amount of technical advice given. These variations are due to the differing complexity of the projects and the objectives in each case. For example, all of the projects are designed to generate personal creative expression through three-dimensional media. Some projects, however, such as The Figure in Foil and Pariscraft, require that you follow methodical procedures at the outset. Those step-by-step instructions are then followed by more free-form directions.

Projects such as Found-Object Sculpture, because of the wide-ranging availability of objects, require nonspecific advice, equally aesthetic and technical in nature, about choosing and assembling objects for creating sculptures. Still other projects, specifically Modeling in Clay, require a more lengthy technical presentation to ensure a successful experience. Your personal success in completing each project is the goal, and the directives offered are toward that end, whether specific or general, lengthy or brief, technical or aesthetic.

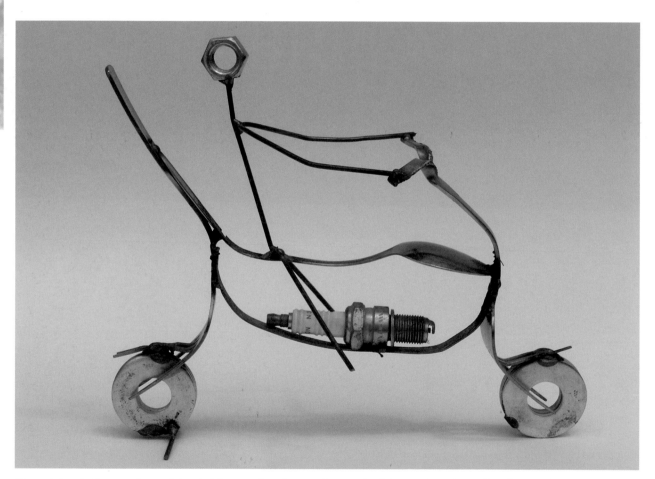

Figure Intro-3. Sources for sculptural vision can be all around you, playful or profound. Unidentified student sculpture. Photo by Hernandez.

Materials and Projects Illustrated in the Text

Almost all of the illustrated work was done by students in the author's Basic Sculpture classes, except for sculptures made by the author. This limitation is deliberate; it is designed to make you aware of the very real possibilities for success as you execute each project. Many of the students were not art majors, just individuals interested in seeing what sculpture was like, which is something you are exploring as well.

The photographs of tools and materials illustrate the standard items needed to create each project. To avoid cluttering the photograph, some easily recognizable items on the Checklists of Tools and Materials are not included.

EXTENDING THE PROJECT:

Art in Human Service
and Other Possibilities

There is a brief section on "Extending the Project: Art in Human Service" at the end of several of the chapters. These offerings might serve individuals working in a recreational or rehab setting where good, creative art activities would benefit the clientele. Often, crafts alone or time-consuming busy work is the only fare available, particularly in nursing homes, senior citizen centers and youth facilities, and the creative projects described will afford a spark of vitality.

The sculpture projects recommended for art in human service should be modified according to the needs and abilities of those participating, but they also should be flexible enough to serve disparate groups. Moreover, they do not require an abundance of materials. Most importantly, the projects chosen for this section will involve hands, mind, senses and emotions all at once.

Some of the chapters end by suggesting other possible ways to use the projects. You are encouraged to seek out additional possibilities on your own, adapting the methods and materials to your evolving artistic ideas. You will probably not respond with equal enthusiasm to all of the projects. Instead, you will discover some media and methods that you relate to more than others, and hopefully, you will continue working in those directions after the 17-week program is completed. An important objective of Sculpture as Experience is to expose you to widely different media, methods and approaches so that you can make that natural determination.

Conclusion

You may find a particular method too difficult or perhaps too easy, or a certain medium too expansive or too limited; and although you may be satisfied with one product and dissatisfied with another, the experience of actually doing the sculpture remains, with all that implies: seeing, conceiving, manipulating materials and producing a concrete object from your imagination. The experience may be frustrating sometimes, but it will be challenging and full of vitality. A state of contentment has never served as inspiration for art-making.

THE DYNAMICS OF SCULPTURE

THE exercises offered in this chapter are designed to increase your perception of the natural sculptural elements that exist all around you, so that you can begin to use those elements dynamically.

Devote a day or two to doing some of these visual exercises as you go about your normal routine. Once you begin seeing with a sculptural eye, aesthetic judgment will accompany each of the projects you undertake and serve as an ongoing resource for your ideas. Take note of the sculptural vocabulary in each section, so that you can define what you are seeing.

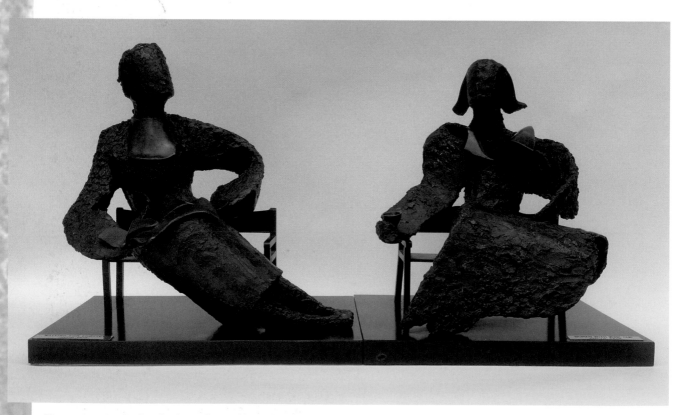

Figure 1-1. Study the rhythmic flow of lines leading the eye from one figure to another; the contrast of straight and curved lines in the skirts; the repetitive pattern of angular chairs that helps to integrate the two separate figures. "Waiting for Lobster" and "Woman with Wine Cup," Judith Peck. Photo by Hernandez.

SEEING WITH A SCULPTURAL EYE

Form, Shape, Mass and Pattern

Look around in whatever room you find yourself, and select a form, shape, mass or pattern that appeals to you. It might be the light fixture in the ceiling, cracks and scratches on the floor, the curve of the water spigot or the grid of the radiator. Maybe it will be an open doorway with muted shapes barely seen on the other side, the shadows cast by a lamp, or a pattern made by wall panels, ceiling tiles or floor boards. It may be the folds caused by the skirt or pants of someone sitting, the vertical variations of a hanging drape, or the heavy outlines of a jacket thrown over a chair.

Give expression to each image that you select by simply noting the object and what you like about it. Select at least ten such images. The only criterion for selection is that you respond in a favorable way to the visual impact of the image.

Then look around the room and make note of the forms, shapes, masses and patterns that do not appeal to you, ones that you dislike. Try to be as honest as you can in your selections. Seeing is not enough. The forms must be claimed. We neither note nor store most of the things we see. But form is to be your visual vocabulary of communication, so it is time to learn and to claim the language.

During the week, do this exercise outdoors; recognize and claim the forms and shapes that give you visual satisfaction. Observe both the natural landscape — skies, clouds, trees, hills and valleys — and the man-made — cars, pavement, buildings, derricks, roadways and people. Look for forms, shapes, masses and patterns, and claim them by making a written notation of what you see.

Tension, Contrast and Design

Place your hands in front of you. Make a fist and see how the bone presses against the soft skin, forming tension at the knuckles and lyrical curves between the knuckles. Make shapes using your hands and fingers: claw shapes, extended fingers, bent fingers. See how the tension between forms creates a contrast between straight and curved, and flat and rounded.

Now, move both hands together in relation to one another. Imagine that they are large sculptural forms mounted in interrelationship. There are solid areas and there are hollow areas. Play the symmetry of the fingers against the solid masses of the palm and wrist. Contrast highs and lows. Have one hand work as an inner form within the other. Enclose space by closing some of the lines of the fingers and creating a form within a form. Each time you change these relationships try to observe, as much as possible, all that is going on in terms of design, and note the relationships that particularly appeal to you.

Figures 1-2 and 1-3. Manipulate your two hands as if they represented shapes made of carved boulders or pieces of steel to get ideas about forming sculptural shapes in interrelationship. Photos by Hernandez.

Observe people sitting and standing in a room. Notice how knees press against skirts and pant legs, forcing the drape of the material to cascade into folds. There are a myriad of high points and strong points (tension points) in the drape and pull of clothing against the body. Dancers use the extra dimension of costuming as an extension of the body's capability for creating tension, contrast, and design in space. Modern dance and sculpture are soul-mates in the quest for exciting designs in space.

Line, Balance and Rhythm

Stand in front of others in a room, or stand alone in front of a full-length mirror. Notice your vertical stance and relate it to the things around you: lower-placed seated people, other standing people, rectangular tables, squarish chairs, or pictures on the wall.

Now, suddenly thrust yourself in a diagonal as if you were about to fall. If you are in front of the room, notice how everyone perks up and takes interest. This is not because they want to see you fall on your face, but because you were off-balance, and that is an exciting dynamic. You created a diagonal line with your body — an action line. We are bilaterally symmetric when we come into the world, and that is our viewpoint in all that we observe. When a picture is crooked on the wall, we can't wait to right it.

And when figures are off-balance, they are out of the norm and visually exciting. Lines can be used in sculpture in dramatic ways — not lines that are incised into forms, but the exterior and interior contour lines made by the interaction of forms. These lines will form the essential designs of your sculpture.

Essentially, rhythm in art has to do with the movement of line in a given space: the contrasting design, for example, of straight lines and curves, highs and lows, or ins and outs. The rhythms you design can lead the viewer's eye in a visual tempo of your own making, as lyrical as a Debussy piano movement or as strong and intense as a Wagnerian opera. Just as you feel rhythm in music and dance, often to the point of moving your body to its engaging patterns, so will you feel rhythm in the emerging sculptural forms of your imagination. Nature is the best advisor on this subject: refer especially to the visual rhythms in trees, rivers, birds, animals and people as they walk, turn, engage in sports and dance (**figures 1-4 and 1-5**). Be alert to the special rhythms that perform for you in daily life, ordinary movements such as the shifts and turns of a short-order cook behind a busy counter during lunch hour.

During the week, make a list of at least ten such designs in the natural or human environment, designs that appeal to you. Then, with pencil and paper, see if you can isolate the essential rhythmic lines in five of your selections: that is, the curves,

Figures 1-4 and 1-5. In dance, designs in space are made by the human body. Alice Teirstein, dancer. Photo by Mariette Pathy Allen.

straight lines and other contrasts that you see. Make some lines more exciting by darkening or coloring the contrasts.

Looking around the room again, review the forms you originally selected as ones you liked. With pencil and paper, try to find the rhythmic lines within those forms. Simplify the lines as much as possible. Repeat the exercise with other objects or relationships that appeal to you. During the week find reproductions from library books on sculpture and modern dance that have especially lyrical or otherwise dynamic designs. Draw, in simple lines, the basic rhythms that form each composition.

This is not a test. The lines you see may be different from those seen by someone else. None of the exercises have right or wrong answers. Their purpose is to engage you in a feeling for rhythm and balance in sculpture and help you incorporate those elements naturally into your work. You might begin by searching for some of the rhythmic lines in the seated figures in **figure 1-1**, and the reclining woman in **figure 1-6** by the author.

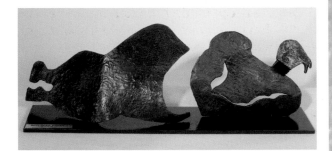

Figure 1-6. Study the lines in this composition for rhythm and balance. Note the stylized contours which create a lyrical design. "Reclining Figure," Judith Peck. Photo by Hernandez.

Texture, Light and Shadow

Texture can provide new sources of interest within a sculpture. In **figure 1-7**, for example, roughly textured patterns contrast with smooth surfaces, extending the personality of the stylish Schrafftsperson. The figure's flamboyant hat, scarf and sandals are emphasized with polished highlights.

Texture, light and shadow, though they may add dimension to the sculpture, must evolve from the sculpture. They must be in concert with the other vital elements of the work. As an exercise, find those textures and shadows in the room that appeal to you and those that do not. Is there an object in the room, or beyond the room, through the window, that does not seem to you to have integrity of texture, that appears inconsistent with other formal elements? In your research during the week, seek out examples of textures that add dimension, emphasis, meaning or dramatic impact to a work of sculpture. Do the same with regard to the dramatic impact produced by light and shadow.

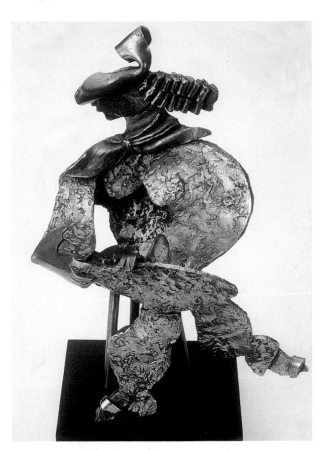

Figure 1-7. Contrasting textures add interest and personality to the figure through the costuming. Swirled patterns in the body of the sculpture contrast with smooth, highly polished accessories that catch the light. "Schrafftsperson," Judith Peck, collection of Mr. and Mrs. Henry Solan. Photo by Pinslcy.

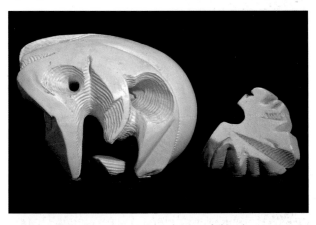

Figure 1-8. Texture is an integral part of this design. Deeply carved stripes form the hollows, while smooth, flat areas highlight the surface planes. "Jealousy," Ingrid Vold. Photo by Hernandez.

Spatial Relationships

Ask five people to line up in a room. Divide the people in a number of different ways, observing all the changes made in the space surrounding the figures as they move to different positions. Use highs, lows and depth relationships among single individuals and units of individuals. Ask yourself the following questions:

1. When the composition changes, how does attention on individual figures change?

2. How does the creation of units change the sculptural composition?

3. What psychological content comes to mind merely by the change in arrangements — for example, loneliness, control, power, isolation, submergence, cowardice, intimidation?

Here are some suggestions:

Try discussing the impact of each move with respect to design and psychological content:

- **Place people in a line with an even distribution of space between them.**
- **Place people in a line, separating the two end figures and bunching three together in the middle.**
- **Place people in a line, bunching the end figures together on either side and isolating the middle figure within the empty space.**
- **Place three people in a circle on their knees and two outside the circle, standing.**
- **Place four people in a line, one behind the other, and one randomly placed, apart.**
- **Move the line-up above to one side of the room, and place the random figure alone in the center space.**

It is interesting to note that the space changes its visual dimensions as the figures change their relationship to one another. It can become more square, more rectangular, smaller, larger, denser, narrower or wider. The space can become more interesting and less interesting as well.

Now, if you have a willing group, take turns in changing the relationships of the figures and surrounding space by moving the figures from the vertical to other angles, such as diagonal and horizontal. Use bent torsos and extended limbs. Try to note the design ingredients of contrast, tension, line, rhythm and balance in space. If you are one of the figures, try to feel these designs in your body as they are being projected.

In your research, examine (either in person or through photographs) sculptural group compositions (figurative or abstract) and single abstract monumental sculptures that have been installed in public places. Try to relate what you have physically participated in to what you see. Observe where compositions are lifeless and where they have force and vitality. Try to isolate the ingredients that make for exciting design.

EXERCISES IN DRAWING

The exercises offered below are an expansion of the experiences in visual perception that you have just had. In these exercises, do not think of drawing as a technique to be learned, but rather as a way of implementing the natural elements of sculpture in an easy way, without having to lift heavy objects with a crane, weld with a torch or carve with a pneumatic chisel. Approach the studies as if you were creating a large sculpture, organizing form, shape and line but without the massive effort that making a heroic sculpture would entail.

Two Relating Forms

Using a narrow and a medium-wide brush dipped in black ink or watercolor and a large sheet of paper, paint several examples of two forms in interrelationship. Use sweeping movements to make definitive lines and shapes. The lines and shapes need not be complex and you need not spend a great amount of time perfecting them. Use contrast, tension, rhythm, balance, opposing lines, or any of the other elements of sculptural design that you have been observing. Be alert to both the positive and negative forms that are created: positive forms are the filled-in masses; negative forms are created by the empty spaces or voids between the masses. You may want to produce some of the compositions you saw when you studied your two hands in interfacing relationships.

Lines can be closed to form shapes, and shapes can be filled to form masses. Make at least six spatial studies, and spread them out on the floor so that they can be seen from all angles. Thinking about what has been produced in terms of the formal design components of the drawings will increase your perception of the relationship of forms in space.

By making these studies and analyzing them, you are confronting many of the same visual problems the sculptor confronts but without the technical problems of fabricating the piece and having it work from all sides. This exercise can save a great deal of time by increasing your understanding of what is strong and exciting in sculpture and what is weak and without impact.

In your drawings, think only of forms. If representational ideas are summoned from the forms that you produce, only then carry them forward.

Sometimes it is rewarding to work with materials other than pencil, charcoal or ink. Paint a background of any kind. Then put rubber cement into a paper cup, make a spout and pour. Work with thick and thin lines, and imagine a wire or steel sculpture, as in **figure 1-9**.

Figure 1-9. Draw with other materials that might inspire sculptural line drawings. Rubber cement on watercolor is used in this illustration. Photo by Peck.

Freeform Scribble

With a pencil or conte crayon on paper 12" x 18" or larger, make a free-wheeling scribble. Do not look for anything at the outset, just scribble. When you have enough lines on the paper look at your markings carefully and then begin to select certain lines to bring out. Forms can be developed by combining lines and masses can be made by shading in areas. The scribble lines can be added to, used as a takeoff point, or selected out and darkened. Whether you develop lines, forms, masses or all three will depend on what you see in the markings and what you want to emphasize. **Figure 1-10** is an example of this exercise.

Figure 1-10. A freeform scribble in pencil, elaborated upon with pen, from which ideas for sculptural forms were generated. Unidentified student drawing. Photo by Peck.

PERSONAL VISION AND STYLE

The conclusion you may reach after a week of seeing and drawing in the ways suggested may be that you do have a distinctive way of seeing, that you respond consistently to certain forms, rhythms and patterns.

If your responses are successful enough to form a basis for good artistic judgment, you are off to a good start. If, however, your visual appreciation of form and shape has been restricted to functional objects, you may find your aesthetic judgment lacking. For example, you may only be at home with the symmetry and familiar geometric shapes of commercial household goods and furnishings. But once you begin consciously looking for and reacting to sculptural stimuli, you will start to enjoy the visual buffet of form and design. As you continue to work, in whatever sculptural medium you come to prefer, you will find this array of sculptural form and design indispensable in helping you establish what you want to say and how you intend to say it.

In this chapter, we have tried to isolate the formal components of sculpture so that the elements may be understood. Once you understand that sculpture involves specific components — the

sculptural vocabulary — you will be ready to try both abstract and representational styles. But whether your work is figurative, representing an easily-seen reality, or abstract, or in-between, these are the components to check on as you work:

How interesting is your piece in:

- **Form, shape, mass and pattern?**
- **Line, contour, design, rhythm and balance?**
- **Tension and contrast?**
- **Texture?**
- **Spatial relationships?**
- **Light and shadow?**

Your style will emerge. It may depend on your enthusiasm with a particular medium, your facility with techniques required, the content you want to convey — any number of factors. Style in art is using the formal components in a given medium to communicate a personal statement. Style as well as content communicates the artist's message, if there is one. A consistent personal style in a body of work evolves only after working for a substantial

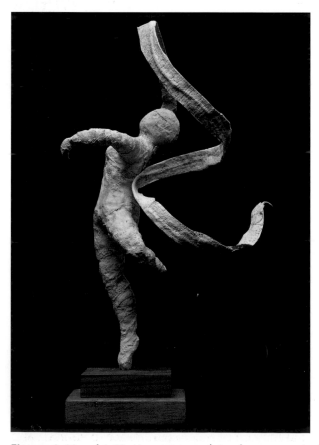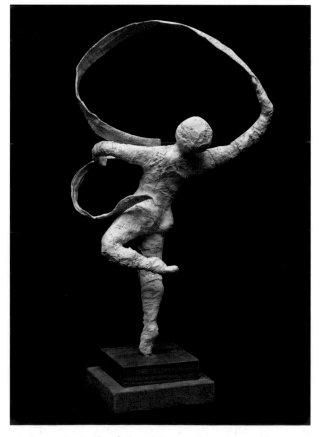

Figures 1-11 and 1-12. How many sculptural components do you recognize in this foil and Pariscraft sculpture of a figure dancing with scarves? "Ribbon Dancer," Arlene Beckman. Photo by Hernandez.

period of time in a medium and understanding its possibilities. Some of the considerations that may form the basis for achieving a personal style in sculpture are offered here, not as specific guidelines, but as a general overview:

- Learning what can be done with given materials.
- Exploring space for sculptural composition.
- Understanding what makes dynamic design and an integrated composition.
- Thinking in a 3-dimensional way when you strive for expression.
- Becoming familiar with the scope of contemporary sculpture as seen in gallery and museum exhibitions, outdoor installations and public buildings.

Abstract or Representational

It is easier to begin the practical study of studio sculpture by proceeding with abstract rather than representational images. Working to get something to look like something else tends to undermine your ability to experiment with all the considerations of form that were described in this chapter. When the formal components are understood and integrated into your artistic activity, you should, and hopefully will, express whatever you wish in whatever way you wish. The dynamics of sculpture are just as forceful and convincing in a good abstract piece as they are in a good representational piece.

It is important not to block off any one area of sculpture as being unworthy of your interest. Innovative media, including telecommunications, performance pieces, conceptual pieces, installations, earthworks and so on, all serve to enrich the environment of sculptural possibility. You need not select any of them as your way. Anger, impatience, frustration and disgust are honest emotions and are sometimes entirely appropriate. Only intolerance is to be avoided because it will distance you too much to draw anything from your experience.

Looking at Your Work

However your style emerges, it is imperative that you learn to work at eye level as much as possible. This can be done sitting, as in **figure 1-13**, using whatever it takes to raise your work,

or standing at a counter or sculpture stand, as in **figure Intro-2**. If "location, location, location" are the three criteria for finding the right house, "looking, looking, looking" is needed to make your sculpture consistently successful.

Figure 1-13. Always work at eye level, whether you are seated or standing. Natalie Megaro. Photo by Hernandez.

Content

Content has not been discussed in this chapter nor will it be, as there are virtually no limitations on the content of sculpture. The vocabulary here is as rich as the individual's awareness of self, society, culture, mythology, history, anthropology or whatever. Content won't be learned or acquired in an art class or an art book, although any learning adds to its store.

Art is a synthesis of idea, visual vocabulary, style, meaning, communication and the artist's projection of his or her person in all its physical, emotional and intellectual energy. The process and the end results are inexorably connected. Sculpture — its materials, tools, techniques, language and structure — must be experienced and practiced. You must approach the practical study of studio sculpture as both an adventurous process and a means to an artistic end, with results that may be of more significance to yourself and to others than you can yet know.

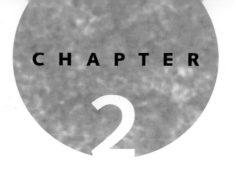

PAPER PRODUCTIONS

THIS project allows you to explore sculptural components by assembling thin paper strips. Paper Productions is a good first project because it lets you quickly see and appreciate sculptural forms in space while using readily available, easily manipulated materials. Because the paper productions are conceived as small models for large works, the project is a gateway of sorts to the larger realm of sculptural composition.

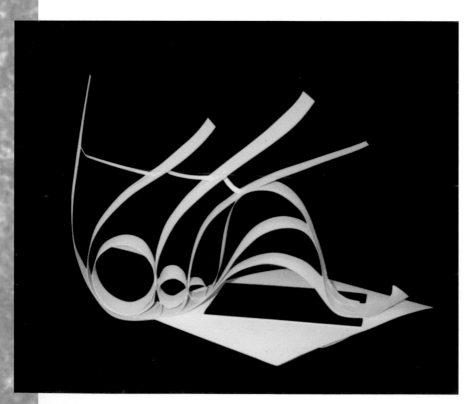

Figure 2-1. Design, Carole Finklestein. Photo by Peck.

THE NATURE OF THE PROJECT

Your overall approach is to assemble a variety of strips on a cardboard base, and then twist and connect them into interesting designs in space. You will adjust the lines and shapes as they emerge, making decisions as you go.

While assembling, cutting and adhering paper strips, be aware of the following sculptural concepts, both as you work and certainly afterwards when you analyze your creation:

- line and design
- pattern
- rhythm
- spatial relationships
- light and shadow
- tension
- contrast
- balance

Add to these components the concept of scale because you will be approaching the paper sculpture as a model for a large-scale free-standing or wall-hung public piece. This will be explained more fully later in the chapter.

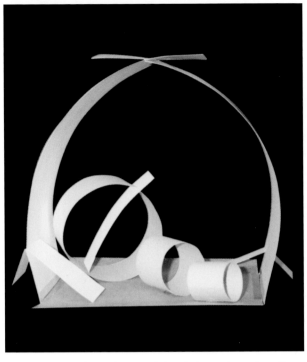

Figure 2-2. Easily explore sculptural elements such as line, rhythm, pattern and balance by assembling, connecting and mounting paper strips. Design, Ilana Houten. Photo by Peck.

CHECKLIST OF TOOLS AND MATERIALS

The Basic Medium

Colored paper, found or cut into strips of various sizes, is the basic medium. Strips can be as varied in size and width as you wish. Strips might be leftover scraps obtained from the print shop or from other class activities. Avoid using too many colors (select only one or two) to maintain focus on sculptural forms. You will need:

- **Paper strips in a range of shapes and sizes, but limited in colors.**
- **Masking tape, 1/4" 1/2" and 3/4" suggested.**
- **Double-sided tape.**
- **Stapler and staples.**
- **White glue or glue sticks.**
- **Scissors.**
- **Cardboard for bases.**
- **Brass fasteners for creating moving parts (optional).**
- **String (optional).**

PROCEDURE

1. A random supply of paper strips is useful to generate ideas. Nevertheless, if paper is not already cut, you can cut what you like from standard sheets.

2. Twist or curve a paper strip as you like it.

3. Fasten the strip to the cardboard with staples, glue, glue sticks, masking tape or double-sided tape.

4. Find or cut another strip, and attach it either to the base or to the previous strip using the same fastener used previously.

5. Build up the sculpture in this way, adding, removing and altering strips to begin the formation of an interesting aesthetic design.

Your creations can be simple or complex. They should, however, focus on a structure, as opposed to a confusion of shapes and colors. Whether simple or complex, your productions should not sacrifice a focus on sculptural form and design. View **figures 2-3 to 2-6** to see how paper strips can be integrated into strong sculptural form and design.

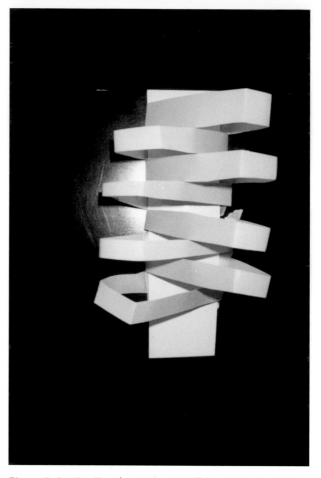

Figure 2-3. "RecTangles," Jarrett Wilkins. Photo by Peck.

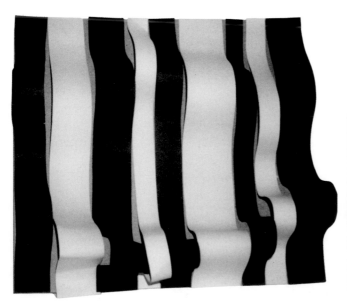

Figure 2-4. Sculptures can be simple and still have strong structural form. "City Rising," Jill Chiorazzo. Photo by Peck.

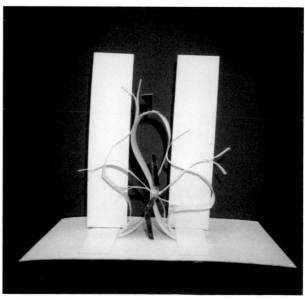

Figure 2-5. ... or be complex. Paper composition, Kate Ferguson. Photo by Peck.

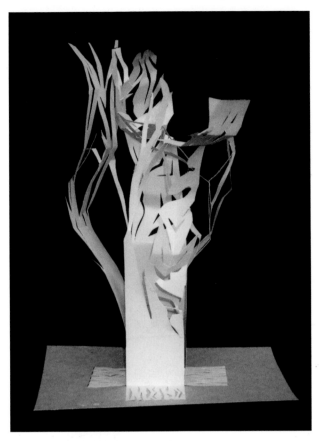

Figure 2-6. ... or be very complex. "Tree," Kenia Liriano. Photo by Peck.

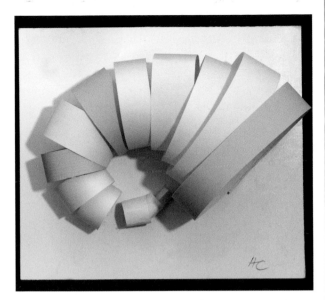

Figure 2-7. Herminia Cedeno. Photo by Peck.

Turn the piece frequently as you work to see it from all sides. Lift it, look at it and perhaps rotate it as if it is to hang on a wall. Sometimes a paper sculpture comes to life when lines project outwards as opposed to standing upright (**figures 2-7, 2-8 and 2-9**).

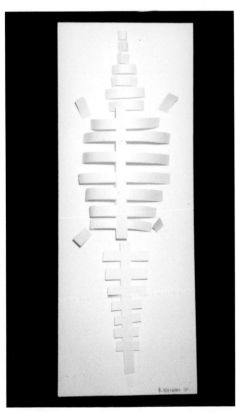

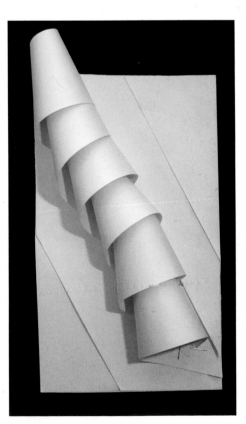

Figure 2-8. Ryan Hoffman. Photo by Peck. **Figure 2-9.** Mike Kinon. Photo by Peck.
Sculptures that begin upright may work better as wall-hung reliefs.

PRESENTATIONS

To get the most from this project, think of your paper sculpture as a model for a large-scale piece. Thus, as the sculpture begins to emerge, start to think about how it could enhance a public space if greatly enlarged, what the finished sculpture would be made of and other concerns, such as those listed below.

For the presentation aspect of the project, you are to describe the finished piece to an assembled group. Pretend the group is a commissioning body. You must therefore relate where, for example, the piece would be placed; how it would be produced; its size, medium, mounting and protection against vandalism or injury to others; and so on.

Try to generate and respond to questions from the group because although everyone, including you, knows you are fabricating information, the questions will stimulate thinking about public sculpture and may generate some new ideas.

Here are some questions to ask or respond to in your presentations:

- Would it enhance the grounds of a corporate headquarters?
- Would it attract visitors if installed in a public park?
- Could it be a memorial and if so, for what?
- Would it be appropriate for a school or university campus?
- How would it look on the wall of a building as a high relief?
- Would it locate well on a hill? In a valley? On rocky terrain? On an urban street?
- Should it be mounted high to be looked up at? Or be seen at eye level? Or built into a pit?
- Should it be made of marble, concrete, wood, brick, plastics, fiberglass, steel or a mix of materials?

- What kind of foundation is needed to support it? How deep or wide?
- Should it have a base? What material? What size?
- What might surround it to set it off: sand, grass, shrubbery or water?
- What approximate size would the finished piece be?
- What would it cost to produce? How much do you want to be paid for your design?
- How will your sculpture be safeguarded from weather? How about vandalism?
- Would it pose a danger to passers-by? If so, how would this problem be solved?

The fact that you will not know the answers to most of these questions should not deter you from speculating and having a little fun in the process.

When the project is done in a class setting, the students set themselves up as the commissioning body and each student presenter in turn shows his or her piece and makes up answers ("winging it") to some of the listed questions. This process of presenting work is not only enlightening and amusing, but it puts the presenter in the position of a professional sculptor who is competing for a paid commission.

Remember, you are not expected to know much about structural integrity, the nature and cost of materials and equipment, foundations, vandalism protection or the price you need to be paid. Presenting your project is simply a way to get you and others thinking about these things and to add to the enjoyment of viewing public sculpture on your own.

Hopefully, this mock presentation generates dialog and interest in contemporary public sculpture and what other sculptors are doing.

Here's a way to proceed:

1. Place the sculpture on a stand at eye level to the group.

2. Turn it as you talk, allowing viewers to see it from all angles.

3. Give an overview of projected size, color, its placement, etc.

4. Open the presentation for questions from the assembled group.

5. Call on people as they raise their hands.

6. Make up the answers as you go along.

EXTENDING THE PROJECT

Viewing Public Sculpture

The next step, of course, is going out into the world and contemplating public sculpture on view in the area, or if not in the area, finding it in cyberspace or the library. Then report, write or think about what you particularly respond to and why. This can provide clues to your own personal aesthetic vision. That vision, supplemented by good training, will eventually inform your development as an artist.

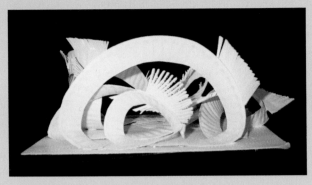

Figure 2-11. Twisted and cut paper plates inspired this complex construction. Katrina Sleder.

Using Other Papers

You can be inventive in your collection of different types of paper for the project. The 3-D quality of Paper Productions can be enhanced by the creation of folded paper constructions, as in **figure 2-10**.

Other papers in addition to strips can also be employed, as in **figure 2-11**.

Color

Although line, design and spatial relationships are your main concern in the paper project, sometimes it works to emphasize color relationships. In **figure 2-12**, strong color contrast makes for exciting sculptures.

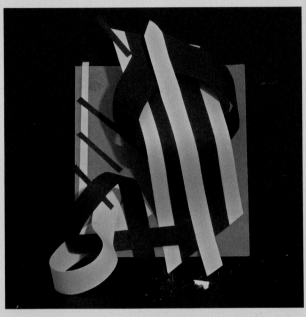

Figure 2-12. Strong, contrasting colors and line formations of different widths work to make this sculpture vibrant and exciting. Natalie Megaro. Photo by Peck.

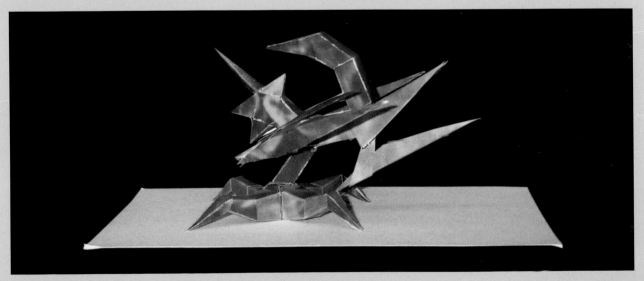

Figure 2-10. Colored paper was folded to create a 3-D appearance throughout the piece. Xiang Ye. Photo by Hernandez.

FOAM CORE FABRICATIONS

FOAM core could be described as a kind of thickened cardboard with smooth texture. The medium is suited to the creation of flat, abstract constructions. Because the material is thick and cutting is not easy, you are forced to adapt your ideas to the construction of planes and concrete structure. This is what makes it an excellent beginning project. The material's very limitation helps you expand your understanding of sculptural form. You will have to cut rather flat geometric shapes without seeking representational images; thus, the focus on form will come naturally.

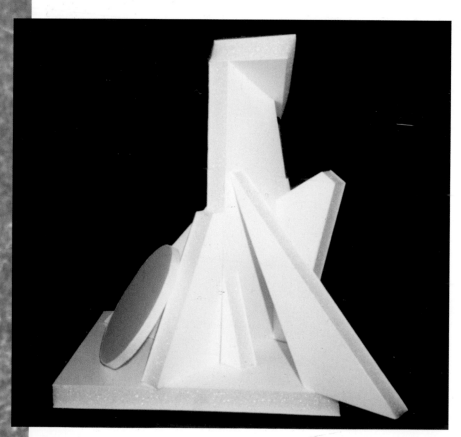

Figure 3-1. Foam core is conducive to creating flat, abstract constructions. Ilana Houten. Photo by Peck.

THE NATURE OF THE PROJECT

The elements to be concerned with are:

- **Form**
- **Shape**
- **Line**
- **Spatial relationships**
- **The play of light and shadow**
- **The play of positive and negative shapes**
- **Balance**
- **Contrast**
- **Texture**
- **Finishing**

Creating a good foam core model will incorporate most of these elements.

As with Paper Productions, think of your sculpture as a large-scale model; this will help you to maximize sculptural forms and minimize fussy detail. Try to keep your shapes cut with precision, even if the sculpture you plan is complex.

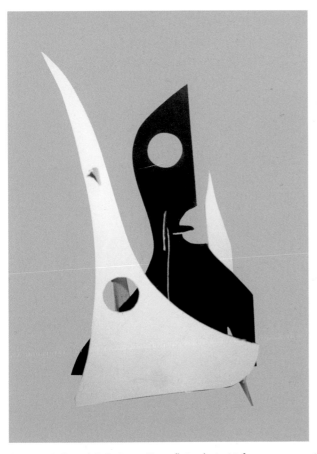
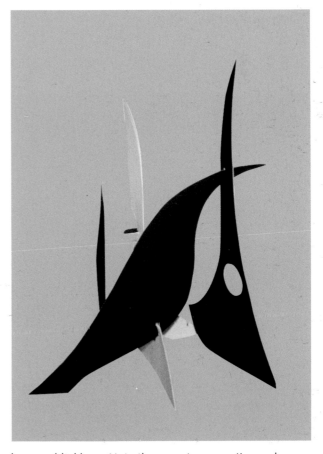

Figures 3-2 and 3-3. Inventive, flat, abstract forms are creatively assembled here. Note the accent on negative and positive spaces. Unidentified student sculptures. Photos by Peck.

CHECKLIST OF TOOLS AND MATERIALS

The Basic Medium

Foam core sheets are supplied in various colors and are generally stocked in 11" x 18" sizes. Combining no more than two colors in a sculpture is recommended. This will keep the focus on form and the elements listed on the previous page without the distracting element of too much color.

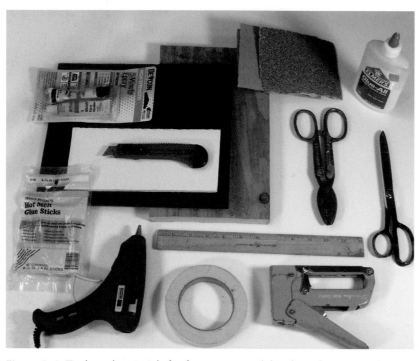

Figure 3-4. Tools and materials for foam core models. Photo by Hernandez.

- Foam core sheets in black, brown, white or red are suggested, choosing one as a possible accent. Shown are samples, not full sheets.
- Utility knife.
- Shears.
- Ruler.
- Cutting board or cardboard.
- Glue gun and hot glue.
- Masking tape in various widths.
- Pencil and paper (not shown).
- Sandpaper.

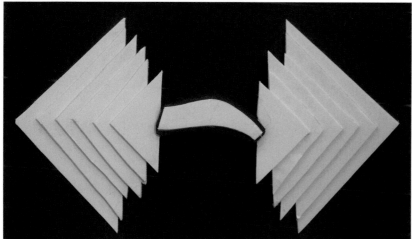

Figure 3-5. Keep it simple but dynamic and use accent colors sparingly to focus on shape relationships. Unidentified student sculpture. Photo by Hernandez.

Figure 3-6. "We Go Together," Paulette Gray. Photo by Peck.

PROCEDURE

1. Protect the surface of your table with a cutting board or piece of cardboard.

2. Select the basic color of foam core you want to use and choose an accent color or colors if desired, as in **figures 3-5 and 3-6**.

3. You can start cutting out shapes at once, or you may choose to sketch out some ideas first with pencil and paper. Take note that just cutting a shape may start the flow of ideas, either from the cut shape or the shape of the remaining void in the board.

4. Fasten the shapes with masking tape or hot glue. Remember that everything that shows — including masking tape or glue — becomes part of the sculpture and thus "chosen" by you to be seen in the finished piece.

5. Sandpaper ragged cut edges, or wrap them with masking tape.

6. Alternatively, you may want rough edges in the finished piece as in **figure 3-7**.

7. Straight pins can be used to connect some shapes if glue doesn't hold, because foam core is thick enough to accommodate them, but make sure the pins are submerged.

8. The construction need not be mounted on a base.

Figure 3-7. You may choose to leave rough edges if they enhance your sculptural concept. Natalie Megaro. Photo by Peck.

Turn your piece as you did with Paper Productions. It may be more dramatic as a wall piece rather than mounted upright, as in **figure 3-8**.

Figure 3-8. Although this composition was made in an upright position, it became more effective hanging vertically with its forms projecting outward from the wall. Lindsey Bartley. Photo by Peck.

Foam Core as a Model for Large-scale Sculpture

As you work, try to think of your foam core sheets as plates of steel that would be welded together if the model were accepted for a large-scale commission. **Figure 3-9** works particularly well in this regard.

Thinking in this direction will help you eliminate unnecessary detail in favor of broad planes and clean, strong geometric shapes. It will also help to spark your interest in seeing professional abstract sculpture on display in and around public places, corporate offices and sculpture parks.

Figure 3-9. Think of your piece as a model for a commission in steel. Carole Finkelstein. Photo by Peck.

Using Cardboard, Poster Board, Tag Board or Other Art Boards

Other types of lighter boards can be used successfully instead of foam core or in combination with it. Because these boards cut easily, more intricate designs are possible. However, try to retain the benefit of the more stringent foam core project, which focuses primarily on strong aesthetic relationships between and among shapes. **Figure 3-10** is a composition in ordinary cardboard. **Figure 3-11** is a composition using poster board.

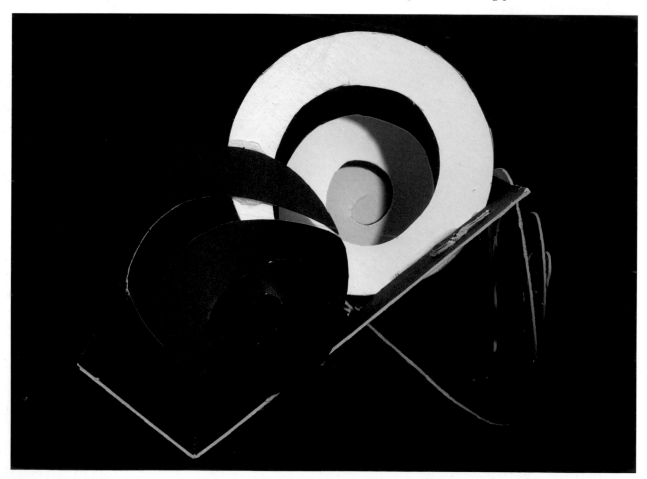

Figure 3-10. This construction and **figure 3-11** in the lighter cardboard material allow for more detailed cuts but still maintain a focus on aesthetic design and contrast. Unidentified student sculpture. Photo by Peck.

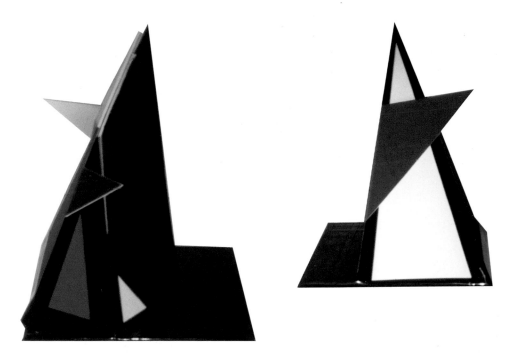

Figure 3-11. Compositions in poster board and other art boards can be more intricate, but should still focus on shape relationships. Limit colors so as not to distract from sculptural forms. Thomas J. Estler. (Two Views) Photos by Peck.

EXTENDING THE PROJECT

Designing Sculpture for a Site

Make it a point to search out modern sculptures erected in public spaces. As you view these, try to imagine how the sculptures may have looked when presented as a model. What materials might have been used to establish the scale, lines, balance and texture? Look in magazines such as Architectural Digest to see examples of the kind of sculptures that grace public buildings.

Consider where the foam core sculpture you have already made could be placed: in front of a corporate building, in a public park or perhaps as a high relief hung on the wall of a lobby.

Start by selecting a site, perhaps one that you frequently see. Design a foam core model for that site. Take other factors into consideration, such as how the surrounding environment will enhance your sculpture and how your sculpture will enhance the environment.

WOOD CONSTRUCTIONS

Wood is a time-honored medium for sculpture for good reasons: wood is fairly permanent, usually has an appealing grain, is pliable for carving and accepts various finishes. Although most sculptural use of wood consists of carving kiln-dried hardwood, this chapter addresses fabricating in wood, which consists of assembling sheets, blocks and rods of soft wood into a sculptural formation.

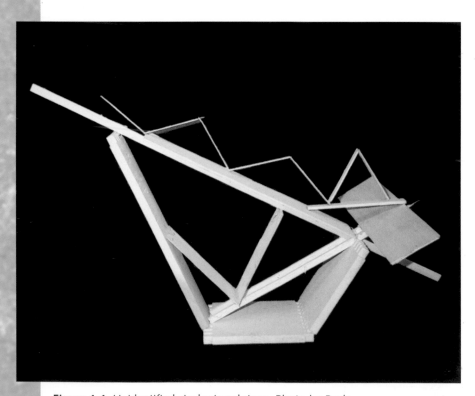

Figure 4-1. Unidentified student sculpture. Photo by Peck.

THE NATURE OF THE PROJECT

The geometric nature of the wood that will be assembled for the project encourages a sophisticated kind of creativity. Because line, rhythm and balance are key aspects of this construction project, you may intuitively feel what will work for an exciting result. You are already tuned to shape and form and now you have a chance to feel the dance and music in your construction. Nevertheless, here once again as in the foam core project, you are relying on the nature of the material to inspire your conceptions, for as you choose this or that combination of boards or rods, the shapes will spark your ideas. Let this happen. Placing the shapes, even tentatively at first, begins the expansion of your ideas.

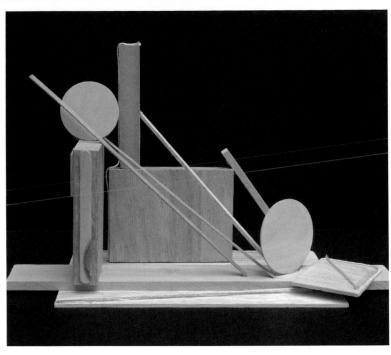

Figure 4-2. Be alert to line, rhythm and balance as you assemble the shapes. Alison Mital. Photo by Hernandez.

CHECKLIST OF TOOLS AND MATERIALS

The Basic Medium

Use thin sheets, blocks and rods of pine or balsa wood. A variety of shapes and sizes for the project should be assembled. An assortment of these can be ordered in bulk from major art supply catalogs (see Appendices). Have somewhat heavier sizes available to use as bases for the constructions. You will need:

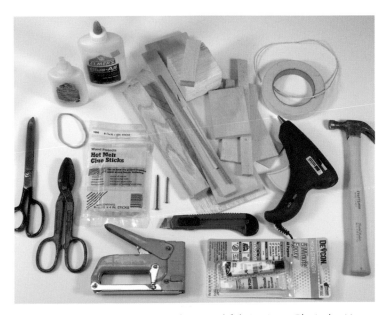

- Wood sheets, blocks and rods in various sizes and shapes.
- Masking tape, 3/4" suggested.
- Stapler and staples.
- Hammer and nails.
- Scissors.
- String.
- Rubber bands.
- Wood glue.
- Glue gun and hot glue.
- Drill with small bit, 1/8" or 1/4"; screws, bolts and nuts (optional).
- Hack saw (optional).

Figure 4-3. Tools and materials for wood fabrications. Photo by Hernandez.

PROCEDURE

1. Select a base — it might be rectangular, square, circular or oval. This wood should be a bit thicker than other pieces to provide support.

2. Begin laying out your sheets and blocks.

3. Balance the supporting shapes temporarily using masking tape, wedges of wood or thick cardboard, or even bits of clay, but keep edges to be glued clean.

4. Lean back as far as you can to see what you think of the emerging design. It is difficult to see any composition when you are on top of it.

5. Arrange the largest forms first.

6. Fill in the large forms experimentally with smaller sheets and blocks.

7. Feel free to glue a piece on lightly at first and then change it; you will solidify the composition at the end to make it more structurally stable.

8. Once the main pieces are together, begin to experiment.
 - See how a linear rod can add energy to your piece by carrying the eye in a different direction as in **figure 4-2**.
 - See how string or a rubber band can add rhythm and tension when affixed between forms as in **figure 4-5**.
 - See how a band of colored masking tape adds a design element as in **figure 4-6**, but don't overdo this.

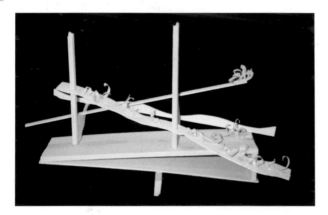

Figure 4-4. Diagonal lines create movement and energy. Here, wood shavings add an interesting texture. Unidentified student sculpture. Photo by Peck.

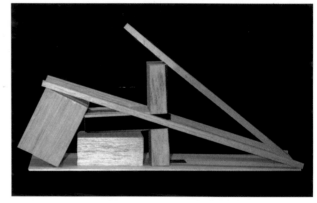

Figure 4-6. A band of masking tape adds tension and design to this strong composition. Robert Steen. Photo by Peck.

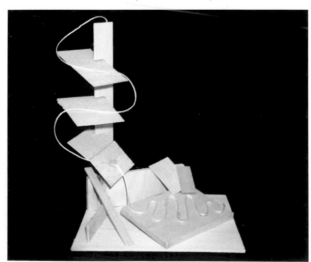

Figure 4-5. The cascading string in its curvilinear formation contrasts with the flat geometric squares. Unidentified student sculpture. Photo by Peck.

Turn your piece continually to see it from all sides and make adjustments, seeking these sculptural elements:

- **dramatic balance**
- **intriguing line formation**
- **a rhythm that carries your eye appealingly from one section to another**
- **a contrast of thick forms against thin**
- **a play of light and shadow**

As in your sculptures in Paper Productions and Foam Core, see if your piece works more dramatically mounted in a different direction (**figures 4-7 and 4-8**).

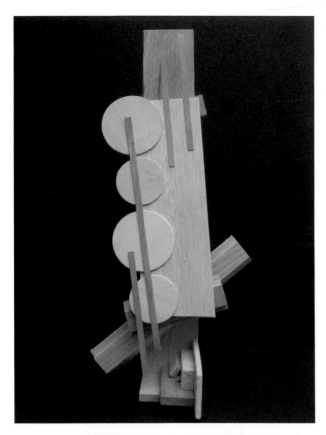

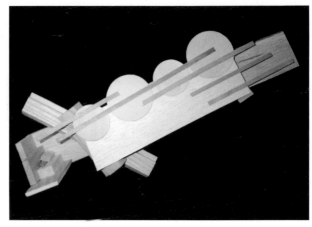

Figures 4-7 and 4-8. This sculpture could be mounted upright, horizontally or diagonally, a purely aesthetic decision. Lindsey Bartley. Photos by Peck.

Experiment and have fun. You cannot "ruin" it. Even if a piece of wood splits, you can replace it or use the split section to summon other ideas. **Figure** 4-9 is comprised of leftovers and a bit of string arranged in a somewhat whacky way.

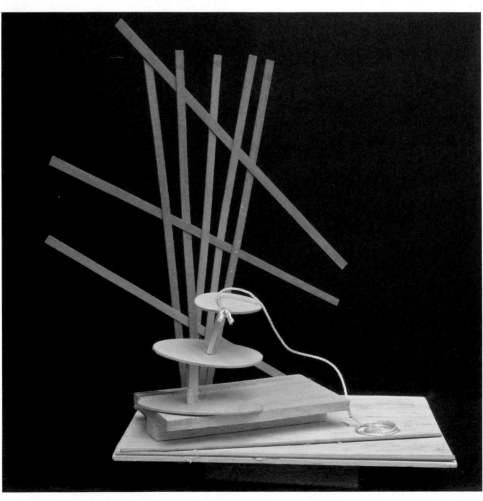

Figure 4-9. This simple construction seems inspired by broken latticework. Carole Finkelstein. Photo by Peck.

There is no one way to construct your sculpture. Work with the medium in a kind of visual conversation with the shapes. The best scenario in creating sculpture is when you work with the medium and the medium works with you. It is a partnership. You are in charge, but if you are not alert to what the medium offers, you deny yourself the gift set before you. Total imposition of your pre-set ideas on the medium will not allow you to move forward as expressively as you might.

The sculptures illustrated below were all created from the same grab bag of wooden shapes. One was meticulously constructed to resemble a flower, one is boldly architectural, and one is a kind of balancing act. Another is inspired by the windows and doorways of a house, another by toothpicks. Each is unique, as yours will surely be with openness to the possibilities of the shapes, confidence in your vision, and patience to put it all together.

Figures 4-10, 4-11, 4-12, 4-13 and 4-14.
There is no one way to construct the sculpture. Work with the medium in a kind of visual conversation with the shapes. Photos by Peck. Digital photos by Hernandez.

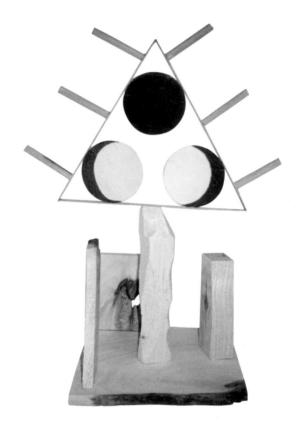

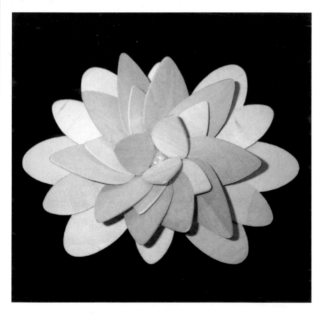

Figure 4-10. "Flower." Xiang Ye.

Figure 4-11. "Tree Form." Thomas Weeks.

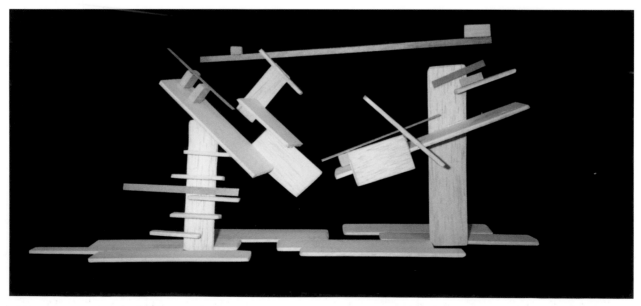

Figure 4-12. Unidentified student sculpture.

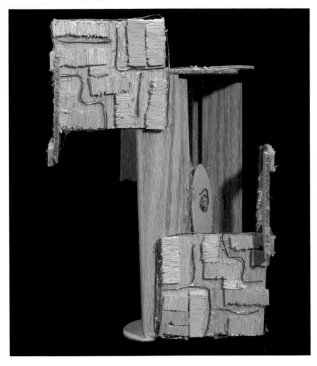

Figure 4-13. "Wood Spokes." Katrina Sleder.

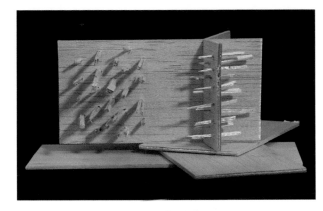

Figure 4-14. "Windows." Colin Kehue.

Take a photograph of your finished pieces. The wood constructions are fragile and may not survive transportation or the hurly burly of a lively household. The photographs will provide a record of the spontaneous work you do in this versatile medium and perhaps inspire more challenging concepts in the future.

EXTENDING THE PROJECT

Working with Nature

Much in the way you assembled geometric pieces of wood, try assembling objects of wood found in nature.

Take a walk out of doors to find items strewn about, such as branches, twigs, tree bark, roots and debris. While you are walking, do not think about how these items might be assembled. Simply look and collect shapes that appear aesthetically interesting to your eye.

Bring your collection to a work place. Then, look carefully at your assembled collection; remember that seeing is the first and often major component in the artistic process.

Visualize, and then try a combination of elements. Lean back while holding pieces in place to see your composition from some distance.

Then, as you did in previous projects, consider starting with a base. Some formations may be free standing and not need mounting on a base, but others will be more secure attached to a firm piece of wood.

Temporarily fasten parts with either masking tape or a spot of hot glue. Step farther back.

Begin adhering parts with hot glue, hammer and nails, staple gun and/or masking tape. Use a drill with screws or bolts to secure heavier sections. Using a bolt, washer and nut to attach the sculpture to a base requires countersinking (see Chapter 13).

Turn your piece continually to see it from all sides, and make adjustments as you did in your initial wood construction, again, seeking such sculptural elements as dramatic balance, intriguing line formation, a contrast of thick forms against thin, and the play of light and shadow.

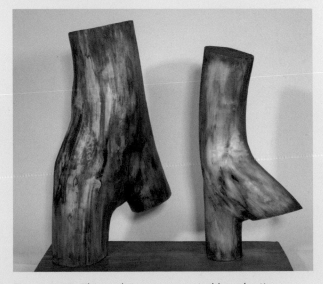

Figure 4-15. This sculpture was created by adapting something from nature's woodpile to a finished, mounted sculpture. "Mother and Daughter," Peck. Photo by Hernandez.

FOUND-OBJECT SCULPTURE

YOU will not need a full week to produce one found-object sculpture if the objects for your piece are already on hand or particularly easy to assemble. You could then use the remaining time to make a different kind of found-object sculpture: a wall piece, for example; or a hanging mobile, balanced in such a way that it moves in normal house atmosphere; or a fountain made of found objects but with the inclusion of a simple pump and hose (see Extending the Project). Once you understand the mechanics of assembling objects into an integrated sculpture, you can create found-object works in many different ways.

If the sculpture in this book is being done in a school program, the found-objects project works best as a home assignment. A class critique would follow when pieces are completed and brought in from home.

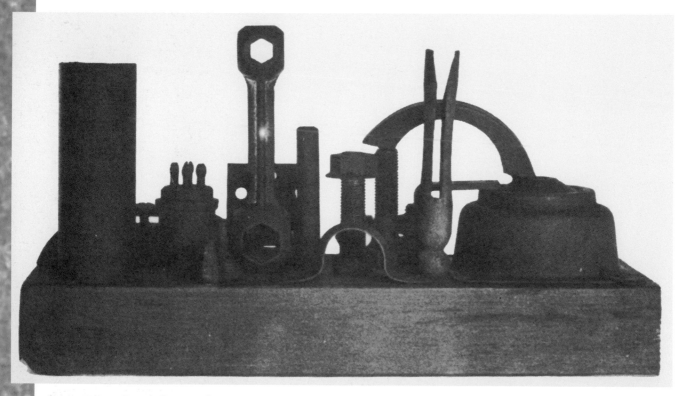

Figure 5-1. In found-object sculpture, space is organized by relating lines, shapes and mass to create an aesthetic interplay. Amy Robinson Zinn. Photo by Vold.

THE NATURE OF THE PROJECT

Creating found-object sculpture involves what the name suggests: finding objects and making sculptures out of them. This project is excellent for beginning sculptors, for if seeing is the eyes of art-making, making aesthetic decisions is the heart of art-making. The opportunity for doing this with found objects is continuous from beginning to end. The necessity to master materials, on the other hand, is much less critical for found-objects than in other three-dimensional media.

Found-object sculpture is highly improvisational. Instructions for the project are minimal and quite flexible in nature, not step by step, and they are offered as a menu of possibilities from which you can choose, guidelines as to what objects might be used for your sculptures and various methods for assembling them. Even so, aesthetic objectives, as in all other media, must not be overlooked in the flurry of gathering and grouping objects.

CHECKLIST OF TOOLS AND MATERIALS

The tools and connective materials will depend on the nature of the objects to be assembled. Those listed below, some of which are illustrated in **figure 5-2** (and also illustrated in Chapter 13, Mounting) are universal enough to enable you to consider a wide spectrum of found objects for your compositions. It is wise to regard all of the tools and materials as optional rather than necessary until the objects for the sculpture are collected and the tasks of cutting, bonding and mounting become clear.

- Stapler.
- $1/4$" or $3/8$" drill with assorted bits (bit size determines diameter of the hole).
- Cutting shears (not shown).
- Wire snips (not shown).
- Saws.
- Soldering iron.
- Hammer and nails.
- Pliers or vise grips.
- Knife (not shown).
- Supporting base (not shown).
- Masking tape, duct tape.
- Sandpaper.
- Cord and wrapping wire (not shown).
- White glue and contact cement (not shown).
- Five-minute quick-setting epoxy resin and hardener.
- Glue gun and hot glue.
- Flat black and flat dark brown spray enamel.

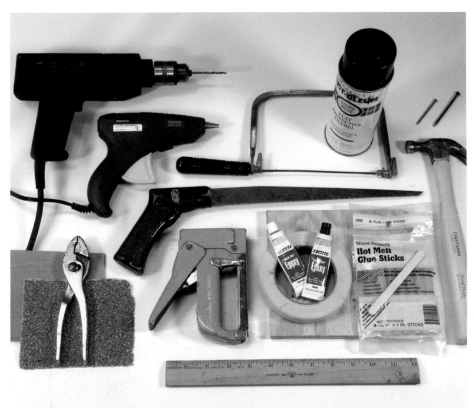

Figure 5-2. All materials should be considered optional, as they will depend on the objects you assemble and how you choose to connect them. Photo by Hernandez.

FINDING OBJECTS

Objects for finding are literally everywhere. Below are some suggestions for items to be found outdoors, followed by items generally found indoors. You surely will think of other objects that are both aesthetically sound and mechanically feasible as your project gets underway.

Outdoor Found Objects

- Nature's debris: branches, roots, bark, stones, bones, feathers.
- Construction materials: roofing, wire mesh, concrete fragments, wire, wood, plastics.
- People's debris: broken garden tools, bicycle parts, car parts, tin cans, cigarette boxes, wrappers, garden gloves, hose parts, flower containers, machinery parts.

Indoor Found Objects

- Hardware: bolts, nuts, washers, flanges, brackets, hooks, hinges, screws, nails, stakes.
- Broken toys.
- Clothing fragments, fabric scraps, cord, rope, ribbon, shoelaces, thread.
- Kitchen utensils.
- Broken or obsolete appliance parts.
- Electrical, machine, plumbing and computer parts.
- Packaging materials: cardboard, corrugated paper, Styrofoam.
- Old costume jewelry.

CRITERIA FOR SELECTING OBJECTS

The objects to be found for making sculptures are indeed plentiful but because of the variety of items available, it may be tempting to include things simply because they are interesting in and of themselves. It is a good thing to be intrigued by the shape and form of objects; in fact, it is actually a necessary first step, but it is easy to be seduced by an enchanting variety of collected materials without seeing how they can be integrated into sculpture. You may want to hold onto interesting objects for future use, and this is a good idea. Be aware, however, that simply assembling single objects and joining them will result in a jumble of unintegrated forms, which ultimately will produce an exhibition of collected items, not a sculpture. To keep this from happening, certain criteria for selection are set forth to help you avoid the pitfall of becoming more a collector fascinated with things than an artist interested in designing a single work.

Obviously, the criteria for selection will be modified according to your own ideas for specific works. However, certain broad features for an aesthetically sound assemblage can be described. It should be noted that most of your decisions will be intuitive in the long run; that is, you will have a gut feeling of what works and what does not work. Nevertheless, in the beginning, it is important to consider formal aesthetic concepts so that you can think about why something is or is not working and how a visual problem might be solved.

Movement Patterns: Line and Contour

Pay attention to the outer and inner line formations that give movement and vitality to the sculpture. Movement patterns may be curved, angular, geometric and so on. The line formations are the contours of the sculpture — for example, they are seen in the silhouette in **figure 5-3**.

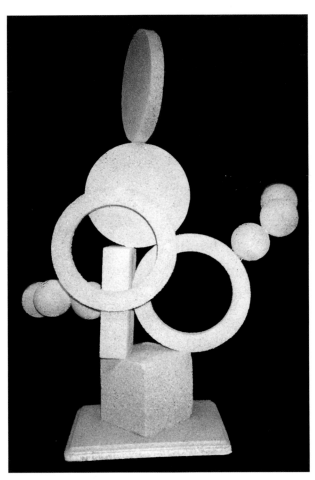

Figure 5-3. The movement patterns in this Styrofoam assemblage are square, round and curvilinear. The intricately devised off-balance construction makes for an interesting line contour. Unidentified student sculpture. Photo by Peck.

Form and Shape Relationships

In addition to concern about line, attention must be given to the relationship of forms and shapes and organizing forms of different mass:

- **Thick and thin**
- **Concave and convex**
- **Open and airy**
- **Closed and dense**
- **Shapes of different widths, depths and heights.**

Try to achieve a dynamic interplay among these elements.

When there are several diverse shapes and changing linear directions in the assemblage, one massive form can provide a kind of visual stability, as in **figure 5-4**.

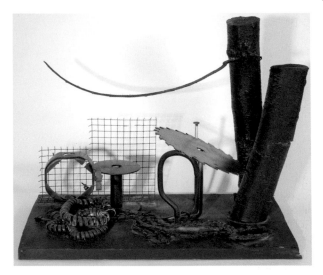

Figure 5-4. The bulky diagonal shapes on the right, the square screen shape in the back and the strong rectangular base give a sense of visual stability to this composition. The essential composition consists of a pattern of circular lines. Jarrett Wilkins. Photo by Hernandez.

Color and Texture Relationships

Finally, pay attention to color relationships. In found-object sculpture, many disparate objects may be placed together because the lines, forms and shapes make aesthetic sense; but the sharply different colors might so intrude upon the composition that cohesiveness is lost. In such cases, it is wise to spray the sculpture one unifying color so that the impact of the total composition will prevail.

Interestingly, contrasts in texture usually add to the sculpture's vitality, so this might work well. Still, carefully consider before putting strong contrasts of very rough and very smooth together. You are searching for an integration of parts overall, and although there may be a focus and that's fine, one part should not overwhelm the rest of the sculpture.

Transformation

For found objects to work as the components of a sculpture, they must in some way be transformed from their original function as objects to their new role as part of a sculptural composition. For example, it might be amusing to use your uncle's baseball cap in a sculpture, but it will be only a short-lived curiosity if the cap is not transformed into a form that makes sense within the piece.

The viewer might recognize real objects used in the sculptures, as in **figures 5-5 and 5-6**, a playful assemblage of recognizable items; but the objects should be transformed so that their primary reality is no longer the function served in their first life, but the role they play in their second life as components of your sculpture.

The concept of transformation is illustrated in these sculptures. Take in the whole sculpture and what it represents. Only then, try to name the objects which make up the forms.

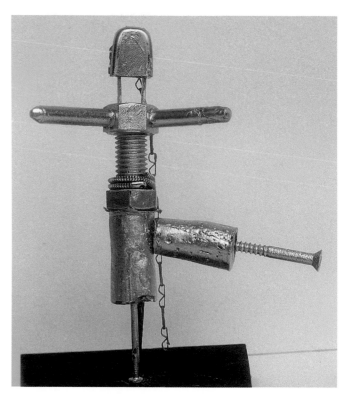

Figure 5-6. The hardware provided the idea and materials for this standing figure but then became only a curiosity in the final sculpture. Unidentified student sculpture. Photo by Peck.

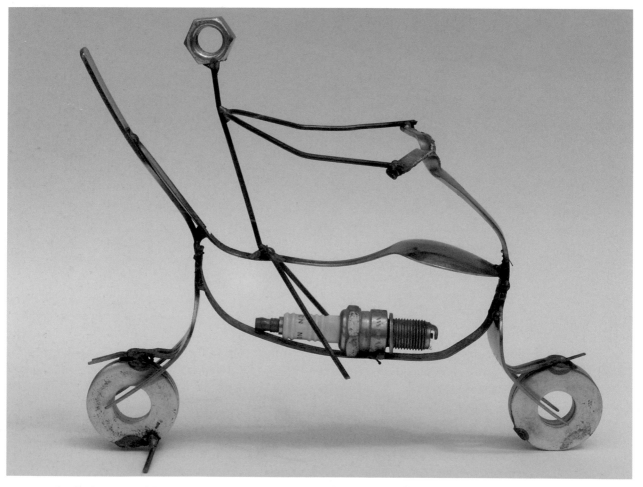

Figure 5-5. You might recognize the hardware in this amusing piece, but the first thing you absorb is a rider on a bike. Unidentified student sculpture. Photo by Hernandez.

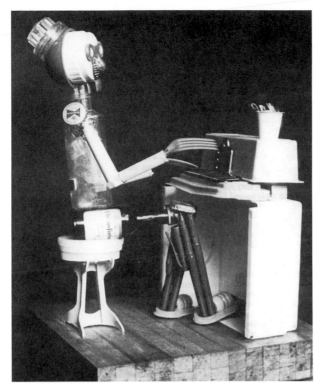

Figure 5-7. The successful transformation of found objects — can you locate them? — into sculptural form marks the change of an object's original use to its role as an integral part of the sculptural composition. "Jazz Man," Joyce Van Dyke. Photo by Vold.

Aesthetic Harmony

Aesthetic harmony refers to the need for a kind of visual logic to be present in the sculpture. For one example, instead of a chaotic display of objects, there will exist a somewhat logical visual relationship between large and small forms or smooth and rough textures. Any number of examples could be given, yet none should be considered rules, only factors to be considered.

Visual logic does not mean that your items must be related logically. A tennis ball can certainly be placed next to an umbrella. Rather, aesthetic harmony implies that the full visual vocabulary of sculpture should be considered as you make your selection of objects and arrange them in interrelationships. "Does it work?" you might ask yourself. If not, what's wrong? Go back and review the aesthetic points raised in the criteria for selecting objects to find out why, and then make some changes.

Listed here are some other aesthetic components which you should think about as you put your items together. Your sculpture will not have all of these components but being aware of what you could add or change by glancing at the list might make a difference in the vitality of your piece.

Look for:

- **Light and shade:** How does light contrast with shadows to add dramatic input?
- **High points and low points:** How does the viewer's eye move around your piece?
- **Concavities and convexities (depressions and mounds):** Does your sculpture contain any such contrasts, and if so, do they need to be expanded or reduced?
- **Massiveness and delicateness:** Does this contrast help or detract from the integration?

Ask yourself the following questions:

- **Are there interesting *contours*, both internal and external?**
- **Is there a sense of *balance*?**
- **Is there a visual *rhythm*, a fluidity of lines?**
- **Does the sculpture have a sense of *design*, including such components as symmetry or asymmetry, repetition or pattern, a central focus and peripheral forms?**
- **Does the sculpture have predominantly geometric, amoeboid, or organic forms or an interplay between them?**
- **What part does *texture* play in adding vitality to your piece?**
- **Is there *stylistic consistency* and a sense of cohesiveness in the separate parts?**
- **Have you achieved *transformation* of the found objects to form a single sculptural piece?**

Structural Stability

Stability in this context refers to whether or not the objects selected can be adequately attached with the available tools and materials. For example, a granite rock cannot be drilled without an expensive drill and tungsten carbide bits, and although the concept of holding the rock aloft between two branches might be an excellent one, the task of making it structurally stable would be challenging at best in a modestly equipped studio (though not impossible). In any case, the choice of objects should include considerations of weight, gravity, adhesion to the base and to other objects, and physical balance.

PROCEDURE

The Base

From the very beginning, the base should be integrated into the sculptural composition as the foundation upon which objects are manipulated and arranged. Bases on which the sculptures are attached should be substantial enough to set off the sculpture properly. For example, heavy metal objects require a base that is sturdy enough to stabilize the piece both physically and visually. Lighter materials require a thinner base so as not to overwhelm the interrelating forms. Bases must, of course, be level and not tippy.

Some sculptures might be more effective as reliefs, in which case the base will be used to support the sculpture vertically against a wall instead of upright on a table or stand. The decision to make the sculpture a relief might not be made at the outset.

When the sculpture is completed, the total composition usually becomes more unified if the base is spray-painted the same color as the found objects.

Temporary Stabilization

When objects have been collected and are ready for assembling into a composition, you face the problem of temporarily balancing the objects to test their visual "rightness" in relation to other objects. To see if relationships *work*, you have to let go of the objects after they are placed and step far enough back to see the impact of the forms in space. The sculpture must be seen not only from the front but also from all sides, and you cannot see how other sides will work without turning the sculpture or moving around it. Gray duct tape is useful for temporary adhesion because it is strong, sticks well to many types of surfaces and is easily removed and placed elsewhere. Larger items can be temporarily supported by rocks, sandbags, cord or wire.

Permanent Stabilization

Permanent bonding or binding can be made by using any of the materials listed, either alone or in combination. You can drill holes into objects to allow two items to be tied together. Look also for the natural holes and crevices in objects as places to tie one thing to another. Metal parts can be soldered. The size and fragility of your piece will determine whether hammer and nails, staple gun, or tape would work best; and there are many glues on the market today capable of bonding things one couldn't imagine would hold, so experiment with those as well.

Aesthetic decisions might actually be made on the basis of what device is used to connect one part to another. This is especially so when you are trying to connect objects intended to have physical movement. Parts can be made to move by natural air currents, by fans or by hand manipulation.

If parts have been bonded, the bonding agent should be thoroughly dry before painting. If tied, the knots should be buried or covered unless you intend them to be part of the sculptural form. Nails, staples, and other hardware should be neatly and securely fastened. The sculpture is enhanced when it emerges as unencumbered as possible by the practicalities of its assemblage.

Spray Painting

Connective materials such as masking tape, cord and wire can be integrated into your sculpture as textures by spray painting the entire composition a single tone when the assembling process is completed. Flat black or flat brown are the recommended choices for spray painting. Using these colors and tones will reduce the disparity of surface textures and also minimize the confusion of unwanted light reflections that would occur with the use of either a light color or a gloss black or brown.

If color is integral to your composition, use it according to your concept. However, allowing the natural colors of the found objects to remain as they are can hinder the "transformation" of separate objects into a single integrated sculpture. When sprayed a single flat black or brown, the various textures will come through as different tones, yet there will be enough integration to allow the sculpture to be seen as a unit.

If plastic packaging material such as Styrofoam is used in the sculpture, latex paint should be brushed on, as spray paint will corrode it. However, partially dissolved or puckered Styrofoam might be incorporated as an interesting object within your composition. Always spray paint in a well-ventilated area.

FREEDOM AND LIMITATION

Described at various points in this chapter is what might be termed the freedom and limitations of working in an art medium. The opposing forces of freedom and limitation are present in most art experiences, but they seem particularly obvious in found-object sculpture: the freedom to select from a wide assortment of existing objects contrasts with the limitations imposed by the need to organize lines, forms, shape and color; to transform objects into sculptural components; to achieve aesthetic harmony; and finally, to render the work structurally stable. It is important to take note of these opposing forces, as they account for much of the tension and excitement in art-making.

Recognizing that there are physical restrictions and limitations which will always be imposed upon the development of your ideas may relieve some of the frustrations you might feel as you set about completing the sculpture with the tools and materials at hand. Such recognition may help get you through difficult sessions when the exuberance of creation has given way to the more mundane tasks of construction and finishing.

Accepting the concept that a contrast between freedom and limitation exists in art-making can have practical implications. For example, the need to channel freedom into some kind of structure can inspire thematic content, as in **figure** 5-8. Here, a confusion of plates, coils of wire and discs resembling children's heads connotes the theme of hectic family life for the artist/mother who created the sculpture while attending school full time. Because it is made of the ingredients of everyday life, found object sculpture is an excellent medium in which to convey narratives about the human condition.

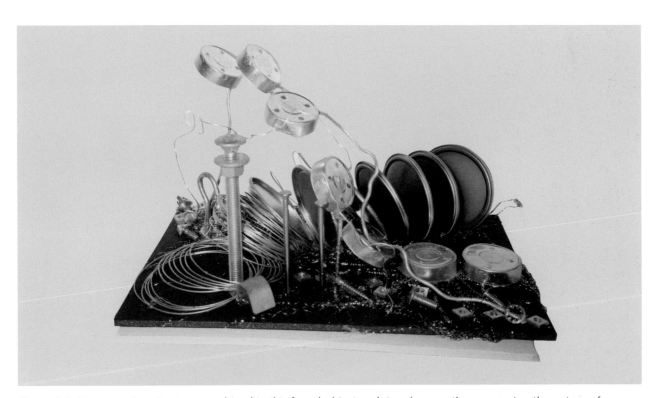

Figure 5-8. Theme and content are combined in this found-object sculpture by a mother expressing the nature of mealtimes in her active household. Kenia Liriano. Photo by Peck.

EXTENDING THE PROJECT

A Walk in the Woods

A walk in the woods is an ideal place to find stimulation for constructing sculptures. For this purely visual stimulus, do not limit yourself to objects that can be brought in and assembled. Expand your visual selections to include anything that has aesthetic components that appeal to you. These might include cloud formations, tree branches, birds flying and alighting, rocks and boulders, mountain ranges, fish in a pond, joggers, bicyclists and so on. The recognition of aesthetically pleasing forms, whether or not they can physically be taken in and assembled, is often sufficient to bring them into your consciousness as part of your arsenal of forms, to be summoned forth at some moment when you are actively solving a sculptural problem.

For more immediate application, use a walk in the woods to collect branches that have evocative formations. The branches can be mounted individually or in combination; they can be collected and organized with humanistic content in mind or as abstract drawings in space. Branches can be combined with taut string formations to add tension to the compositions.

Because found objects are out there for the finding and collecting (if they don't belong to somebody else), the process of creating sculptures from them should generate ideas, not only for the project at hand, but for your future work in other media as well. Selection is a major aspect of art-making, and the more experience you have in making artistic selections, the closer you will come to producing from your own personal vision.

Art with Social Impact

The found-object project lends itself to themes of social consciousness. Expressions relating to war, crime, poverty, politics, the environment or human emotions of sadness, joy, loneliness, pain and humor will cause others to respond to your work. Engaging others in the aesthetic statement that artists make through their art productions is one of the principal reasons that art lasts through the ages. So go for it.

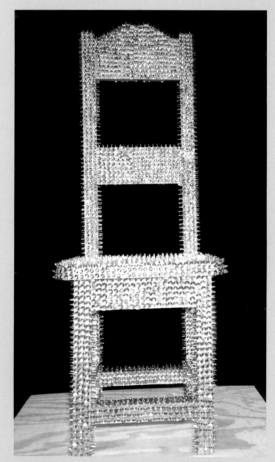

Figure 5-10. Here a chair formed the structure for the attachment of hundreds of shiny metal tacks projecting out. The connotation can be anything you want it to be, but the image certainly evokes an emotional response. Thomas J. Estler. Photo by Peck.

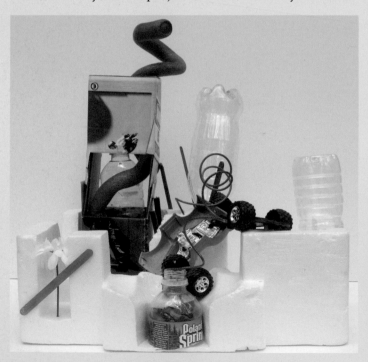

Figure 5-9. In this assemblage of found items, titled "Urban Sprawl," original colors of objects are retained, but the composition is carefully arranged to integrate the "mess." Carole Finkelstein. Photo by Hernandez.

Group Themes

If a group is involved, as in a class, why not plan a found-object circus or animal farm. Ingredients can be whatever individuals turn up. The theme can generate ideas. Accoutrements such as painted scenery as a backdrop would add a nice touch for an exhibition. The giraffe in **figure** 5-11 generated this group project.

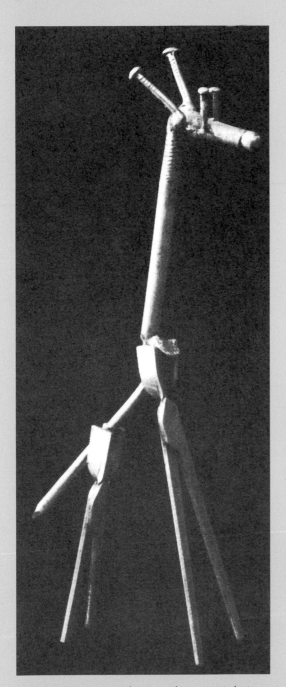

Figure 5-11. A group theme with one topic but different ways of going about it should make a fun and challenging exercise. Nails and tongs provide the materials for this giraffe and then become only a curiosity, so obvious is the animal. Susan Balacich. Photo restoration by Csokasi.

Found-Object Fountains

Fountains seem like a complicated enterprise to undertake, but the creative aspect is similar to found object sculpture; only the mechanism is extraneous. You will still seek objects to use that are found in and around your dwelling. These must be sculptural in quality, which means adhering to concepts described throughout this chapter, and of course, your fountain must have structural soundness so that water does not end up all over the floor.

Some suggested materials are listed here and seen in **figure** 5-12. The basic materials for creating a fountain, are the pump and some plastic tubing (both available in a pet and fish supply store), one or more found-object vessels, and camouflaging material for the pump and the plastic line.

Materials for Found-Object Fountains:

- A multi-use adjustable pump.
- A length of plastic tubing as determined by the size of the project.
- A vessel in which to collect water.
- A receiving tray (a larger vessel; in some fountains, the only vessel).
- Something to hide the plastic tubing (if needed for aesthetic reasons).
- Camouflaging stones, shells or rocks.
- A source of electricity.

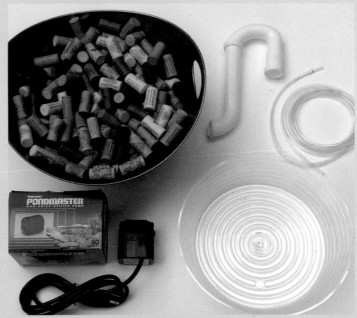

Figure 5-12. Pictured here are sample kinds of materials you would need to make a simple fountain. All items should be seen as choices that you would be making for your particular design. Photo by Hernandez.

Here is a simplified process for creating a found-object fountain:

1. Submerge the small fish pump in a receiving tray (the large vessel); you may only need one, depending on your design.

2. Attach the plastic line to the pump.

3. Arrange a way for the pumped water to enter the vessel through the line. You want the pump hidden from view and the receiving tray deep enough to allow the submerged pump to send and return water through the line.

4. Arrange a way for the pumped water to return into the supporting vessel. The pump has attachment connections to support this operation.

5. Arrange a way to camouflage the plastic tubing. Ideally, you only want to see the water flowing into the vessel.

6. Set stones or shells or other camouflaging material over the pump. (Colored corks are used in the illustration).

7. Sound is a factor to think about in fabricating a fountain. You can change the volume of the water running through the tube via a lever in the pump; this will change the sound as well as the flow.

8. You can increase the descent of the water coming into the vessel by drilling a hole at a point above which you don't want the water to rise. The more hollow your vessel is, the louder the sound will be.

Figure 5-14. In this figurative fountain, two clay heads were created and hollowed out, and water cascades like tears from one. The pump is hidden in the bottom of the vessel under stones. Victoria Fernandez. Photo by Mosia.

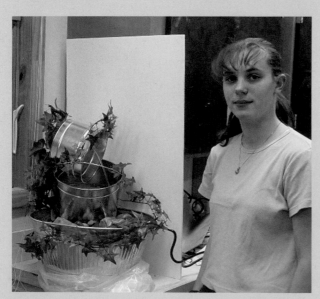

Figure 5-13. In this fountain, two different size vessels with holes punched into them send water cascading into a third vessel. Artificial leaves and decorative rocks hide the pump. Kristen Petela. Photo by Mosia.

Figure 5-15. This decorative fountain features a curved arch containing the plastic line. "Rock Garden," Krystal Ciocon. Photo by Mosia. Digital restoration by Csokasi.

50

MODELING IN CLAY

HOPEFULLY, the limited time allocated for working with clay will encourage spontaneity, yet be sufficient to introduce you to this very versatile medium. In the 2-week time period you will be creating first an abstraction, then a small seated or reclining figure. The reason for first doing an abstraction is to keep your focus on form and the relationship between forms, as opposed to diverting your attention toward getting your piece to look like something realistic which you have in your mind's eye. Later, if you have the time and inclination, you might make a representational image of any kind. Then, by the time you make that realistic, you should have a grasp of structure and planes and solid forms to ensure that your sculpture is foremost a good sculpture and only then a good turtle or duck or whatever.

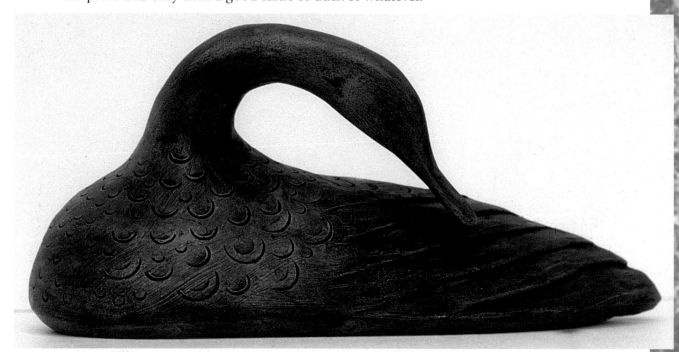

Figure 6-1. With a focus on form more than efforts toward realism, you will work toward solidifying round forms as well as flat forms through use of your wooden block and tools. Paul Barbier. Photo by Peck.

THE NATURE OF THE PROJECT

Clay is a flexible medium. This can be good or bad for beginners: good because clay responds to every push, pull and pat; bad because it offers so little resistance that all direction must come from you. Little guidance derives from the medium as, for example, in carving or in welding where the rigidity of the material forms a basis for attack. The sculptor's approach in manipulating structurally solid media such as stone, wood, and steel is predicated to some extent on existing forms: removing masses in carving; organizing shapes in welding. With clay there are no existing structures other than those you create. This means that you must develop a good sense of the formal dynamics of sculpture to deter you from going in too many confusing directions at once.

Despite clay's flexibility, respect for the material is necessary. Yes, it follows your direction, but only to its own critical limitations. In this chapter, you will come to understand those limitations and how you can control them to your advantage. Understanding the techniques of clay modeling is initially a matter of plunging in and working.

Avoiding Frustration

When you model in clay, as in other projects described in this text, try not to become too frustrated or put off by the myriad of "looking fors" that constantly appear while you are working: looking for the proper size wood to prop a sagging form; looking for a larger base on which to work; looking for a decent plastic for wrapping. In sculpture, you work with things — a lot of things — and these, in turn, are supported by other things.

Clay modeling involves only a moderate amount of things to be concerned with in comparison with other sculpture techniques, but one must expect and allow for time to be spent setting up and cleaning up materials, and in the interminable "looking fors" in between. Advance planning and good organization will help, of course, but in the throes of creative work those qualities do not regularly appear. Even experienced sculptors can get bogged down while searching, gathering and adding supports. Therefore, patience and fortitude are the virtues to be sought.

THE BASIC MEDIUM

This chapter refers to clay work for kiln firing; therefore, water-based clay is the medium described. Water-based clay, even when dry and hard, is not permanent, however; it crumbles easily and will revert to its mud state when wet and thus needs to be fired in a kiln. Oil-based clay or plastiline (which cannot be fired) never dries; it remains flexible. Although not addressed in this text, sculpture made in both water-based and oil-based clay can be made permanent and duplicates made through the process of casting. Casting involves preparation of a plaster mold of the sculpture, then making a cast in liquid materials which become hard when set. Casts might be in plaster, hydrocal, clay slip, concrete, metals or thermosetting resins. Preparing such casts can be done in the home studio; however casting in metal is done in foundries specially designed for sculpture casting (see Appendices for bronze foundries and for books on casting).

Several firing clays are suitable for sculpture. Three readily available clays are Jordon Buff with grog (light tan), Terra Cotta with grog (deep red) and Dover White with grog, which fires white. There are others with different firing properties. Clay is most economically purchased in 50-pound cartons, each consisting of two 25-pound plastic-wrapped bags.

Oven-firing clay is clay that does not require firing in a kiln but can be baked in an ordinary home oven. It is more expensive and smoother in consistency than those recommended above. Avoid "non-firing clay" sold in hobby shops, as it is rubbery and difficult to work artistically.

Grog is pre-fired clay that is ground into small particles and mixed evenly throughout the firing clay. It reduces the risk of breakage in the kiln by creating pores through which moisture can escape; it also helps to modify shrinkage, as having already been fired, the grog can no longer shrink. Grog also creates a mildly granular texture that inhibits the slick finish that beginners sometimes attempt at the expense of form when they first approach the medium. The amount of grog in commercially pre-mixed clay is normally from 20 to 30 percent, and the particle size is usually medium grain. Both the proportion and the particle size can be custom ordered, or clay and grog can be bought separately and mixed to fit special requirements. The easiest way is to purchase pre-mixed clay.

Clay and modeling tools are found in sculpture supply houses (see Suppliers). The remaining materials are available in household goods or hardware stores.

CHECKLIST OF TOOLS AND MATERIALS

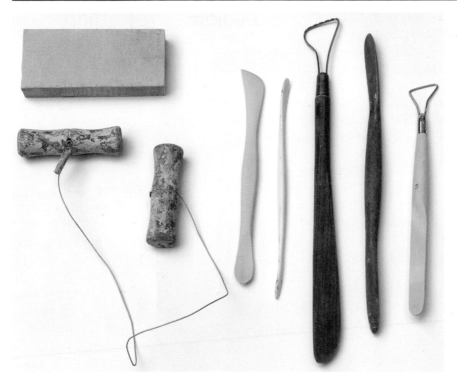

Figure 6-2. Tools and materials for clay modeling. Photo by Hernandez.

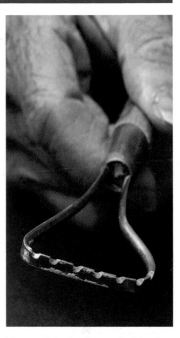

Figure 6-3. A wire-ended tool, one edge serrated and the other flat, is used to carve the clay and help you define the shapes and contours of your work. Photo by Hernandez.

Tools and materials are shown in **figures 6-2 and 6-3**:

- Small wooden blocks: cut from scraps in assorted sizes with varying thickness, ranging from ½" to 1-½", used as initial hand tools in forming the sculpture. The blocks also serve as props for support while working.
- Wooden modeling tools with thin, flat surfaces and slightly curved, rounded ends: modeling tools begin where the small blocks leave off to press, shape, carve, curve and direct the forms.
- Wire-ended tools: most practical are tools with wire inserted on one end and a flat wooden surface on the other. The wire is a carving implement, triangular, with one surface serrated, the other flat (figure 6-3), useful to define shapes and contours and to control surface textures.
- Plastic modeling tools: these are sold as a set and are useful for detail because of their thin blades and flexibility.
- Turntable or lazy Susan: used to turn the work-in-progress so that it can be seen easily from all sides (not shown).
- Rags, plastic bag and plastic wrap (heavy duty): for keeping clay damp while work is in progress (not shown).
- Plaster bat: for drying out clay if it is excessively moist (optional, not shown).
- Wire with wooden handles for dispensing clay.
- Metal file: for repairs after firing, as needed (see Project Preservation and Patina).
- Five-minute quick-setting epoxy resin: for repairs after firing, as needed (see Project Preservation and Patina).
- Plastic bins (2): for storing clay. One is used to reconstitute dry clay; the other is used to store clay that is ready for modeling. Covered plastic garbage bins are adequate (not shown).
- A sturdy box or stand to maintain work at eye-level (not shown).

MODELING IN CLAY

PREPARATION OF CLAY AND WORKSPACE

Clean the surface on which you will be working because loose particles of debris may mix with the clay and cause damage during kiln firing. Any flat surface will do. You may sit or stand, but your work should be at a height convenient for your hands to work without strain and positioned so that you are not looking down upon it, but it is raised to eye level. You can use an ordinary cardboard box with flaps closed for sturdiness to raise your work to an adequate level.

Obtaining the Right Consistency

The moist clay should be of good working consistency without the need to add or evaporate moisture. Sometimes clay is too moist or too dry to work easily. If the clay is only moderately "sticky," proceed to wedge the clay and get to work, as most excess moisture will air dry within the first hour of working. If, however, the clay sticks to the working surface and will not wedge, it may be flattened out on plaster bats (make sure there are no loose particles of plaster or other debris). The excess moisture will be absorbed from under the clay as the air dries it from above; flipping it over will hasten drying. The clay is ready for working when it does not stick excessively to your hands or the work surface but is still soft and malleable. Use a wide, flat spatula to lift the clay; avoid chipping the plaster bats, as plaster mixed with clay is dangerous in kiln firing.

If the clay is too dry, wrap it in a very moist rag and cover it securely with a plastic bag. The clay must remain wrapped overnight to be easily handled for modeling, assuming that it is only a little dry and not hard and lumpy, in which case the clay must be reconstituted (See Repairs on page 66).

Wedging the Clay

Wedging is a process of compressing clay particles to remove air bubbles. Pockets of air remaining when the sculpture is finished and dry can cause the piece to explode in the kiln. Hollowing (described later) substantially reduces this risk; wedging at the outset is a double precaution.

1. Cut off a substantial mound of clay from the block with wire or a clay dispensing tool.

2. Clean the working surface, and position yourself higher than the clay mound for body leverage.

3. Throw the clay into a ball or rectangle by slamming it down on your counter surface. This should be done repeatedly and is usually an adequate method of wedging for sculpture.

Another method of wedging used by potters and suited to delicate modeling projects (where later hollowing is not intended) is this:

1. Take an amount of clay that fits comfortably in your hands and form a ball.

2. Press the ball down and away from you in a rocking motion, so that the clay nearest to you tilts up behind the heel of your hand.

3. Rock the ball back toward you and pivot it slightly; then, without lifting it, press again in a rocking motion, squeezing down with the heel of your hand and again tilting up the clay nearest you. The clay "flap" that appears behind the heel of your hand will work itself into the ball each time you pivot and press. In this manner, the clay is compressed and air bubbles are squeezed out.

4. Repeat the motion until you have made two full circles in your pivots.

Whichever method of wedging you use, prepare at least two mounds, one for your initial shape and another one for adding to it. Lightly cover the second mound with plastic.

PROCEDURES AND PRECAUTIONS

As you work, the following procedures and precautions are necessary. They are fine points but technically essential, so it is a good idea to refer to them periodically as you move from conception to completion to cleanup to the next project:

- Prepare a closed container such as a plastic bin for storing dry clay that will later be remoistened.
- Particles of dry clay in your sculpture can cause air bubbles and breakage in firing; therefore, do not add them to your mounds but put them into the clay bin for reconstituting.
- Place a damp rag around clay that is not being worked to prevent it from becoming dry.
- Collect all small scraps of usable clay and press them together. Keep this mound under a damp rag as well.
- Dry clay should be scraped from tools before they are used. Scrape wet clay frequently from tools and put that clay under the damp rag also. A tool is no longer a tool when it is covered with clay; it is simply a muddy stick.
- When you leave the sculpture for any length of time, it is wise to cover it unless it is very wet and needs to dry out. If you are leaving the piece for several days, wrap it in a damp rag and cover that with a plastic covering. Bind the plastic at the bottom with a wire, or wrap the plastic under your working base so that the sculpture remains air tight.
- If the piece is left for longer than a week it should be checked, the cloth moistened and rewrapped. Do not work on a dry piece because the fresh clay will peel off or crack. Superficial wetting is of no value when the piece is dry, as the outer layer of moisture will evaporate quickly.
- Thoroughly dry clay intended for reuse must be reconstituted (a process described later).
- Clay can clog the sink drain, so it is wise to first wash clay-covered hands and tools in a pail of water. Let the clay water sit until the clay rests on the bottom before pouring off the water. The residual clay is reusable.

STUDIES IN FORM: ABSTRACTIONS

The first project in clay should be an abstraction and the reason bears repeating: to keep your focus on form and the relationships between forms, as opposed to trying to get your piece to look like something realistic in your mind's eye. What is in that eye might not yet be trained in the aesthetics of sculpture.

As you manipulate the clay, experiment by using the various tools at your disposal, observing the unlimited variety of possible effects. Forming the sculpture involves a great deal of looking. More than half of your time, in fact, may be spent looking and not working.

Looking 1: The Initial Shape

Achieving an interesting beginning shape is a significant first step. Throw one of the mounds of clay onto your surface. Throw it several times until a shape that interests you appears. (This process might already have occurred in the wedging.) The shape may be rectangular, triangular, amoeboid, square, oval or circular. Whatever shape you arrive at, it is a good idea to elongate the initial form to allow for some settling or "squatting" of the soft clay as it is worked. Now press the mound onto your lazy Susan so that it will be easy to view from all sides as you proceed.

An alternative way to form the initial shape is to prepare two clay mounds and combine them. The two forms may make an intriguing structure to start off with. When combining the two forms, roughen the bonding surfaces first and press them together well. At this point, the mounds are soft and will not need slip, a mixture described later, to join them.

Using the Small Wooden Block

The wooden block should fit comfortably in your hand; it need not be a specific shape or thickness. Push and press the block against the mound and make planes as you work the clay (**figure 6-4**). Take note of the shapes and masses that appeal to you as they form. You may not use all or any of the shapes that emerge as you play with the wooden block against the clay mound, but they become part of your visual vocabulary

for future use. In addition to making planes, you can use the edges of the block to carve into the clay, continuing to make a mental note of the forms that interest you.

Now begin to relate the important masses. Do not be concerned with details at this point. If the block is soft and sagging, push in an upward direction as you work with the wood. If it is too soft, set it aside without wrapping, and begin to work on another clay mound. Begin as before by slamming the mound into an interesting shape and paddling with the wood block to solidify the forms.

Adding Clay

While adding clay, it is helpful to roll a pellet of clay between your hands before pressing it on. This slight movement gives the clay more consistency and makes it more compact. It also gives you a chance to look at the sculpture for another moment before pressing on more clay. When you have built up a form, press in the additional clay with your block of wood, striving for planes. You want a structural solidness, whatever the shape.

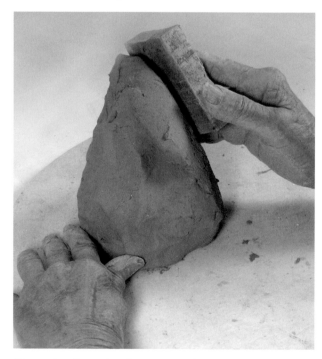

Figure 6-4. To make planes, press the block against the clay and apply the pressure you need to shape the forms. Photo by Hernandez.

Looking 2: Step Back

It is impossible to see your work only at close range. As indicated earlier, sculpture must have space around it for the forms to be seen clearly. Periodically, step far back from the sculpture — across the room if possible — so that all details disappear and only the large forms are in viewing range. Decisions are constantly being made in sculpture and they cannot be made without seeing and recognizing the problems.

Looking 3: Turn the Sculpture Frequently

Do not finish first one side and then another. Anything done on one side of your sculpture will surely affect the other, and changes will occur continually as you work because of those changing relationships. Remember also that there are not merely four sides to a sculpture; all views count within a 360-degree radius. Include the bird's eye and worm's eye views in your looking, as every view will affect the ultimate form. To turn the piece comfortably, secure the base of the lazy Susan to the working surface with a few daubs of clay so that only the upper disc moves.

USING CLAY TOOLS TO CREATE PLANES AND SHAPE FORMS

A good tool is said to be an extension of the hand, and this is certainly true in clay modeling. Hands can compress the clay and fingers can apply clay and shape the masses, but hands and fingers cannot do the job completely because they are rounded and soft. Wooden tools (**figure 6-5**) with flat blades, properly shaped, can form planes which solidify and crystallize the forms. A well-structured round form is just as easily made with a wooden blade as is a flat shape, and it will, in fact, be more evenly rounded than if formed with your fingers and hands (**see figure 6-6**).

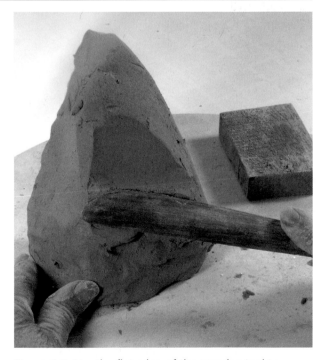

Figure 6-5. Use the flat edge of the wooden tool to solidify your planes and the cutting edge of the tool to carve away. Photo by Hernandez.

57

Where planes meet, high points or depressions are formed with distinct sculptural characteristics, such as ridges, curves, hollows and other shapes. These intersections cast shadows which form much of the impact and vitality of sculpture (**figure** 6-6). Try to train yourself to see forms in terms of planes and the way planes meet, rather than as unfathomable mounds, bumps and grooves.

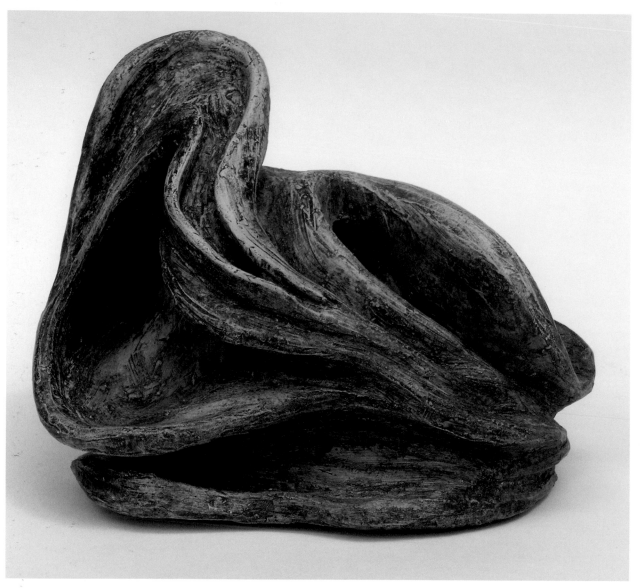

Figure 6-6. Note the high points and boldly carved depressions which create dramatic cast shadows in this abstract sculpture. Kate Fergusen. Photo by Hernandez.

Shaping Large Masses

Pay attention to the outer contours of the clay mound. You will be building out at times and carving in at other times to create movement, contrast and balance. Negative spaces (openings) can be cut into the mound and can also be developed into shapes as in **figure 6-7**. The internal form of those shapes is defined by the surrounding structures.

Look carefully at the emerging forms. Could a form extend farther, move deeper, be more angular or become more rounded? Develop a single form fully, carrying it around to other sides. Consider making variations on some forms to place in other parts of the sculpture. Develop variations for both positive and negative spaces.

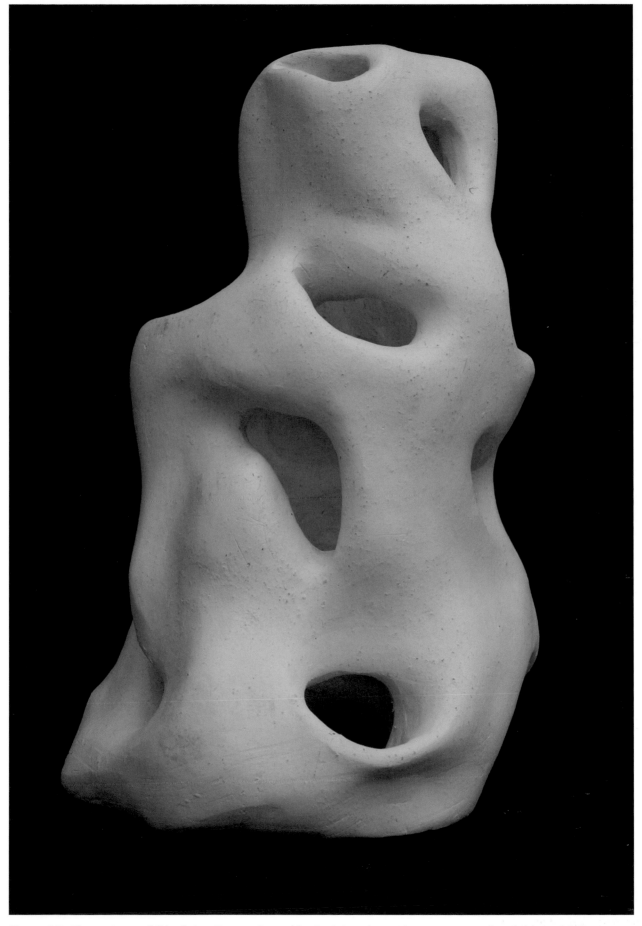

Figure 6-7. The contours of this abstraction are formed by the internal negative spaces as well as the external. Ilana Houten. Photo by Hernandez.

MODELING A FIGURE

After you have created an abstract sculpture using the methods described above, try creating a figure. Because you are working with clay that will be fired, no armature or support can be used, as the piece must first be hollowed out before entering the kiln (described later). Thus, the human figure you create will likely be in a seated position. You may have a live model to work with but whether or not you do, you should work in a gestural style. That is, quickly sketch directly in clay the overall stance or action of the figure.

Do not focus on details of anatomy or clothing. Do not work over-long in any one area as you begin forming the piece but instead, quickly add clay, press it into place, pat the forms with your wooden block, and turn it. Your objective, as you continually turn it, is to produce the overall gesture of the pose. Turning the piece frequently has two advantages: it encourages you to grasp the action and vitality of the figure and forces you to see it on all sides, thereby insuring a more cohesive finished product.

It is helpful to know at the start that it takes years of study to understand the human body and to render it with sensitivity and beauty. The exercise described is only a means to approach the figure, more with spontaneity than accuracy. In the next chapter you will be creating quick and easy figures in action — two, in fact, in relationship — but in this single figure in clay, you should try for these objectives:

- Find the rhythm and balance of the pose.
- **Try not to let one part of the figure overwhelm the rest (overlarge breasts, for example).**
- **Try not to break bones by bending legs and arms in places other than the joints. Limbs should appear as solid-looking planes, not worms.**
- **Avoid details; even a face may not be necessary. Simply indicating the planes of forehead, cheeks, brows, nose and chin may be sufficient to indicate the contours.**
- **Remember that even when you are looking for realism, your work must still project strong sculptural forms in space. Always be as concerned with sculptural elements as with revealing your subject matter, no matter what you are representing.**
- **Would another person be likely to say, "That is a good cat" rather than "That is a good sculpture?"**

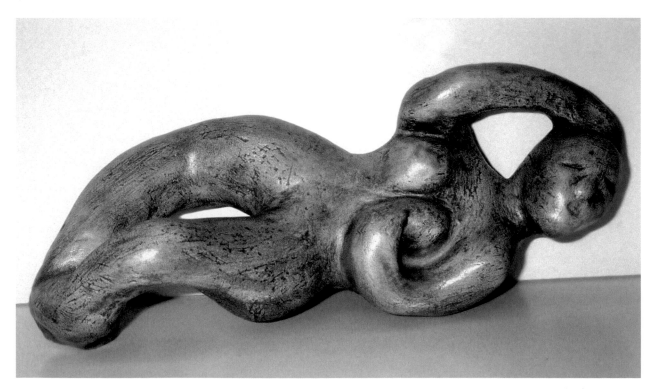

Figure 6-8. Go for the gesture of the pose primarily, working all around the figure. Avoid details. Have some fun with it. Unidentified student sculpture (with patina). Photo by Peck.

Do not attempt to smooth your piece as you apply clay. Applying clay firmly and letting the marks show rather than rubbing in clay, not only adds to the spontaneity of production, but prevents your work from being overly pressed down and possibly collapsing from the pressure. Should you ultimately want the piece smooth, there is a proper way to do so, explained later. Meanwhile, roll bits of clay, press it onto your form, pat to solidify the form (not smooth it), and look at and turn your piece continually, striving to produce a figure with action and vitality.

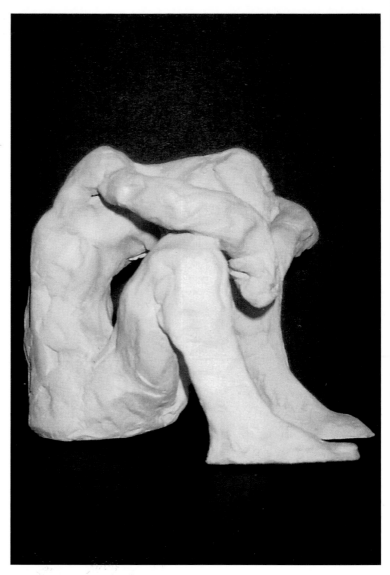

Figures 6-9 and 6-10. Seated or reclining figures are easiest, for stability without use of an armature. The focus is on overall gesture in reasonable proportion. Photos by Peck.

Figure 6-9. "Huddled Man," Jarrett Wilkins.

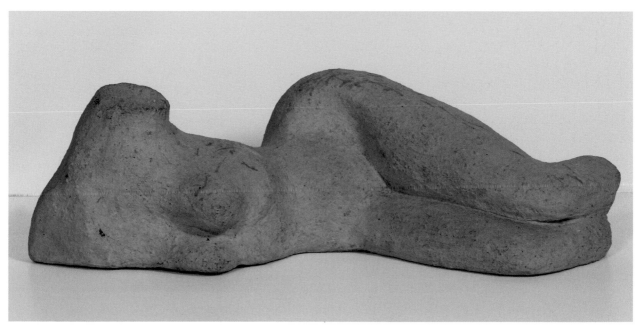

Figure 6-10. Unidentified student sculpture.

Figure 6-11. It was chest and muscular anatomy that interested this student who created a torso rather than a full figure. Michael Kinon. Photo by Hernandez.

You need not do a full figure — a torso might be more to your liking, as in **figures 6-10 and** **6-11.** You might prefer abstracting a figure, as in **figure 6-12**, rather than making one anatomically realistic.

Figure 6-12. This elegant abstraction with its flowing lines conveys a statuesque figure. Unidentified student sculpture. Photo by Peck.

Style

Try for stylistic consistency. For example, an anatomically realistic limb modeled on an abstract figure will probably result in a stylistically inconsistent piece. Forms can have contrast (such as flat against curved, sharp against round, rough against smooth) and still have stylistic consistency whereas detailed, delicate designs together with bold, roughly-hewn or jagged shapes might be inconsistent in style. The sculptures illustrated all project stylistic consistency.

Smoothing

Texture is an important element of sculpture and it comes in many guises, as described more fully in Chapter One. We are used to the smoothness of store-bought items made from clay, such as pottery and figurative sculpture produced commercially, and so you may already have an established vision of how clay sculpture is supposed to look. But do not be adverse to a rough surface in original three-dimensional artwork. Texture adds interest to a sculpture; it enhances the play of light and shadow and excites the sensuous feeling of touch. In addition, your hand and tool marks add to the sense of originality in the finished piece.

Nevertheless, if a smooth exterior is what you are after, there is a right and a wrong way to obtain it. The wrong way is to wet and slick over the form and rub it with your thumb or fingers. Think of smoothing a road. If a construction crew slicks over a rough road with a smooth wet substance, you will still have a rough road to drive on, only with a slick, smooth surface. So, to smooth your piece:

1. First, level the area. This is done with the serrated side of your wooden modeling tool (**figure 6-3**).
2. Move your tool one way and then another over the area until it is level. (The area will look rougher than before in this process.)
3. Turn your tool over and use the flat side to smooth over the marks that the serrated edged tool has left.
4. The area then becomes both level and smooth.

CREATING OTHER REPRESENTATIONAL SCULPTURES

Animals, birds, natural and inanimate objects all are fine representations for production. A composition is fine too, as seen in **figure 6-13**. Work from your imagination as much as you can, only seeking pictures for details if you really need that help. Do not place a store-bought object in front of you to copy, however, because that is copying other people's commercial or handicraft imagery and leads you away from your personal vision. If you are at a loss for representing, say, a bird or animal or object of nature, it is better to work from a photograph (from National Geographic Magazine, for example). Even then, use the illustration only as a starting point to understand essential features. Then use your block of wood and tools to create the planes that will give the piece good sculptural form and a unique rendering.

Always keep in mind that first and foremost, your piece is a sculpture with integrated sculptural qualities of form and design; only then, is it a sculpture of a car or bird or fish or whatever.

Figure 6-13. This piece shows the rear view of a man at a urinal. It was fun to do and fun to view, yet sculpturally, a success. Unidentified student sculpture. Photo by Hernandez.

Figure 6-14. This dragon is elaborate in pattern and decoration but without sacrifice to form or design. Unidentified student sculpture. Photo by Hernandez.

WORKING WITH THE ACCIDENT

As you work, some shapes that emerge will be rejected by you immediately and others will be carried forward to be extended, exaggerated, distorted and so on. You are quite naturally experimenting with form by trial-and-error, since only as forms emerge can they be seen, assessed and related to the piece as a whole. Being new to sculpture, you are not bringing images to your work so much as finding them as you work. But sooner or later, you will begin to crystallize your forms, define directions and feel that you know what you are doing.

Then, something may happen that you did not intend. Perhaps you cut too far into your piece or something fell off or someone's elbow smashed into it. Before you surrender to the mishap, look carefully, for accidents can be significant events in the creative process, hurtling us into creative advances that would not have happened otherwise. It is human nature to be cautious and in art making we may rely on images which are familiar and comfortable to us. But we want to "break out," and so lacking courage, we sometimes subconsciously cause accidents to happen to be forced to act strongly. An accident, no matter how strange it may first appear to the eye, can inspire you to leave tired images and see things with a fresh eye. Try using the accident as a new possibility, a new direction. Then begin to have confidence in the new images that begin forming in your head, and try them out as well.

Your art is rarely "ruined." Yes, when it blows up in the kiln, the work is ruined (although even then, remarkable things have been known to emerge from the shards). But as long as you are not ruined, the process goes on. The process in art is valid at every step along the way. Even though you may ultimately reject the product, the process of making it was an experience that remains. Formal aesthetic decisions were made, some of which may appear in other combinations in future work.

This section covers reconstituting dry clay to a moist and malleable condition and repairing sculptures while you are working on them and after firing.

Reconstituting Dry Clay

Use a separate, covered plastic container for reconstituting clay when it is too dry to use. In the container or on a table, break large lumps of clay into small pieces with a hammer. Press the clay down in the container, and add water, but only enough to cover the clay. Then close the container. When the clay has absorbed the water (a large amount takes several days), bail out the excess water.

Form the sticky clay into mounds and spread out the clay on plaster bats to absorb the excess moisture. Then knead the clay until it is the right consistency for modeling. A second airtight bin should be used for storing ready-to-use clay.

Using Slip

Slip is a combination of clay and water mixed to the consistency of heavy cream. Slip can be made and stored in a covered container or simply mixed on the spot. You will use slip to attach parts that crack or fall off of the form before it is fired. You will also use it to add parts to the form unless the clay is so soft that additions adhere easily. Never glue parts together if you expect to fire the piece because glue does not behave like clay in the kiln.

You can use slip if your sculpture becomes "dumpy" and you want to elongate it. This sometimes happens when modeling a figure and the torso has crunched into the hips or the hips into the thighs and you need more clay to raise the area. To do this, make a thick separate base (as much as you think you need to elongate the sculpture). Then adhere the sculpture to this new base using slip in the method described. Carve out from this block what you need to elongate the torso or hips.

How to use slip:

1. Prepare the edges to be joined by crosshatching both sides with your sharp wooden tool.

2. Add a coating of slip and wriggle the two sides together so that slip oozes out of the crevice.

3. Pinch the sides all around the joint, pulling the top of the joint to the bottom and the bottom to the top.

4. Fill the slight depression between the joints with more clay, bringing it flush with the rest of the piece.

5. If the extremity added or repaired is thin, cover that area with plastic while continuing to work, for if the mended area dries too quickly it might break off again.

Breakage after Firing

If small parts break off in firing they can be repaired. Parts can also be repaired if they break off when the kiln load is ready and there is no time to go through the wetting and drying process of slip application. In each case the piece is fired with its parts and put back together later in the following manner:

1. With a metal file, scrape some particles of fired clay from the bottom of your sculpture onto the table surface.

2. Wearing disposable plastic gloves, mix a small amount of five-minute quick-setting epoxy resin and hardener per package directions. Use a wooden stick and apply the well-mixed resin to the joint; then wriggle the parts together so that a bit of resin oozes to the edge of the seam. Again, using an implement and a plastic glove, apply the particles you have scraped so that the seam is covered. Be careful not to disturb the setting process as you do this. Do not get the epoxy resin on your skin.

HOLLOWING, DRYING AND STORAGE

Slow and even drying is the key to safe drying, drying without cracks. In order for the sculpture to be allowed to shrink in the drying process, it must be hollowed out while it is still damp. As a general guideline, a thickness of approximately one inch throughout is desirable. Thicknesses less than that do not require hollowing.

Hollowing

Hollow as follows:

1. Wait until the piece has lost most of its softness so that it will not cave in.

2. Hold the piece (if it is small) or lay it down on its least elaborate side on some rags or plastics.

3. With your large wood and wire tool, scoop out the clay from the bottom. Use the wire for digging out the middle and reaching up into the form, and the wood for scraping out a neat inner wall.

4. Try not to puncture the outer wall, though you can repair it by simply adding some clay if you do. View the exterior form as a directional guide, inserting your tool inside and then out to see how deeply you have gone (**figure 6-15**). Strive for a one-inch-thick wall.

5. If a form is difficult to hollow and not especially thick, insert a long thin stick into it and out again so that some air space will be made to accommodate shrinkage. A pin hole at the top of the form to allow steam to escape is also a good idea.

6. When the form is thick and needs hollowing but is inaccessible from underneath, has no designated bottom, or is too large to manipulate, it must be hollowed in another way. Remove a slice of the form near the inaccessible area, hollow the form, and replace the slice with slip in the manner described for repairs.

Figure 6-15. While hollowing, insert your tool inside and then outside of the form to judge how deeply you have gone. Photo by Hernandez.

Storage During Drying

Place the sculpture on two evenly thick slats of wood so that air can circulate under as well as around it. The wood slats need be no more than an inch thick, but they should be placed far enough apart so that there is a flow of air.

Begin air drying the sculpture by placing a loose plastic covering over it, so that the top will not dry more quickly than the bottom. The plastic can be removed when the piece begins drying throughout. The sculpture must be bone dry inside and out before firing. You will know it is dry when the color changes, but do not dry it quickly or unevenly by placing it near a radiator or in the hot sun. Even when the sculpture appears completely dry, it will still need slow kiln drying at a low setting to remove all moisture.

PLANNING FOR KILN FIRING AND ALTERNATIVES

As stated earlier, clay, even in its hardened state, is not permanent. It will crack and crumble and if moistened sufficiently, will revert to its original mud condition. Firing the clay (baking it in a very hot oven) causes chemical changes in the clay body that make it permanent. Indeed, fired clay sculptures and pottery have endured for centuries.

Nevertheless, firing your sculpture may present problems because kilns are not always readily available for your use. The following section addresses that problem as does the information provided on finishing techniques in Chapter 13.

Kiln Firing

In a school art program, you will have access to a kiln and work will be fired appropriately. If you are working at home, schools or local ceramic facilities might be willing to fire your work for a fee. Works are loaded with sufficient space to allow for air flow around the pieces. The settings are on low to start and gradually set to hotter temperature, the hottest according to the type of clay and its cone range.

It is doubtful that you will invest in a kiln in the early stages of your experience with clay. If you do, it will be purchased according to your individual needs and available space. Procedures for firing will vary according to the type of clay used, the size of the kiln and the amount, size and type of work being fired. The dealer can provide the information you need (see Appendices).

Adaptive Clay Selection

Different clays fire at different temperatures, so try to make arrangements for firing at the outset so that you can plan to use the same clay that the school or the ceramic facility uses. Then wedge, construct and hollow your first piece with care so that your craftsmanship will be trusted for future loads.

Another alternative if you cannot find a kiln is to purchase oven-firing clay, a clay body described at the beginning of this chapter.

Casting

The most widely accepted alternative to firing is casting in plaster. While this process is not overly complex for simple forms such as a head, it can be complicated for more elaborate forms. Because casting is a common process in sculpture, later you might try to cast your work in both waste-mold and rubber-mold procedures; good books are available with step-by-step instructions (see References and Resources for casting).

Laminating

Other finishes, such as laminating your sculpture with various products after it has been fired or even before, are described in Chapter 12, "Project Preservation and Patina."

EXTENDING THE PROJECT

Art in Human Service

Because clay is so flexible and handles easily, the potential for using it to create expressive works of both the inner and external worlds is unlimited. In this context, the human form is one of the most expressive themes. Making gesture studies in clay, that is, informal, three-dimensional "sketches" of people such as that illustrated in **figure 6-16**, is a stimulating creative venture. The "sketches" are modeled with spontaneity and with an emphasis on movement and style.

Expressive studies, such as the mother and child in **figure 6-17**, help give voice to human joy and sadness.

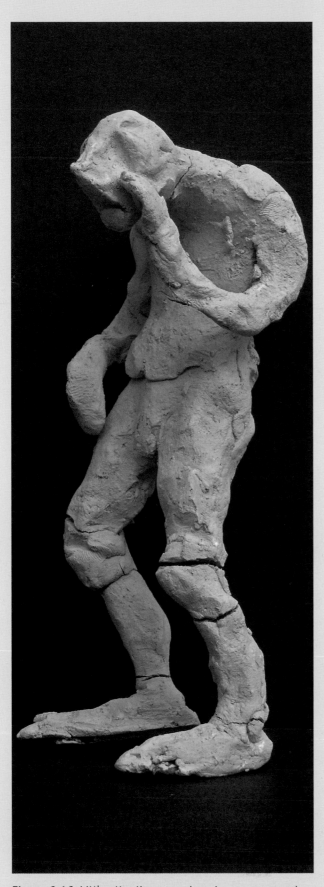

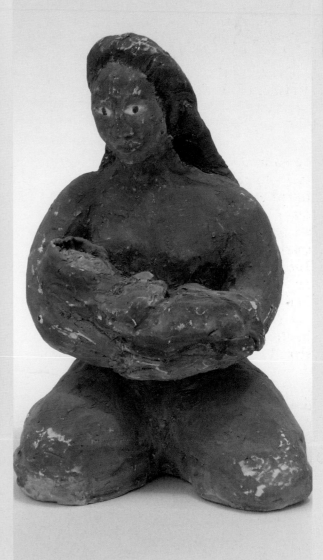

Figure 6-16. Little attention was given to permanence in this expressive clay gesture of a man hollering for his dog. Unidentified student sculpture. Photo by Hernandez.

Figure 6-17. This clay mother and child was painted in loving detail with acrylics after firing. Unidentified student sculpture. Photo by Hernandez.

More Ambitious Projects in Clay

The figure gesture studies mentioned above are excellent exercises to prepare you for making a concentrated figure study in clay using a model. A moderate-size seated or reclining figure is best produced for this long study, as it can be supported by wooden blocks as you work. A wooden dowel, temporarily inserted in the torso of the figure and into the clay base will provide additional support if needed; it is removed at the time of hollowing.

Clay is also a good medium for making models for larger pieces or for working out your ideas for sculpture in other media. Plastiline is an oil-based clay that does not dry, so it is especially useful for this purpose.

Large sculptures can also be made in clay and kiln-fired by first cutting the sculpture into sections, then hollowing and scoring the sections for assembly with five-minute quick-setting epoxy resin after firing.

Useful Objects in Clay

Many useful clay items can be made with sculptural integrity, including pottery, jewelry, wind-chimes and even lamps. You would create a lamp, for example, in this way:

1. Model a sculpture — make it reasonably tall so that light will be cast downward (**figure 6-20**).

2. Weight the sculpture with a heavy base so that it won't tip when handled.

3. Hollow the sculpture.

4. Give it to an electrical supply store to outfit the wiring. Make sure it is wired correctly to avoid shocks.

To conclude then, with care and concern for the medium's strengths and weaknesses, you will find clay a versatile medium that you can use to accomplish any number of aesthetic objectives.

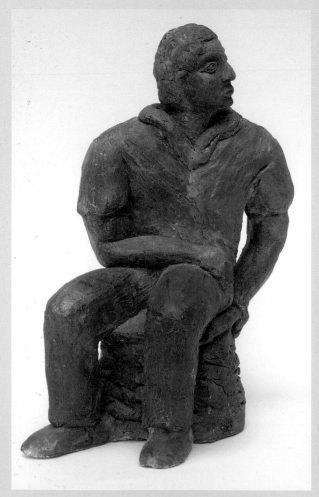

Figure 6-18. A longer study of a seated figure allows for more detail in posture, clothing and expression. Unidentified student sculpture. Photo by Hernandez.

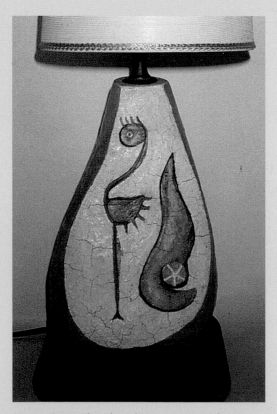

Figure 6-20. This clay object was turned into a lamp with added acrylic decoration. The bottom was weighted so as to prevent tipping. Judith Peck. Photo by Peck.

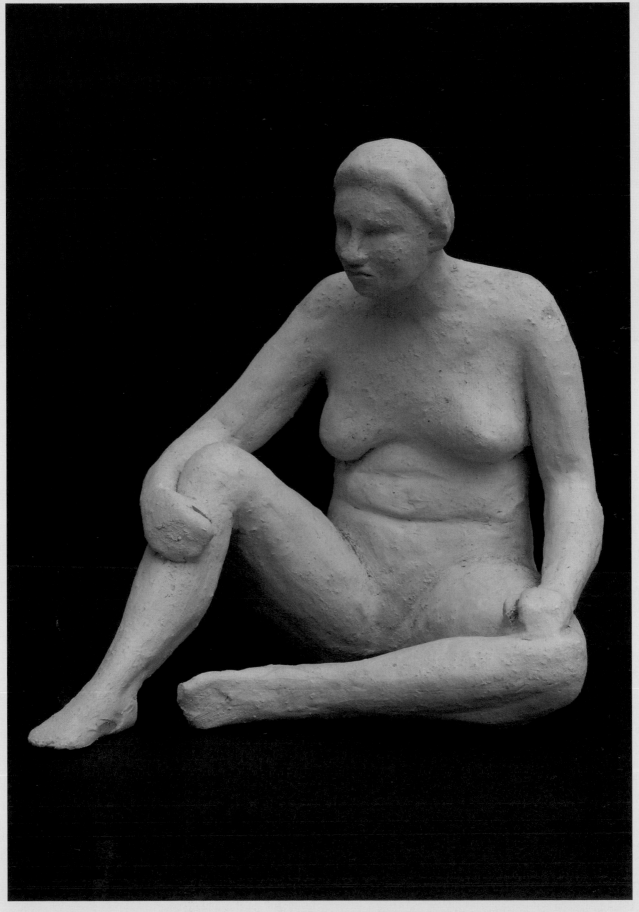

Figure 6-19. The planes are simplified and well structured in this much longer study of a seated figure. Unidentified student sculpture. Photo by Hernandez.

THE FIGURE IN FOIL AND PARISCRAFT

THE NATURE OF THE PROJECT

MOST beginning sculptors do not have the ability to create three-dimensional figures in action; yet, having that artistic ability is valuable if you want to represent and communicate to others your perceptions of the human activities around you. This chapter describes procedures for creating a single figure, two figures in some relationship to each other, or a group of figures engaged in an activity such as sports, socializing, performances or every-day duties, and then placing the figures in interesting compositions.

Because of the ease of creating figures in this engaging medium, the efforts of the artist can be devoted more to aesthetics and content than to the mastery of materials and techniques. In addition, the supplies needed are inexpensive, and most are available in the usual household, a situation that tends to minimize the fear of failure.

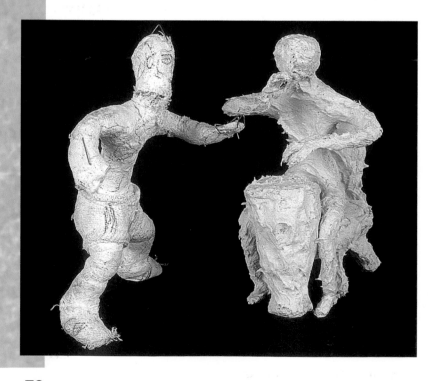

Figure 7-1. The design of this drummer, bongo and dancer, artfully arranged on a base, forms a good composition. Unidentified student foil sculpture. Photo by Vold.

The Basic Medium

Aluminum foil is available in two thicknesses: regular and heavy-duty. The regular thickness comes in 12" widths and is recommended for the project because cutting a 12" square makes for good figure proportions. The heavy-duty foil is 18" wide and when cut into a square, will produce a larger figure (18" tall). Begin with the regular 12" width and perhaps experiment with the greater width later.

The foil must be covered with a firmer material to stabilize and finish the sculpture. Pariscraft,

a coated gauze, is well-suited for this, and it is thin enough to conform to the shape of your foil sculpture. You may be familiar with it in other thicknesses and coatings if you have ever broken a limb and had it wrapped in plaster-coated gauze. For use as an art medium, Pariscraft is sold in individual rolls or by the carton in art supply stores. When strips are cut from the roll and dipped in water, the plaster is activated and the drying and hardening process begins. The material is odorless, nontoxic and easily washed off your working surface. It is therefore a convenient product to use both in schools and in the non-studio facility.

CHECKLIST OF TOOLS AND MATERIALS

Some of the materials listed are pictured in **figure 7-2**. See also **figure 13-2**.

- Aluminum foil, standard size and width.
- Pariscraft.
- Cotton, facial or bathroom tissue: as stuffing for the head and other areas requiring mass.
- Empty coffee tin for holding water.
- Scissors for cutting Pariscraft into strips.
- Small straight pins for adding artifacts to the figure composition (optional).
- Cardboard for creating environments or furnishings (optional).

- Hammer.
- Headless nail, approximately 3" long for securing standing figures to base; short nail to secure seated figures.
- Thin wire for wrapping at least one leg of the figure to a supporting nail.
- Wooden base (small, square or rectangular, depending on figure composition).
- Sandpaper (assorted grits) for preparing base.
- Spray enamel, black semigloss for painting base, or Kiwi shoe wax as an alternate finish.
- Polyurethane spray, clear or satin: for a protective finish (optional).

Figure 7-2. Tools and materials for foil and Pariscraft sculptures. Photo by Hernandez.

PROCEDURES FOR FORMING THE FIGURE

1. Cut a square of foil (12" x 12") and place it on a flat surface. To form the head, tuck a small amount of cotton or tissue just below one corner of the square and wrap and squeeze it into a ball (**figure 7-3**). Use two small cotton balls, two squares of bathroom tissue or half a facial tissue to form a head that will be in good proportion to the body for an adult. Add slightly more for a child's head, which is larger. Flatten the foil sheet.

Beginning at the corner opposite the head, tear from that point to the middle of the square to begin forming legs. The legs will be uneven in length (**figure 7-4**) due to the configuration of the initial square, but this will be fixed later. Again, flatten the foil so that you can see what you are doing.

2. Squeeze the two cut halves into legs. Fold the foot of the longer leg upward to even the legs; fold the foot of the shorter leg as well to give it more substance. The procedure should result in legs and feet of equal size. (See **figure 7-5**.)

3. Two large arcs will now remain below the head on either side. Begin about one-third down on each arc and tear horizontally toward the middle of the square to begin forming arms (**figure 7-5**). Leave enough foil in the center to form the body. Once again, flatten the foil sheet.

4. Now, squeeze the upper portions of the two cut arcs into arms; they will be uneven in length (**figure 7-6**). Fold the end of the longer arm to even the arms and fold the very tips of each arm to form hands.

5. The remaining foil can be used in several ways. It can be squeezed into the midsection as part of the body or it can be further manipulated into wearing apparel such as a skirt, dress, shorts, or pants (**figure 7-7**). Cotton or tissue can be added and covered over with foil to form breasts, belly or buttocks (**figure 7-10**).

Figure 7-3. Begin by cutting a square of foil. To make a head, wrap cotton or tissue in one corner and squeeze it into a ball. Photo by Hernandez.

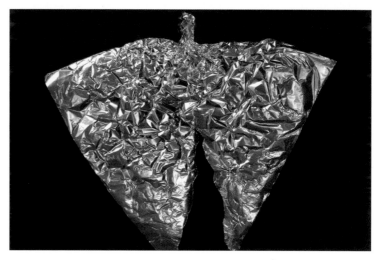

Figure 7-4. Starting at the corner opposite the head, tear inward to the middle of the square to separate the legs. Photo by Hernandez.

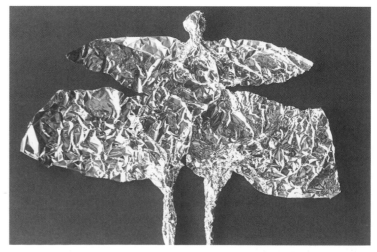

Figure 7-5. Squeeze the two cut halves below into legs and form feet. Tear toward the middle of the square to begin forming arms. Photo by Vold.

If longer arms are needed or if a tear occurs, cut a strip of foil and place it across the shoulders (it will look like a shawl); then squeeze it outwards from the neck and shoulders to form arms (**figure 7-8**). Cut to the length desired. Add extra sheets of foil elsewhere in a similar fashion as needed.

When the figure is fully formed, it is ready to be bent into action poses. Remember that bends, twists, and pivots occur only at the joints and along the spine. Try many different movement combinations.

Move only at these joints:

- neck
- shoulders
- elbows
- wrists
- waist
- hips
- knees
- ankles

Do not bend the figure along the straight "bones," or you will make anatomically unrealistic, snake-like forms. Practice bending your own body in front of the mirror to see where movement is natural. Move the figure in several ways before selecting a final pose (**figure 7-9**).

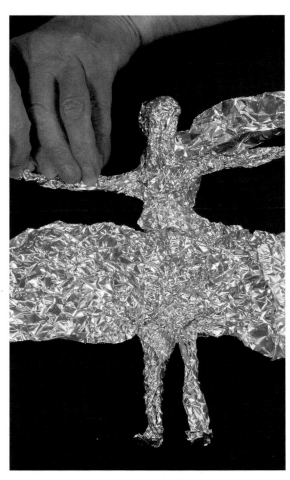

Figure 7-8. "Mending" or extending a form is done by adding strips of foil as needed. Photo by Hernandez.

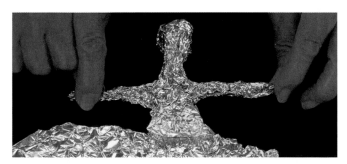

Figure 7-6. Squeeze the separated upper section into arms. Photo by Hernandez.

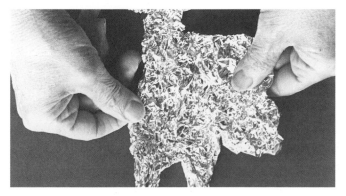

Figure 7-7. The remaining foil can be squeezed into the midsection as part of the body, stuffed with cotton or tissue for fuller anatomy, or shaped into wearing apparel. Photo by Vold.

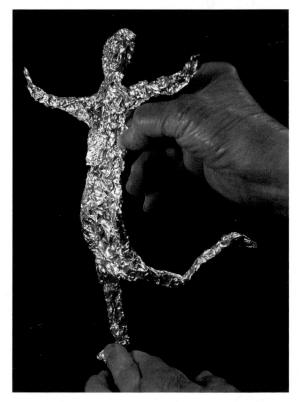

Figure 7-9. Move your figure in many different ways before you decide upon a final pose. Photo by Hernandez.

GROUP COMPOSITIONS

Make a second figure to relate to the first figure, and possibly even a third figure. One reason for doing this is to practice making figures while the procedures are fresh in your mind. More important, however, is the sculptural advantage — the increased opportunity to make interesting compositions (**figures 7-1, 7-10 and 7-11**).

Experiment by manipulating the figures in a variety of attitudes; for example, the figures need not be erect; one or more can be sitting, lying down, falling, kneeling and so on. They can be engaged in work or play activities, fights or embraces, performances of all kinds (music, theater, dance, circus acts or gymnastics) or simply talking, eating, taking out the garbage or walking. If you are in a group situation, you might have a single theme to which everyone contributes a figure or two.

Before coating the figures with Pariscraft, select a base and tentatively position the composition.

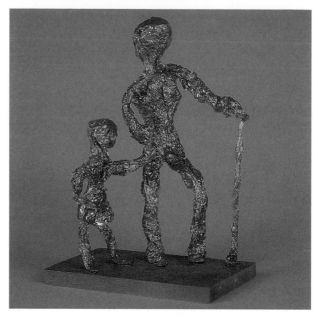

Figure 7-11. After creating two figures in relationship, select a base of the right size and position the figures temporarily to make an engaging composition. Photo by Peck.

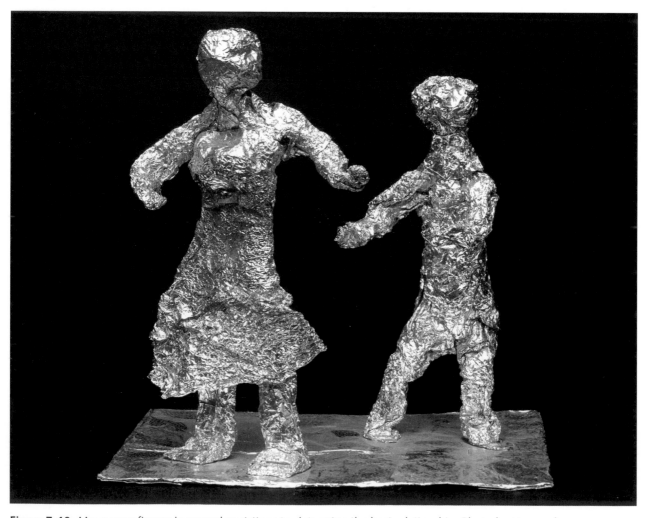

Figure 7-10. Move your figures in several posistions to determine the best relationship. Photo by Hernandez.

APPLYING PARISCRAFT AND MOUNTING

Apply the Pariscraft strips after the figure composition is formed and you know its position on the base. Additional bends in the figures can be made after the Pariscraft is applied, but only for a limited period, as setting begins about 20 minutes after the material is dipped in water.

Cut strips of the dry Pariscraft to whatever width and length seem manageable. A narrow width, about ½" is suggested in starting out, as the thin strip will be easier to control. Dip the strips lightly, one at a time, in a can of cold water and apply around the form (**figure 7-12**). Cover all of the sculpture except for the lower portion of one standing leg which later will be wired to a nail protruding from the base for support. One layer of Pariscraft is sufficient to create a firm surface. More than that may add bulk and alter the forms.

Control the application of strips so that unintentional lumps do not appear. Try extending the Pariscraft beyond the figure in various places to create lines that will enliven your figure, such as costuming and hair (**figure 7-13**).

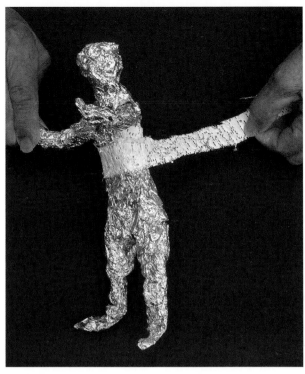

Figure 7-12. Cut the Pariscraft strips, dip each lightly into water and wrap around the form in a single layer. Photo by Hernandez.

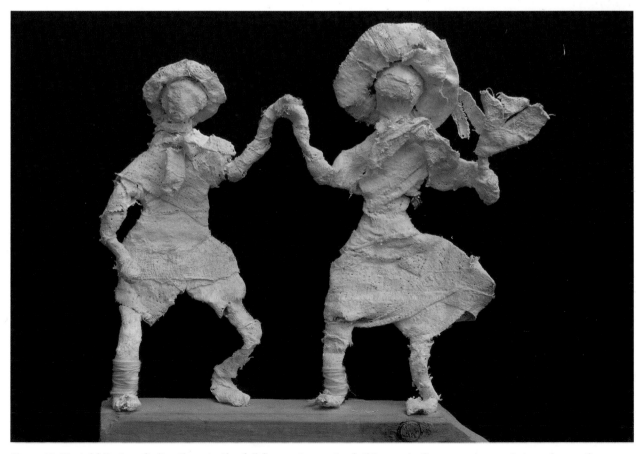

Figure 7-13. Add Pariscraft directly onto the foil figures to create clothing and other accoutrements to enhance the gestures. Photo by Peck.

Preparing the Base

The relationship of base to sculpture must always be an integral one; the base must "belong." It should set off the sculpture from its surrounding environment and enhance the total conception. A relatively thin base is best suited to the foil figure composition, as the figures tend to be linear in form and a thick base could be overwhelming.

Select the appropriate size and shape for the base. Cut the edges of the base squarely (not irregularly) to size. Sand the surface and sides, and remove all traces of grit and dust. It can then be spray painted; black is recommended, but brown Kiwi shoe polish in paste form makes a good finish. Or the base can be coated with linseed oil mixed half and half with turpentine. Refer to Chapter 14 for further guidelines on selecting and preparing bases.

Figure 7-14. Hammer a brad into the prepared base to support the figure. Photo by Hernandez.

Mounting the Figure

Small nails are adequate to support seated or prone figures with patches of Pariscraft applied to cover the nail-heads.

If the figure is to stand erect, do not completely cover the standing leg with Pariscraft when you cover the rest of the figure. That leg, in order to support the standing figure, should first be wrapped with wire around a nail that has been driven into your prepared base. Use a long brad, about 3". Nail it securely to the base, and wire the foil figure to it just above or below the knee, depending on the pose (**figures 7-14 and 7-15**). Then apply a strip of Pariscraft to cover the leg, wire and nail.

Figure 7-15. Wire the figure to the nail. Afterwards, cover the supporting leg with a strip of Pariscraft. Photo by Hernandez.

Protective Spray

The sculpture is essentially "finished" after the Pariscraft is applied and it is mounted. Spray the composition with a clear satin polyurethane to protect the figures from dust and grease. This will add a slightly reflective surface.

Color

In general, the form and movement of the figures in action show up most forcefully when the sculpture is left an unpainted white. The use of color is, of course, a matter of personal preference. One must only be aware that sculptural form has a different visual impact when coloring is added.

To color the finished Pariscraft figures, use watercolors or acrylics. Watercolors will be less opaque, and acrylics will be more vibrant. Mix colors for more interesting hues rather than using them directly from the jar or tube. There is no question that coloring the figures is fun, and though colors detract somewhat from the formal aesthetics of the medium, they add quite a bit to the human interest. See "Extending the Project: Art in Human Service" at the end of this chapter.

Adding Artifacts

The figures may be enhanced by artifacts as seen in the examples illustrated below: a mirror (**figure 7-16**), a rope (**figure 7-17**), chairs (**7-18 and 7-19**) and a park bench (**7-20**), or tennis rackets, grand pianos or whatever else you can create. Make artifacts out of foil, cotton, wire, wood or cardboard — anything that works for your theme.

Some artifacts are best added directly in Pariscraft cut in fringes, rope lengths and many other shapes. In **figure 7-21**, Pariscraft strips are laid over wire to create a dancer with scarf unfurled into the air.

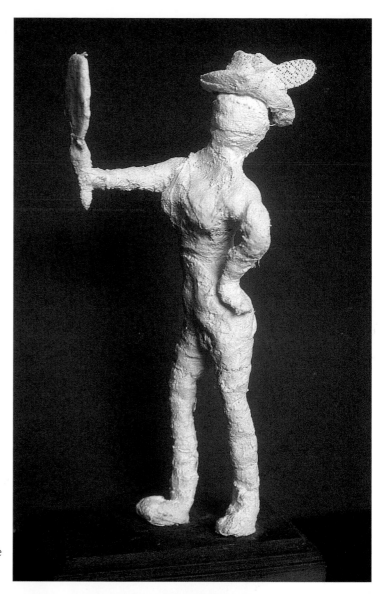

Figure 7-16. "Woman at the Mirror," Nancy Rider.

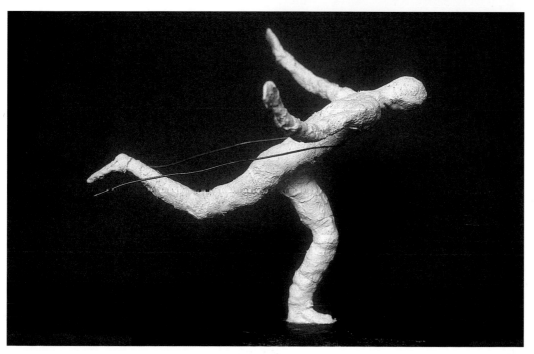

Figure 7-17. "Runner," Paul Barbier.

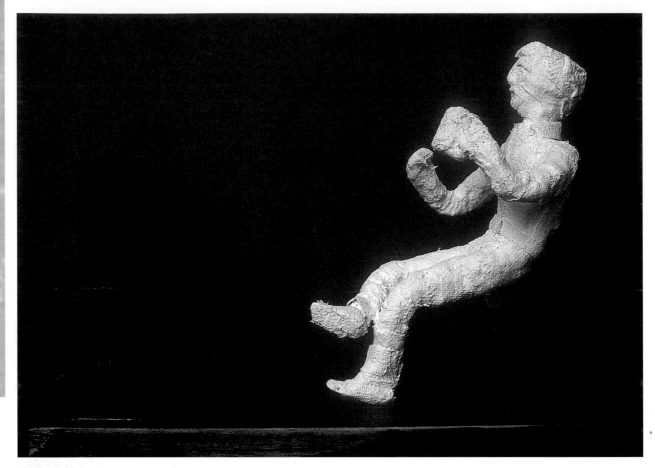

Figure 7-18. "Superbowl," William Francisco.

Figures 7-16 — 7-20. See how adding any type of artifact in cardboard, string, wire or extra Pariscraft can enhance the action and the composition. Photos by Vold.

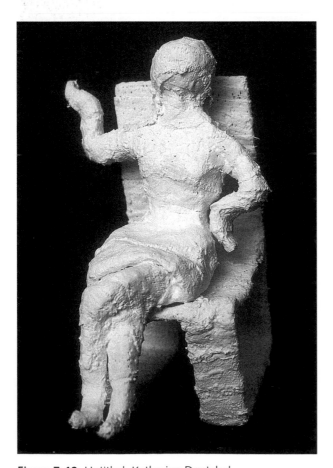

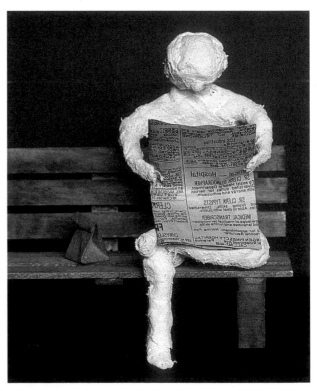

Figure 7-19. Untitled, Katherine Deutchel.

Figure 7-20. "Park Bench," Geralyn Clare.

Texture

Sometimes it is effective to allow the texture of the Pariscraft material to show in the finished piece. In **figure** 7-22, the open weave of the Pariscraft material comprising the shawl shows up well against the more solidly covered seated figure.

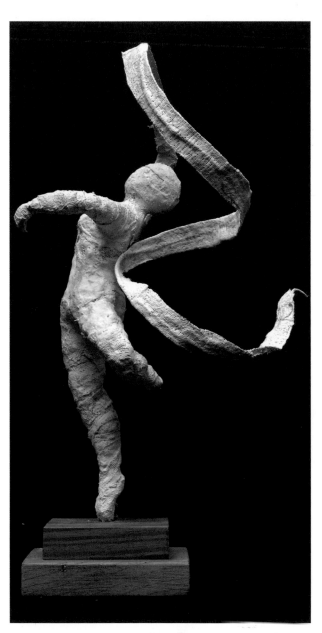

Figure 7-21. Wire was used as a frame to support the scarf with strips of Pariscraft applied as drapery. The movement of this twirling dancer is portrayed by the circular swirls. "Ribbon Dancer," Arlene Beckman. Photo by Vold.

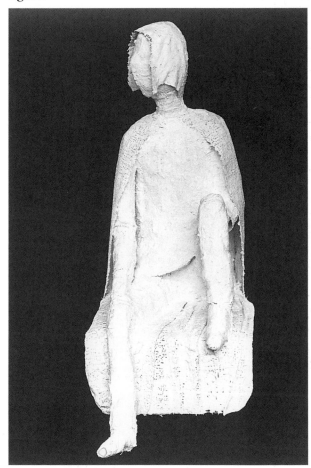

Figure 7-22. By controlling the way Pariscraft is dipped, the open weave of the material contrasts with the more solidly covered figure. "Seated Man," Sam Pepperman. Photo by Vold.

EXTENDING THE PROJECT

More Ambitious Constructions

See Chapter 12, Project Preservation and Patina, for ways to use Pariscraft to make more substantial sculptures. For example, instead of foil as a foundation, Pariscraft can be applied directly over such materials as chicken wire and wire mesh. While it is beyond the intended scope of this section to describe such constructions, you should be aware that materials made of metal, wood and even found objects can be used as supports for Pariscraft figures and compositions. **Figure 7-23** shows a torso in which Pariscraft was applied over chicken wire. Notice that the draping quality of Pariscraft is used to advantage.

Another way to extend the project is to apply plaster of Paris directly onto the Pariscraft to add substance. You should prepare the plaster as described in Chapter 10; however, make only a small quantity at a time (perhaps a cupful), and do not stir. Put plain cold water in a separate cup, and brush the area to be coated before applying plaster. This will moisten your sculpture so that the fresh plaster will adhere. Use a flat-bladed knife or plastic modeling tool to apply the plaster to your piece.

The foil and Pariscraft project can be extended in a variety of ways, which you might explore by incorporating objects lying about your home or work place.

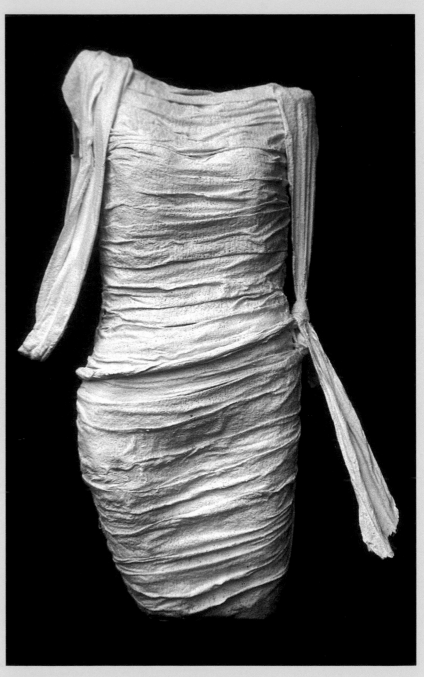

Figure 7-23. In this torso, Pariscraft was applied over cut and shaped chicken wire. "Judith," Theodora Zacker. Photo by Vold.

Art in Human Service

It is easy to see the expressive potential of this project. Individuals can portray much about their own body image and the way in which they view others by the style and actions of their foil figures. Several compositions illustrated demonstrate the potential of this project for making evocative creations: a beer-drinking man watching television, a person reading on a bench, a runner making it through the finish line. Each composition strikes a mood, and although the groupings may convey familiar circumstances, they also project emotional associations onto the viewer.

Because human figures in various surroundings are relatively easy to produce in foil and Pariscraft, the project can be an initial step to generate productive discussion about how one feels in these situations. Rather than a single figure, participants should create two people in a significant relationship, such as a mother and daughter, a father and son, lovers in or out of love, a husband and wife, siblings and so forth. Then the composition should be discussed in a trusting group to extract fuller meaning from the observations. Having a physical representation before you of two people in conflict presents a visible resource that can provide a kind of shortcut to reach out and touch emotional problems.

Even more engaging is creating a foil and Pariscraft project in which an entire group participates. A band playing various instruments, pictured in **figure 7-24**, was created by a single individual but is a good theme for a class or small group. A circus, a book, a play or a movie or museum visit are evocative themes for group projects.

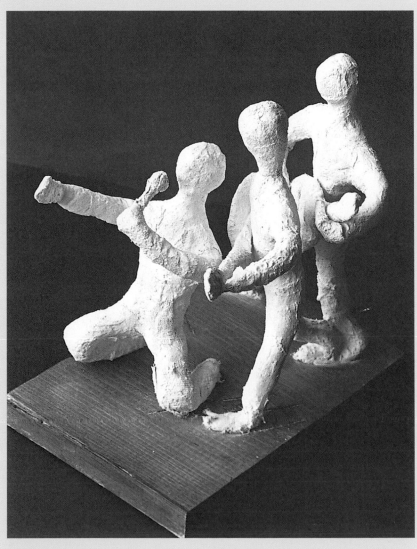

Figure 7-24. This grouping of a singer and musicians in a band should inspire other themes for group compositions. "The Band," Walter Tanks. Photo by Vold.

Color

The addition of color will extend the expressive possibilities. Choosing colors is important when using art in human service for many reasons: colors have emotional significance; color adds the ingredient of "play," which can be liberating; and having to choose what colors to use, as in making personal decisions of any kind, can be beneficial.

Below are some evocative combinations of foil and Pariscraft sculptures painted with acrylics to give you some ideas about how you can use and expand on this engaging project.

Figures 7-25 — 7-30. Colorful and imaginative examples of foil and Pariscraft people engaged with one another, painted with acrylics. Unidentified student sculptures. Photos by Peck.

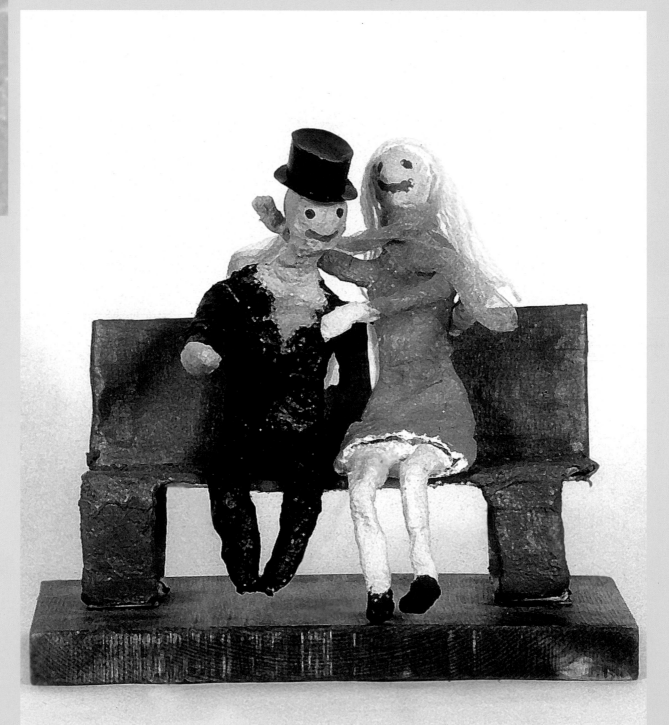

Figure 7-25.

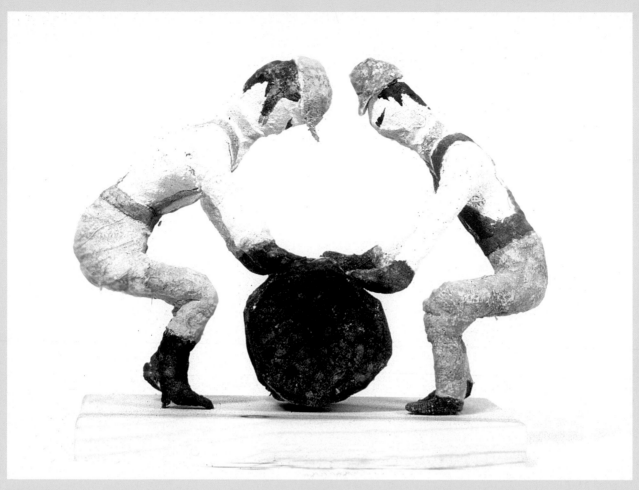

Figure 7-26.

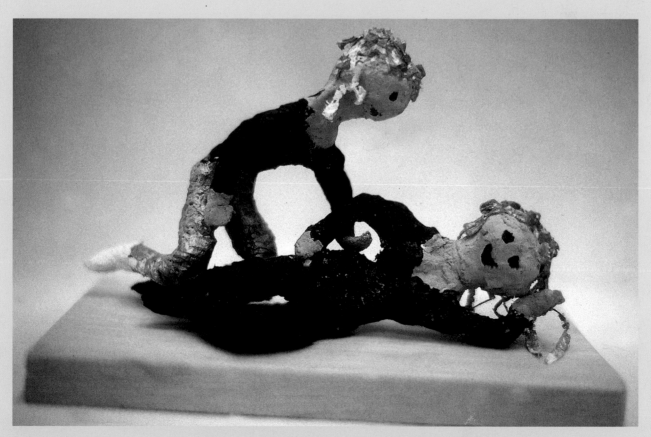

Figure 7-27.

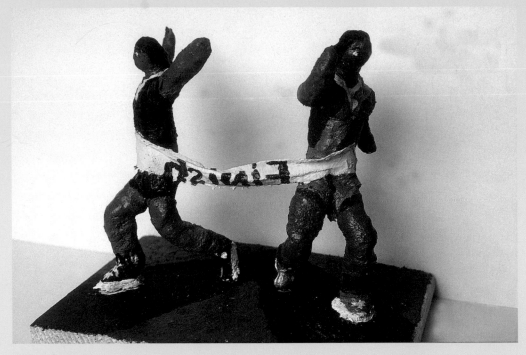

Figure 7-28.

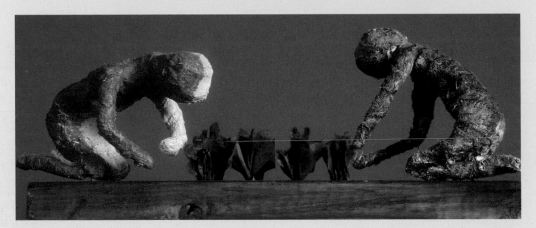

Figure 7-29.

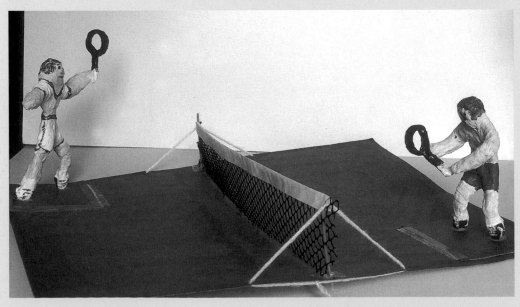

Figure 7-30.

CHAPTER

8

FABRICATING WIRE SCULPTURE

MOST likely, you will be pleased with what you can produce in a one-week time frame because the tools and materials for this project are not difficult to manipulate and the medium lends itself to experimentation.

Fabricating wire sculpture in linear formations can be considered a kind of drawing in space. The artist draws the contours of a three-dimensional form in wire, and the viewer fills in the masses by imaginative association. Because the viewer, in effect, completes the process of seeing mass where there is only contour, the medium can stimulate a playful interaction between artist and viewer. In **figure 8-1**, for example, the viewer is drawn to the artist's perception of two people in conversation by the simple but highly stylized profile lines.

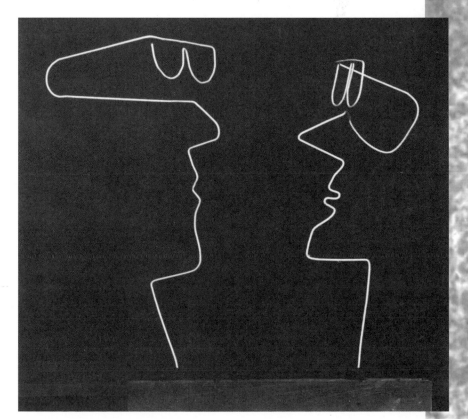

Figure 8-1. The contours of the wire create a drawing in space, leaving the viewer to fill in the three-dimensional mass. "Conversation," Stephen Issler. Photo by Vold.

WHY WIRE?

Working in wire is an excellent exercise for the beginning sculptor in the same way that learning to write journalistically might be a good starting place for the creative writer. The process forces simplicity of line and statement, but at the same time it necessitates well-crafted execution. The lines in their linear sweep must not be carelessly bent or they will lose their forcefulness. Moreover, the connections holding pieces together must not intrude too much with the lines of the drawing in space, yet must be sturdy enough to hold.

Wire is a permanent material and no other steps are required after fabrication to make it durable other than mounting the piece to hold it firmly in place. Wire is also available in a wide variety of styles and types.

The wire portrait in **figure 8-2** reveals both the fun and feasibility of working with wire.

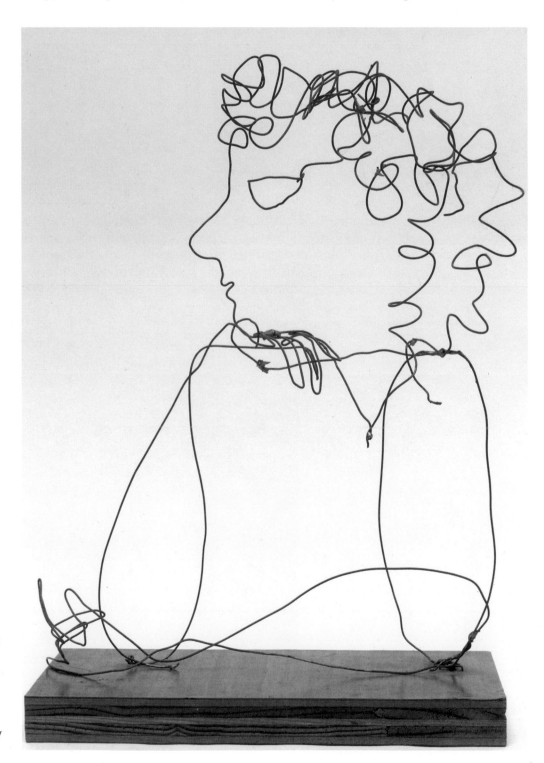

Figure 8-2. This thoughtful woman reveals personality with only a few simple lines, and some of the fun of working in wire. "Pensive," Arlene Beckman. Photo by Hernandez.

CHECKLIST OF TOOLS AND MATERIALS

The Basic Medium

Wire comes in a variety of widths and weights. You might begin with an idea and try to find wire for it, or you might look at several kinds of wire and get your ideas from the materials on display. Rolls of galvanized steel, copper or brass wire are sold at the hardware store. You might also find wire in your own home or neighborhood and get some ideas from what turns up there. Clothes hangers are difficult to bend with precision, but they can be used if cuts and bends are carefully controlled (for example, bent around a rigid form).

Other types of wire to use are strapping wire, aluminum armature wire, thin steel or brass rods, and anything else that can curve, bend, hold its shape, and be joined to other wires and to the base. Most wire sculptures illustrated are made of aluminum or steel, but **figure 8-3** is a seated figure formed in copper wire.

The equipment and materials for wire sculpture are pictured in **figure 8-4**; some items mentioned are pictured in Chapter 13, Mounting.

- **Thin wire for binding, used to connect parts.**
- **Round-nosed pliers for forming the wire without creases and for creating hooks that allow wires to be joined without solder.**
- **Flat-nosed pliers for creating sharp bends.**
- **Small table vise for holding wires to be soldered (optional, not shown).**
- **Soldering iron, used with solder containing flux (optional). Most work will not require soldering, as wires will be joined in other ways.**
- **Jeweler's torch with fine tip, used with solder containing flux; useful for continuing work of a more intricate nature (optional, not shown).**
- **Wire snips for cutting thin wire.**
- **Metal shears for cutting heavy wire.**
- **Five-minute quick-setting epoxy resin and hardener (optional).**
- **Staple gun and staples for mounting (optional).**
- **Drill ¼" or ⅜" with narrow bits for mounting (optional).**

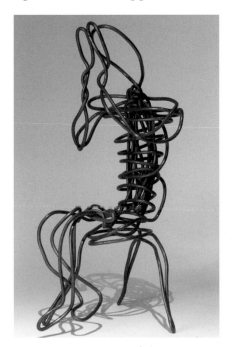

Figure 8-3. Copper was the material used for this expressive seated figure. Untitled, Jarrett Wilkins. Photo by Hernandez.

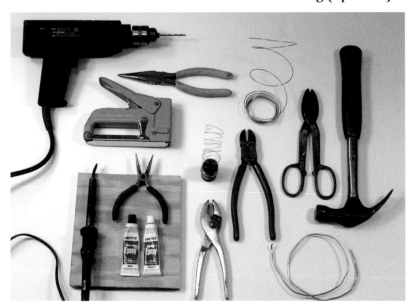

Figure 8-4. Tools and materials for wire sculpture. Photo by Hernandez.

Most of the tools and supplies needed for creating wire sculpture can be purchased in a hardware store or found around the house. Hobby shops may have a wider selection of wires and pliers. Not all of the tools listed will be needed for the sculpture you do; indeed, very few may be called upon depending on your choice of materials and design. In any case, securing the parts and mounting the sculpture will vary with each work.

PROCEDURES FOR FORMING AND FINISHING

Glance at the student works pictured in **figures 8-5 through 8-8.** As you read through this chapter, refer to these illustrations, as well as to **figures 8-9 through 8-14** to see the various ways in which wires are connected and mounted.

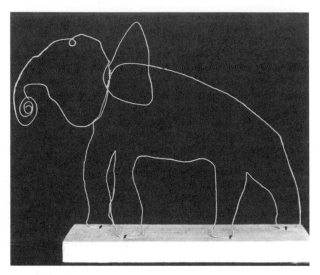

Figure 8-6. "Elephant," Barbara Lawrence. Photo by Vold. Digital enhancement by Csokasi.

Figure 8-5. "Antelope," Ingrid Vold. Photo by Vold.

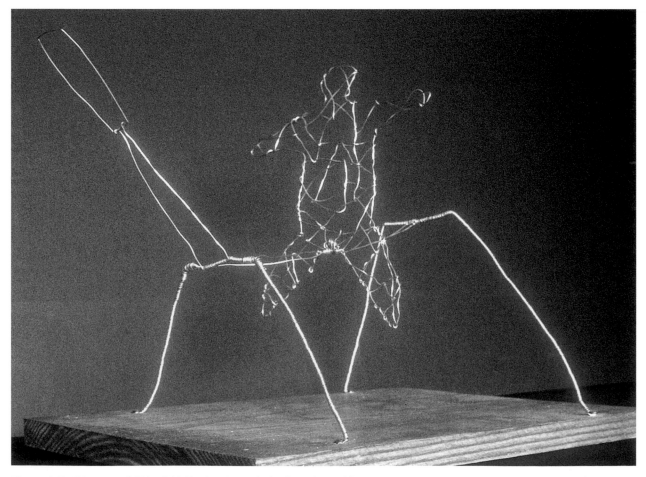

Figure 8-7. "Horse and Rider," Katherine Deuschel. Photo by Vold.

Selecting Materials

The first step in making wire sculpture is to select the material to be used. The creative process in sculpture often begins in the store or wherever the materials are seen. The fact that you respond to certain wires and have no interest in others has to do with your personal way of seeing. As you view and handle various wires, you may begin to visualize something taking shape.

Many things may influence your immediate perceptions: something in nature that you have recently seen; an image that has been settling in your head for some time; even the glimmer of surrounding merchandise if you are shopping in a hardware or plumbing supply shop, or a hobby or art store. Indeed, during this exciting period of initial creation, many perceptions past and present may play a part in your choice of materials and selection of forms.

It is also possible that you will visualize nothing as you look at the wire, wondering what to make. You may discover what you want to make only after you begin twisting the wire into shapes, trying to get started, and that's fine too.

Whether or not you have something specific in mind, you might begin by securing the wire in one hand with your fingers or with pliers, or held in a vise, and then simply proceed to bend it (**figure 8-9**).

Figure 8-9. One way to start is to grasp the wire at both ends with your pliers and bend and shape an initial form. Photo by Hernandez.

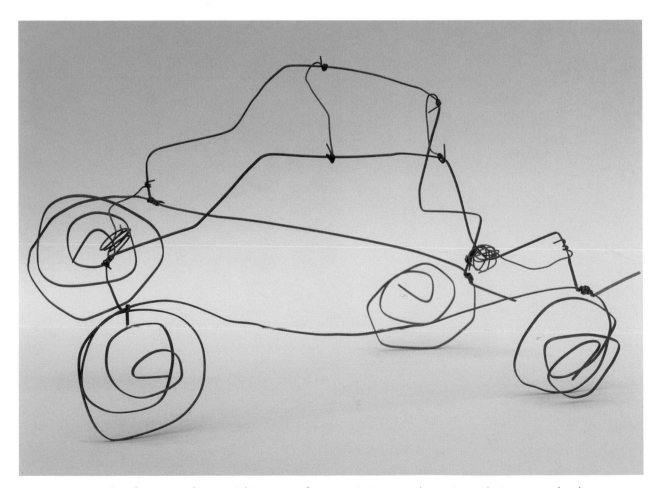

Figure 8-8. Your ideas for wire sculpture might generate from your interests and experiences but appear only when you begin twisting the wire. Car trouble might have influenced this unidentified student sculpture. Photo by Peck.

Connecting the Wires

You may be able to make the entire sculpture from a single length of wire, in which case no procedures to connect wires will be necessary other than securing the sculpture to the base. But more often you will need to connect sections of wire. There are various ways to do this:

- Bend a small hook in one end of the wire and a loop in the other as in figure 8-10. When the connection is in place, close the hook. Silver wire necklaces and bracelets often have this kind of attachment. You may want to have a moveable sculpture in which the parts can be hooked and unhooked by the viewer.
- Wire the parts together. The connective strands can become part of the sculptural texture, as in figure 8-11.
- Solder the two ends of the connection together. To achieve a good bond, cut the ends so that they are exactly flush, heat the ends and connect them while adding a touch of solder to the joint.

Figure 8-10. One way to connect wires is to bend a small hook in one end of the wire and a loop in the other. Photo by Vold.

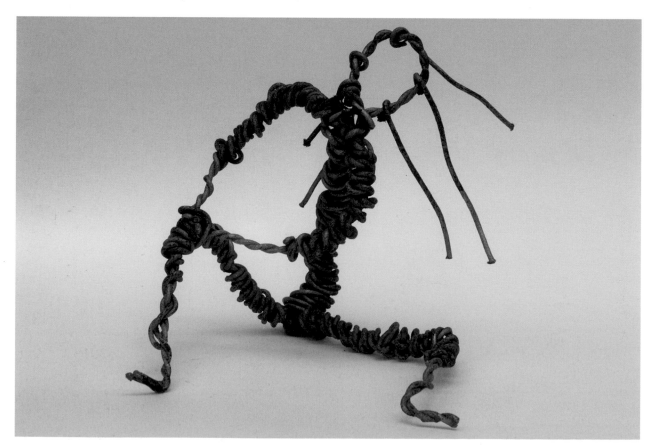

Figure 8-11. Adding wires in various places can extend the contours of the sculpture and increase the air of spontaneity. Unidentified student sculpture. Photo by Hernandez.

STYLE

Wire sculptures will have a wide stylistic range. Forms may be three-dimensional and encompass mass, as in **figure 8-12**.

Wire sculptures can be linear profiles, a kind of drawing in space, as in **figures 8-1, 8-5, 8-6, 8-7 and 8-13**. They may be amusing stylized compositions, such as the guitarist in **figure 8-13**, or representations of action, as in **figures 8-14 through 8-17**. All of these compositions afford a liveliness and spontaneity that other materials such as clay, stone, or even foil and Pariscraft are largely unable to provide.

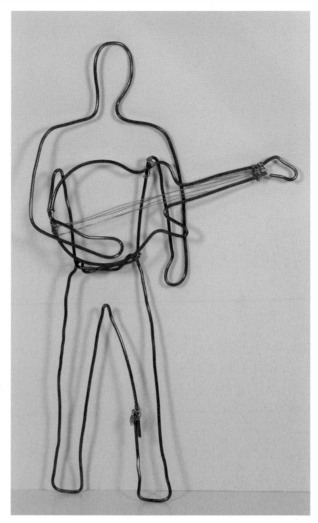

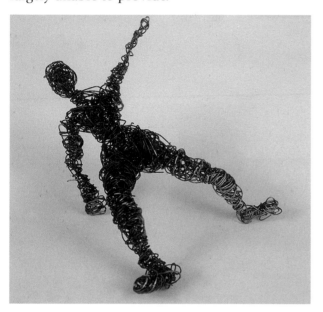

Figure 8-12. Wire sculptures can be mass-encompassing as well as linear, as in this ambitiously wired female figure. Margaret Petruchkowich. Photo by Hernandez.

Figure 8-13. Wire sculptures can be stylistic and tell a story, like this guitarist. Jill Sparling. Photo by Hernandez.

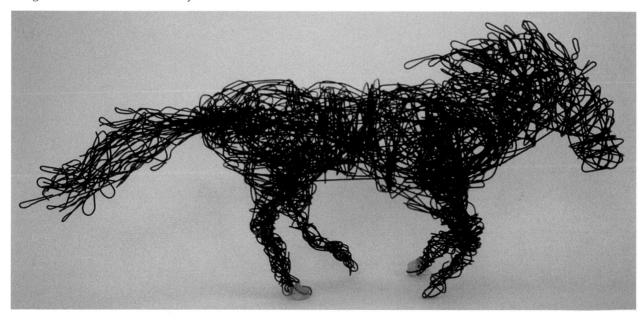

Figure 8-14. Energy is conveyed by the exuberance of wire connections in this running horse. Allison Mital. Photo by Hernandez.

These action figures are in the nature of 3-D sketches.

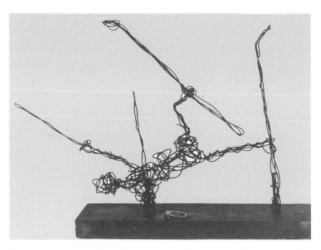

Figure 8-17. "Fallen Skier," Malik El-amin. Photo by Vold.

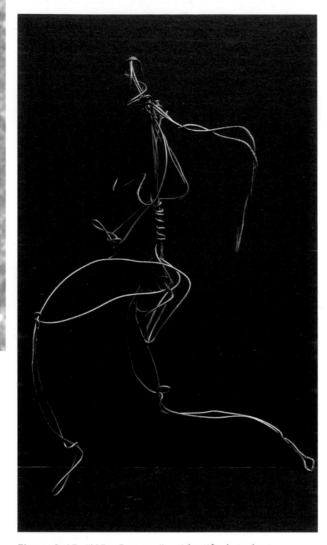

Figure 8-15. "Wire Runner," unidentified student sculpture. Photo by Hernandez.

Seeing, Manipulating and Changing on the Go

In creating your wire sculptures, try to maximize the qualities that are unique to the medium itself. This is something you should be doing with each of your projects, for example, are you using:

- wire's linear flexibility?
- wire's color and sparkle?
- wire's reflection of light and shadow?
- the ease with which forms can be manipulated and changed?
- wire's lightness and portability, which allows the sculpture to be perched high, set low and continually turned to be seen from all sides during the creative decision-making process?

As you begin to handle the various wires, you will encounter and work through the distinctive challenges that arise.

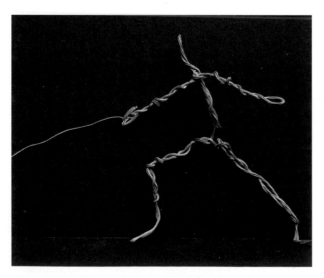

Figure 8-16. "Fencer," James Nardello. Photo by Hernandez.

MOUNTING

The base should be fully prepared before the sculpture is mounted (see Chapter 13 for base preparation and guidelines for mounting). The base must be heavy enough to prevent the wire sculpture from toppling over and the right size to effectively complement the design. Depending on the sculpture created — the sculpture's size, style and disposition on the base — the following methods of mounting can be considered:

- Nail or staple the wire or wires to the base. Neatly done with the proper nail, brad, or staple, tacking can adequately and aesthetically secure the composition.

Or:

- Drill a slender hole deep into the base, keeping it narrow enough to grip the length of wire to be mounted. Mix a small amount of five-minute quick-setting epoxy resin. Coat that section of wire going into the hole and hold until the epoxy resin has set.

Or:

- Solder the sculpture to a metal base. The metal base can then be fixed to a wooden base with contact cement or epoxy resin.

EXTENDING THE PROJECT:

Mobiles and Wall Sculptures

Wire sculptures can be constructed so that some sections are made to move while the major structure is mounted solidly on a base. A viewer may set it in motion, or it can be designed to move gently with natural air currents.

The entire sculpture can be made as a mobile, in which case it need not be mounted on a base (although a mobile emerging from a base can make an intriguing composition). Instead, the sculpture would be suspended from the ceiling. In making a mobile, you must find the fulcrum, that place where the extended arms of the wire sculpture balance when suspended. Connecting the wires for a mobile construction can be accomplished in any of the ways previously described.

Wire sculpture can also be made as a wall-mounted sculpture (relief). The sculpture can be completely formed and then mounted, or it can be created directly on its wall-hung background, a piece of wood, for example. To do this, prepare the surface in advance, and hang it on the wall. Then, tack the wires in position as you form the composition, making changes as you go along. Life-size sculptures can be made out of wire with comparative ease in this way, since a free-standing support for the composition does not have to be constructed.

Art in Human Service

In some settings, wire may be considered too dangerous to use because it is sharp and many of the tools could conceivably cause injury. When this factor is not an issue, the project is a good one because of the potential for producing a successful, durable finished product. Interestingly enough, many individuals who are new to art are quite hesitant about drawing on paper, believing they must be "artists" to be able to draw anything. Drawing in space with wire, because it is a new experience, has no similar preconceptions attached to it and is often approached with a positive, explorative attitude.

Wire sculptures need not be elaborately constructed to be effective; simple lines, effectively mounted, can convey a striking image. Executing simple facial features in wire, for example, as illustrated in **figures 8-1 and 8-2**, can open an avenue of stimulating discussion concerning an individual's feelings about himself and other people.

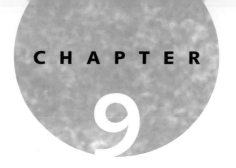
WORKING IN WAX

THE NATURE OF THE PROJECT

WAX is an enchanting medium for the inventive sculptor. When heated, wax can be manipulated and modeled. When cooled, the wax hardens and modeling stays more or less in place. Because it is firm when cool, wax may not require the rigid external supports needed by other soft media, such as clay, to keep sculptures upright. Clay, for example, may require the construction of an armature before any forms are modeled, and armatures limit the freedom to change forms while the work is underway. Thus, the unusual combination of flexibility and sturdiness that wax affords allows for a rich expansion of ideas.

Many artists create sculptures in wax that are intended for future casting in bronze, preferring it to clay because of its flexibility.

Wax sculptures require support as well, but the external supports needed might only be wax rods (called sprues) welded in place as work progresses. The position and curvature of these rods can be changed as the design changes. Various types of wax have varying degrees of hardness and softness, allowing some to be used specifically for support and others for modeling and texturing. A degree of patience, however, is needed to work with wax. You must hold warm wax in place as it cools, wait for tools to heat and so on; so be prepared.

Figure 9-1. These delicate fauns with their spindly legs could not have been created in clay without an armature. Wax allowed the artist to freely create her biblical theme, using warm wax to model the legs, which cooled to become hard and firm. "Twins of a Gazelle," Judith Peck. Photo by Hernandez.

PRESERVING WAX

The disadvantage of wax as a sculptural medium is its impermanence. The heat needed to manipulate wax is the same heat, unfortunately, that emanates from radiators and the hot sun. Therefore, unless the sculptures are kept reasonably cool, they will eventually collapse. The harder forms of wax last the longest.

The traditional method of preserving wax sculptures is to cast them in bronze, a technical process usually done in a foundry. Wax sculptures can also be cast in other metals and in materials such as plaster, plastics (clear resins used alone or resins bonded to bronze or stone powders), concrete and so on (see the Appendices).

There are ways to preserve wax in the home studio. The materials and procedures to do this are described in Chapter 12.

THE BASIC MEDIUM

Wax can be purchased in blocks or sheets. You can make sheets by cutting chunks off the block and melting them in a pot on a portable stove, then pouring the liquid wax into single sheets, a process described later in the chapter. You then cut out the shapes and weld them to form flat constructions. Because basic principles of welding are used in such construction, albeit on a less complicated scale, wax welding might serve as a good preliminary exercise for future welding in metal. The procedures for preparing, cutting, welding, forming, modeling, texturing and finishing wax are described in this chapter. Another way to create wax sculptures is to warm the wax by applying heat — sometimes merely by the warmth of your hands — and then modeling your forms using a heated blade.

The terminology in the Checklist is offered to assist you when ordering various waxes from a supplier. To begin an initial project requiring little support you may need very few of the many items listed; you may only need a tool, a knife, a mounted candle and a slab of microcrystalline wax, all of which are obtainable from sculpture supply houses.

A significant advantage to fabricating sculptures in wax is the relative simplicity of the tools and materials needed to do the job. The items listed and shown in **figure 9-3** are suitable for all aspects of sculptural fabrication in wax: supporting the forms, cutting, welding, modeling, applying wax and texturing. Some items are recommended but listed as optional. The thermostatically-controlled wax melter, for example, can reduce frustration and increase efficiency, but it is not a requisite and other ways of softening wax are offered in the text. In the interests of further economy, an alcohol burner or even a candle can substitute for the soldering iron; however, these items are considerably less efficient. The various products suggested for lamination (a way of preserving wax sculptures) are listed in Chapter 12.

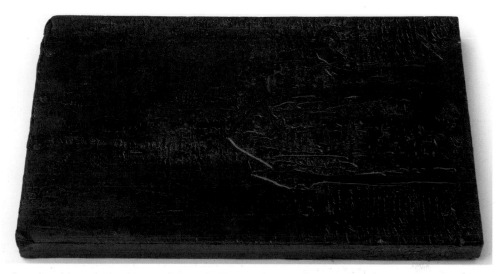

Figure 9-2. A microcrystalline 2" thick wax slab for breaking into pieces and softening, used for modeling and for preparing wax sheets. Photo by Hernandez.

CHECKLIST OF TOOLS AND MATERIALS

As stated, not all of the materials and preparation listed will be needed for the sculpture you create, as your design may not call for it. For example, low forms may not require any wax rods for support, and small modeled forms may only require fragments broken from the block.

- Microcrystalline wax sheets of ⅛" thickness (colored black or brown), used for cutting into patterns to create forms.
- Square-cored ⅜" hollow wax rods called sprues (factory-colored red), used to provide solid support for long, vertical designs.
- Round solid ¼" wax rods or sprues (factory-colored green), used to connect and support angular forms.
- Sticky wax, small chunks obtainable from a sculpture foundry, to join difficult welds if needed.
- Soldering iron (electric hot knife) to heat tools, soften wax, and join wax sheets and rods; usually includes base holder for soldering iron.
- Wax tools with small flat oval blades to apply wax and model forms.
- Paring knife (thin-bladed) to heat on soldering iron and use for cutting.

- Putty knife for clean-up operations.
- Lazy Susan to place under work board for easy turning (optional).
- Wooden base to use as work board.
- Nail brush or small scrub brush and green soap for washing hands.
- Protective covering for floor and table as needed. Newspapers are adequate for the floor; keep away from heat. An old Formica table is suggested as a work surface.
- Alcohol burner filled with denatured alcohol — substitute for soldering iron, though slower working (optional).
- Candle — substitute for soldering iron, though considerably slower (optional).
- Electric wax melter, a thermostatically controlled heater to melt wax to consistencies desired (optional).
- Thin cotton cloth for rubbing smooth textures (optional).
- Thin cotton material for drapery (optional, not shown).
- Cookie tin or pan for pouring wax sheets .
- Waxed paper for pouring wax sheets.
- Electric portable stove and pot for melting wax and heating sticky wax if needed.

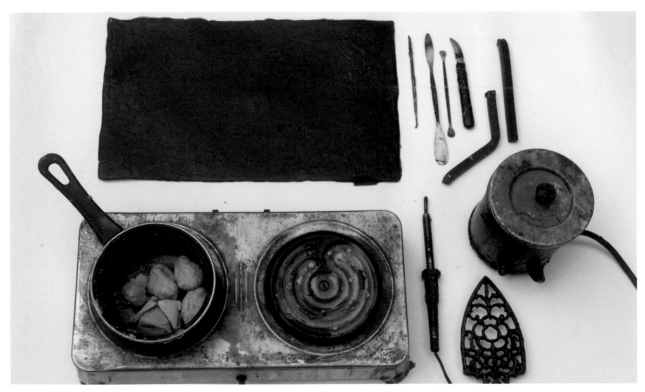

Figure 9-3. Tools and materials for working in wax. Photo by Hernandez.

PREPARATION

Preparation requires these conditions:

- **Wax and tools on hand for creating a sculpture.**
- **An appropriate and safe place in which to work, in an area with good ventilation so that the vapor, which forms as the wax melts, can escape.**
- **A table surface that can be used solely for wax, such as an inexpensive folding table with a Formica top. A flame-proof surface is ideal should your hot knife slip from its stand.**
- **Protected surfaces for wax drippings; wax will accumulate on the table and on the floor. Drips can be scraped up with the putty knife and wax stains are removable with turpentine, but it helps to protect those surfaces in advance.**

Pouring Wax Sheets

Sheets of wax are useful for creating broad forms. These sheets can be purchased through wax or sculpture supply houses or made in the home studio following this procedure:

1. Melt the brown microcrystalline wax in the electric melting pot or on a portable stove in a pot that you do not plan to use for anything else.

2. Line a cookie tin with a sheet of waxed paper and place the tin on a flat surface.

3. Pour the melted wax onto the sheet to a thickness of approximately 1/8". Allow this to cool.

4. Place another sheet of waxed paper over the hardened wax; repeat the process for each additional sheet that you need. How much wax to melt will depend on the thickness of your cookie tin and the number of slabs you intend to make.

5. If a slab is shy, melt and add more wax, even if the first layer has cooled; it will adhere easily. The waxed paper allows the sheets to be separated when ready for use.

6. The wax can be reheated if it begins to solidify.

Setting Up

1. Use a flat piece of wood, tile or Plexiglas as a base and place the lazy Susan under it for easy turning while the work is underway.

2. Plug in the soldering iron and the wax melter (if used). A 60 watt light bulb hung over a tin can filled with wax might substitute for the wax melter.

3. Lay out the wax rods and the slab of microcrystalline wax.

4. Pre-cut some small sections from the slab by breaking off pieces with a chisel and hammer. Place these in the melter or can.

5. Save all wax fragments, large and small, keeping a box for that purpose. The wax can eventually be re-melted, but beyond that, it helps artistically to have an assortment of wax forms to select from when the work is underway.

PROCEDURES FOR WORKING WITH WAX

The steps described and illustrated in this chapter demonstrate a more complicated form than you may be creating. This is done to enable you to take your sculpture as far as you wish to go. You should extract from the description only what you need to proceed.

In this initial effort, you should begin with an uncomplicated form that requires a minimum of support and welding.

Heating the Tools

Heating the blade of the tool is the necessary first step in all wax cutting and application procedures. Wax, in its cool state, is brittle and hard, but it cuts like butter under a well-heated blade. Heat the tool by laying the blade on the soldering iron. Always be careful to place hot items in such a way that the table does not burn and your arm, hand or fingers will not brush up against them while working.

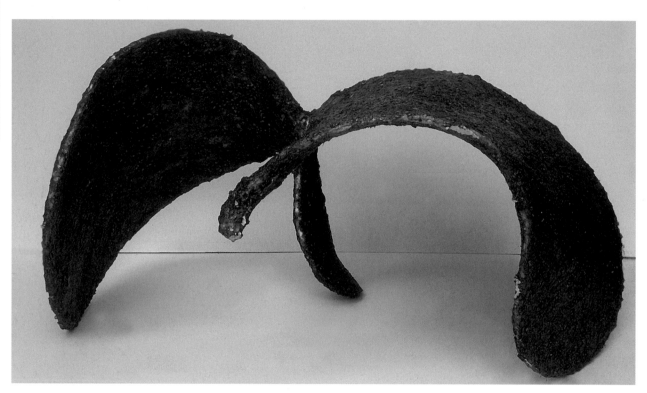

Figure 9-4. Begin with a simple construction to get the feel of cutting shapes and welding forms together. "Condor," Peter Nurcio. Photo by Peck. Digital enhancement by Csokasi.

Support: Cutting, Fusing and Bending Wax Rods

The amount and kind of support needed will depend on a number of factors; for now, consider mainly the size and shape of the work. At a more advanced level, you would be concerned with how it is to be finished. Will it be cast? If so, will a plaster mold be made or will it be cast directly from the wax in the so-called lost wax process? How complex will the mold have to be? Will it be conventionally cast (solid investment core) or cast in the ceramic shell process, in which case the piece must be made to withstand many dippings in a "batter" of liquid and granules?

For now, however, only minimum support is needed and several methods are described which you will modify as needed.

1. To begin, cut the square-cored hollow red rods (sprues) with the heated knife to the angle or curve that will support your design.

2. Fuse these to the base and to each other. These wax joinings are literally melted into each other.

3. When welding any joint, make sure that the ends to be joined are matched as closely as possible (with no air gaps). A tight fit allows the wax to fuse evenly, ensuring a good bond.

4. Pass the hot blade between the ends to be joined, and hold the joint together for several seconds until cool.

Figure 9-5. The supporting rods are welded to the base and to each other. A hot blade is passed between the ends to be joined, and the joint is held together for several seconds until cool. Note that to keep the process going, the knife is heating while the tool is in use. Photo by Vold. Digital enhancement by Csokasi.

5. Reinforce the joint by passing the heated blade or soldering iron lightly around the circumference and adding soft wax as needed (**figure 9-6**).

Figure 9-6. The joint is reinforced by passing the hot blade or soldering iron lightly around the circumference and adding soft wax as needed. Photo by Vold. Digital enhancement by Csokasi.

6. The wax rods can be bent to the shapes desired either before or after they are set in place, depending on how securely attached they are. Since the wax is brittle, the rods might have to be softened slightly to be pliable. This is done either by dipping them in hot water and then bending them or by passing the soldering iron very lightly over the area as you bend the rod into position (**figure 9-7**). The rods can be re-bent as you go along, should your forms change.

Supports can also be constructed from balsa wood or thin Styrofoam sheets, both of which would burn out in a bronze foundry furnace. Wooden toothpicks, which will also burn out, can be used as connectors if needed. When casting is intended, the foundry should always be informed about any such materials used.

Figure 9-7. To bend the supporting rod, pass the soldering iron lightly over the area, then slowly bend the rod into position. Photo by Vold. Digital enhancement by Csokasi.

Cutting and Fusing Wax Sheets

The sheet wax is thin and cuts easily with a heated blade. One can be exceedingly free in spirit when cutting out sheet forms for developing into sculptures (**figure 9-8**). In order to keep the process going, heat the blade by resting it on the soldering iron while you use the knife (alternating tools). Because the wax sheets are thinner than the wax rods, they are easy to bend and manipulate with no source of heat other than the warmth of your hands. You can also soften the wax by dipping it in hot water, but dry it after bending and before adding heat to prevent sputtering. Because the sheet wax has little strength of its own, new supports may have to be added as the forms take shape.

Wherever the sheet forms touch one another or the rods, they should be welded fast by delicate fusing. The thin sheet wax requires less heat to melt than the rods, so lightly melt the edge of the rod first, and then touch heat to the sheet and hold (**figure 9-9**).

If holes are melted through the sheet, patch them with more wax. Between sessions the work should be refrigerated or placed in a cool basement to solidify the structure. On removal, remember that whenever soft wax is joined to hardened (cold) wax, the cold surface should be heated lightly to permit good bonding.

At any point your sculpture might change in form as your ideas change and you become inspired by what emerges. Don't be adverse to pulling off a form and re-doing your concept. Your work in foam core prepared you somewhat for this process.

Applying Soft Wax

To add bulk or texture to your piece, you would apply soft wax. The electric wax melter allows you to adapt the consistency of the wax to a putty or liquid state. If you do not have an electric melter, simply cut a piece of wax with a hot blade, and then place the wax in an ashtray or jar cover. As you need it, melt the soft wax with the soldering iron to a putty or liquid consistency. To keep the wax in a spreading consistency, you might also place the wax fragments in a tin can with a light bulb above it.

First, lightly heat the area of application if it is cold, so that the soft wax will properly adhere. Then, apply the soft wax with your flat tool. Shape the wax with the heated tool.

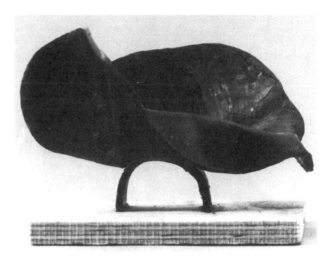

Figure 9-8. One can be extremely creative when cutting out wax sheet forms. Stephen Issler. Photo by Unhjem/Cavallo. Digital enhancement by Csokasi.

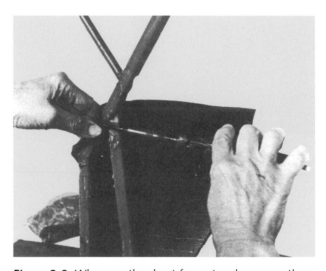

Figure 9-9. Wherever the sheet forms touch one another or the rods, they should be fused. Lightly melt the edge of the rod first, then touch heat to the sheet; remove heat and hold. Photo by Vold. Digital enhancement by Csokasi.

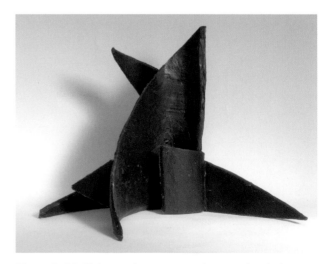

Figure 9-10. Slabs can be rearranged as you begin to see what you have. Unidentified student sculpture. Photo by Peck.

ESTABLISHING A RHYTHM FOR WORKING

You will find that you are applying and cutting wax away intermittently. You will also be welding form to form. As the knife is heating, you may use the time to hold welded forms together while they cool and harden, or search for an interesting scrap of wax to attach to a form, and so on.

Eventually, you will establish a rhythm with the various aspects of wax manipulation: heating, cutting, welding, holding and soft wax application. See some of these operations illustrated in **figures 9-9 to 9-14**. Keep your fingers out of the way of dripped wax, though you should expect the mild discomfort of this from time to time.

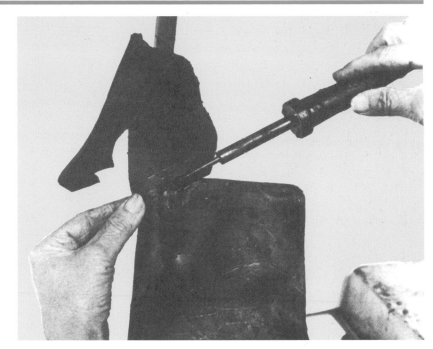

Figure 9-11. Instead of pre-planning, proceed, in these first attempts, with a sense of experimentation: bravely apply and then cut, or cut and then apply your sheet wax patterns. Photo by Vold. Digital enhancement by Csokasi.

Figure 9-12. Initially, you may apply too much heat and create holes in the wax, or you may use too little heat and cause a wax section to drop off. Both conditions are easily fixed by reapplying heat and wax. Hold joining edges for several seconds to create good adhesion. Photo by Vold. Digital enhancement by Csokasi.

Figure 9-13. A form cut away from the sculpture often goes well in another area; that curve or angle, appearing elsewhere, also lends "visual logic" to the composition. Photo by Vold. Digital enhancement by Csokasi.

Figure 9-14. When melting edges together, keep your hands out of the way of hot dripping wax. Photo by Vold. Digital enhancement by Csokasi.

TEXTURE

The finished texture of the sculpture is an important consideration and may take many forms; it may be rough, swirled or smooth. Texture can also be made by imprinting the soft wax with objects and heavy fabrics.

For rough textures, melt fragments of wax to a putty consistency and apply the putty to your form in the desired texture. Remember that if the surface form is cool, it should be heated slightly to permit good bonding of the soft wax. A rough texture can be dramatic, as it reflects light with its surface highlights and depressions. Since this can create the illusion of depth, rough texturing might be particularly effective in a stylistically flat piece or wall piece, as in **figure 9-15**.

Figure 9-15. Rough texture can create the illusion of depth and might be particularly effective in a wall piece. "Passage," Holocaust Memorial, 36" x 12", bronze, Peck. Collection of Rockland Center for Holocaust Studies and Northshore Synagogue, Syossett, NY. Photo by Harry Peterson.

For swirled textures, heat the wax tool and use the flat blade to lightly soften the wax surface. Move the tool across the form to create a random pattern of swirls as in **figure 9-16**.

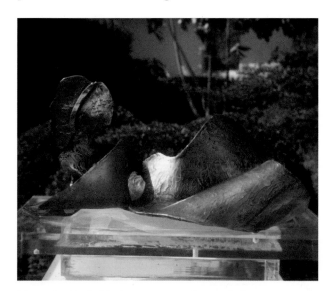

Figure 9-16. Swirled patterns can be made by manipulating a heated tool across the surface. "Sunbather," 7.5" x 12" x 8.75" bronze, Peck. Collection of Stephen L. and Nancy Rosen. Photo by Peck.

DRAPERY

Soft cotton material can be dipped in molten wax and then quickly applied to the sculpture to form drapery. The folds should be allowed to drape naturally, unless other specific forms are intended. Reinforce thin portions of the drape by adding wax with the tool. Figure 9-17 illustrates drapery done in this manner. Drapery can also be created by fusing interesting shapes directly onto the form.

For smooth textures, fold a piece of soft cotton material several times to form a pad. Moisten with a bit of light oil (mineral oil or machine oil). Touch the pad to the soldering iron or hot plate, and rub it over the wax surface. It will pick up wax and gradually become easier to use. Smooth textures can enhance the lyrical quality of curved forms, as seen in portions of figure 9-18. In bronze, such forms are often polished and given a highly reflective patina.

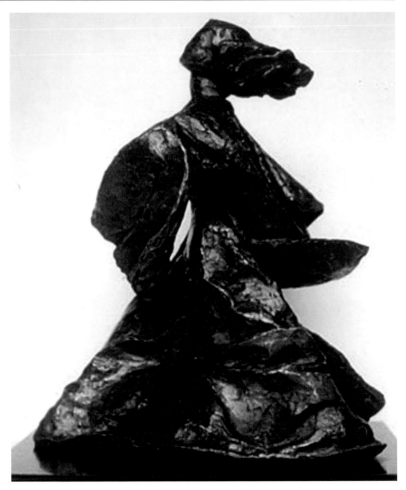

Figure 9-17. Soft cotton material dipped in molten wax can be applied to the figure to form the basic structure of drapery. It is then reinforced and shaped with soft wax. "Music," bronze, 16" x 13" x 9". Peck. 1st cast. Collection of Irving and Sydell Fishman. Photo by Vold.

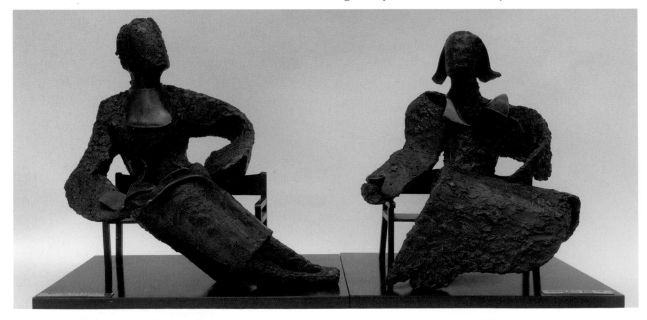

Figure 9-18. Texture complements form. Here, flat textures enhance both the contours and theme. Left: "Waiting for Lobster." Right: "Woman with Wine Cup," both bronze, approximately 10" x 11" x 9" each. Peck. Photo by Hernandez.

FINISHING

Wax, as previously stated, is frequently cast in bronze (sources for bronze casting are included in the Appendices). Bronze casting is the most beautiful and lasting method of finishing, but it is also the most expensive. Other methods are less successful as measured against bronze, but they are also less costly. Moreover, it may take some time before mastery of the methods and materials of forming sculptures in wax will result in a piece that is ready for bronze casting. Therefore, laminating might be considered as a method for preserving wax. Materials, techniques and various products for laminating are offered in Chapter 12.

Mounting

Select a base of appropriate dimensions, as described in Chapter 13. The base, as in all mounting procedures, should be fully prepared: sanded and then painted, stained or burned. To remove the sculpture from your working base (which by now will be wax-encrusted), heat your flat blade and pass it under the form.

Mount your sculpture by melting a small amount of wax to the finished base in various places; then, spot melt your sculpture to it. If you are laminating your piece, the laminating resin can be used as the adhesive. Take care that the mounting material (wax drippings or resin) is not seen. If drippings should appear, scrape them off and retouch the base. In mounting, neatness always counts.

Student sculptures in wax are illustrated in **figures 9-19 and 9-20**.

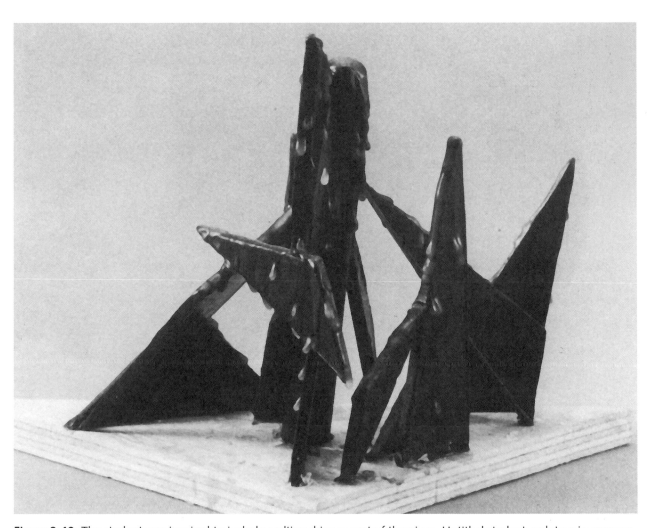

Figure 9-19. The student was inspired to include melting drips as part of the piece. Untitled student sculpture in progress. Photo by Unhjem/Cavallo. Digital enhancement by Csokasi.

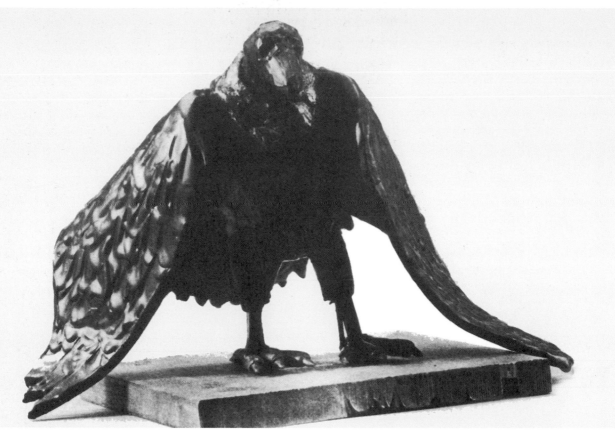

Figure 9-20. A texture of swirls adds to both the sculptural quality and theme. "Condor," Peter Nirchio. Photo by Unhjem/Cavallo. Digital enhancement by Csokasi.

EXTENDING THE PROJECT

Art In Human Service

Wax in small mounds and thin fragments is pliable in the warmth of one's hands yet hardens when cool; thus, for simple modeling procedures, one might manage with no tools. It is therefore a good semi-permanent sculptural medium for use in institutional or agency settings where budgets, set-up time, space and manual dexterity may be limited.

Imagery that may be particularly stimulating for self-expression and for promoting group discussion includes faces, food, animals, flowers, bugs and other articles from the real and natural world.

If warmth of the hands is not sufficient for making the wax pliable, wax fragments can be placed in a bowl of hot water before modeling. Participants new to modeling in any medium are often self-conscious about "dirty" hands; therefore, be sure to have soap and a nail or scrub brush available. Of course, the problem of hot tools and the care needed to prevent uncomfortable burns prevents this project in its entirety from being used in venues other than a school or home studio. The project can, however, be successfully used by limiting it to modeling wax pieces in the warmth of one's hands.

CARVING IN PLASTER AND CEMENT & VERMICULITE

HOW TO GO ABOUT THE PROJECT

WELL, that will depend upon time available, and as everything in life and art, priorities. There are several ways to approach the project. One plan is to read about both mediums and then choose between them, carving in either plaster or cement & vermiculite. A second plan, if you have more time and the inclination, is to devote two weeks to each. A third plan is to work on the two projects concurrently.

Each medium has distinctive characteristics to consider: Plaster is softer and less brittle than the cement & vermiculite mix, and it may prove easier for you as your first carving experience. Plaster lends itself to smooth finishing, which may be a factor for you, while cement & vermiculite becomes dusty with sanding and is better either left rough or filed.

In this chapter you will explore the processes of mixing and pouring plaster and cement & vermiculite into containers, removing the containers when the mixes have set, and carving the blocks or boulders into finished sculptures. Both plaster and cement & vermiculite are excellent materials to use to approach the experience of carving. Both follow the same general principles, with technical and aesthetic variations particular to each medium.

THE NATURE OF THE MEDIUM: PLASTER

Plaster is a versatile sculptural medium. A gypsum product, it is relatively soft and unresistant to the blade. It has no grain and no impediments. Beginning as a fine white powder, it mixes easily with water into a creamy liquid; as it sets, it becomes a semi-soft putty and finally, a solid. Each of these manifestations of plaster's unique identity can be used to advantage in making sculpture, but each has time restrictions and you must design your sculptural choreography to meet those limitations.

Because plaster is liquid before becoming solid, it can be poured into a container or mold, splashed onto or into an existing form, laminated onto cloth or burlap to wrap around an armature, such as chicken wire, and adapted to numerous variations on these themes.

Plaster is the most common material used in making molds for sculpture. Plaster is also used for the actual casts, although casts are more often made with Hydrocal, a stronger gypsum product in the same family. As indicated earlier, this book will not examine the mold-making and casting process, nor will it explore wrapping and modeling with plaster. Rather, you will explore the material in its solid state as a creative medium for carving.

Superfine grade plaster in 5-, 10-, 25-, 50-, or 100-pound bags is available in art stores or sculpture supply stores. A more porous grade of plaster can be found in hardware and paint stores in 5-, 10-, or 25-pound bags and is still adequate for sculpting.

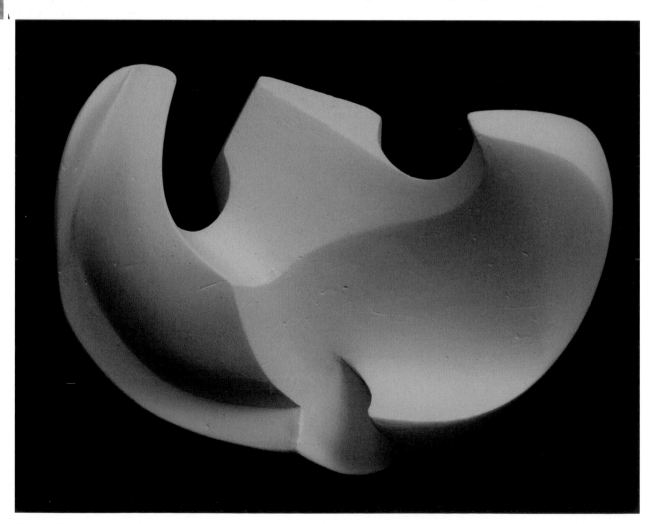

Figure 10-1. Plaster lends itself to the creation of solid or lyrically flowing forms because it is easily smoothed. John Reda. Photo by Hernandez.

THE NATURE OF THE MEDIUM: CEMENT & VERMICULITE

Cement, mixed with sand or aggregates (various stones), is used extensively in building construction. It is also a medium for sculpture in two general ways: the mix is either poured into molds taken from clay or plaster models or built up directly onto supported wire lathes. You will be using the cement for carving only, so neither the casting nor the building-up process will be described, and for the purpose of this project, a heavy-duty mix is not necessary.

What is needed instead is an attractive material that offers permanence without being too difficult to carve. Cement & vermiculite together provide this. The particles of vermiculite, a product used to aerate soil and nurture plants, when spread throughout the mix produces a glistening effect similar to the mica found in quartz. This reduces the somewhat dusty quality of pure cement without compromising its solidity.

The cement & vermiculite mix is poured into a container of your choice. When it sets, a solid, durable form is ready for carving. Cement & vermiculite is stronger than plaster and because of its surface roughness and density, it is more closely akin to stone. When cured, it can also be placed outdoors, unlike plaster. The surface is not completely impervious to weather, since patterns of pockmarks may form with prolonged exposure to the elements; however, these marks might sometimes enhance rather than detract from the texture.

The color of the block will be light gray or off-white, depending on whether you choose gray or white Portland cement. The vermiculite adds gray crystal-like particles to the block. The cement & vermiculite mixture, unlike plaster, takes from one day to several days to set, depending on the size of the block.

Portland cement (cement only, unmixed with sand or aggregates) is found in lumber yards. Gray is more readily available than white, and it is also less expensive, although the product (considering the amount of carving material it produces) is inexpensive overall. Portland cement is generally sold in 80-pound bags.

Vermiculite is purchased in garden-supply stores in granular form. Note that vermiculite is also sold in lumber yards in small chunks as attic insulation, but this product you do not want, so make sure you procure garden vermiculite.

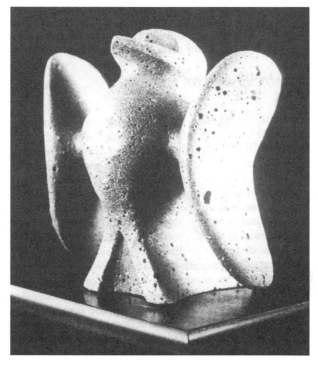

Figure 10-2. This sculpture is an example of well-defined forms carved in cement & vermiculite, filed and mounted with care. "Bird," John Reda. Photo by Hernandez.

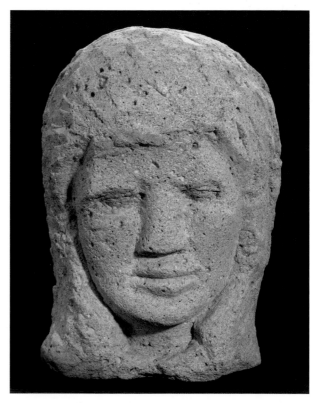

Figure 10-3. This large cement & vermiculite head was left outdoors for three years in a northern New Jersey climate. It is weathered with pockmarks, but other than that, survived well. Peck. Photo by Hernandez.

CHECKLIST OF TOOLS AND MATERIALS

The equipment needed is shown in **figure** 10-4.

- Plastic mixing bowl three-quart size or more, depending on the size of the container to be poured (not shown).
- Steel chisels, at least two, small and medium size, for carving the block; flat-ended are recommended as a start.
- Steel mallet for use with chisels to carve the block — 1-1/2-pound for the average woman; 2-pound for the average man. The side of a metal hammer can be substituted, although it will not perform as well.
- Serrated knife, household variety, for push-carving small forms.
- Metal files and rasps for modeling forms and smoothing rough areas.
- Wire brush to clear files and rasps of grit.
- Wet/dry Carborundum papers for smoothing plaster; these are black and are available in coarse, medium, fine and extra-fine grits (not shown).
- Sandbags (two) for supporting work in progress; purchased in sculpture supply houses or made by hand.

- Rocks and slivers of wood as needed for propping up work for critical viewing (not shown).
- Sturdy stick for mixing cement, vermiculite and water (not shown).
- Disposable gloves (optional) if hand-mixing the cement, vermiculite, and water, as contact with the liquid mix can be irritating.
- Dust mask (optional), used when mixing if you are sensitive to cement dust.
- Goggles used when carving cement & vermiculite.
- Containers: suggestions are milk and juice cartons; detergent and bleach bottles; shoe boxes, soap cartons, other cardboard boxes lined with plastic; large plastic cups, deli containers, plastic soda bottles with the tops cut off for pouring, or any other container that can hold liquid without collapsing and be peeled away when the mix has set.
- Plastic bags (Ziplock quart size) for creating an improvised plaster form (not shown).
- Saws to help remove container after material has set (optional).

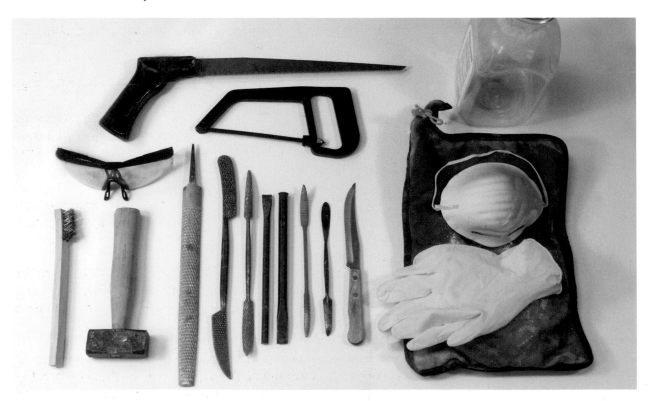

Figure 10-4. Tools and materials for carving plaster and cement & vermiculite. Photo by Hernandez.

PREPARING THE PLASTER FORMS

Avoid getting moisture in the bag from which you are dispensing plaster (from water drops or damp hands) because it could make the remaining plaster lumpy and unusable.

When pouring plaster into a plastic bag, furrows or grooves may form that remain to frustrate you when the container is removed. You may decide to work deep ones into your composition. When the container is a plastic bottle, the form will be very smooth. You may want to retain portions of those areas in the finished piece because contrasts of smooth and rough texture can be effective in both cement & vermiculite carving and plaster carving.

Words may have been imprinted on the container. Bleach bottles, for example, have raised lettering and you might choose to integrate those markings into your sculpture. Any or all of the characteristics or imperfections of your container may be utilized in the finished piece. You might indeed decide to do nothing at all with a boulder after its wrapping is removed. **Figure 10-5** is a product of a largely pour-and-unwrap procedure.

Figure 10-5. You may decide to leave the plaster exactly as it was cast in the bag, but you should do an additional sculpture to get the full carving experience. Unidentified student conception. Photo by Unhjem/Cavallo. Digital enhancement by Csokasi.

Pouring the Plaster into Rigid Containers

Plastic cups, bottles and jars are suitable containers if they can be peeled away when the plaster sets. Cardboard boxes can be used, but if they are not already coated to prevent liquid absorption, line them with plastic before filling.

If the container is an upright carton, tap it gently after filling so that trapped air bubbles can rise to the top. If it is a long, low box, also tap it but more gently to avoid spillage.

Pouring the Plaster into Plastic Bags

Pouring the plaster into a plastic bag will produce an irregular shape.

The plaster will set according to the pressure exerted on it — the pressure, for example, of a counter's edge or block of wood or mound of clay wedged underneath it. So if you are using a plastic bag rather than a rigid container, you must give thought to that potential shape by searching around the room for a suitable "setting" before you pour. The plaster sets quickly so you won't have much time after pouring.

1. Prepare your plastic bag by checking for holes.

2. Locate a good place to hang or prop the bag.

3. Have someone hold the plastic bag open for you while you pour; if you are alone, hang it inside a pail. In either case, pour over a bowl in case the bag springs a leak.

4. Fill the bag with as much plaster as you think it can bear (or as much as you want to work with).

5. Close the bag tightly with a plastic tie or wire, and then hang it up with a wire; or drape it over a counter or some other form that you have chosen.

6. Before it sets, you have a few minutes to manipulate the shape, using anything on hand to press into the form — wood, stones, clay, rags, etc.

113

The Plaster Mix

The following procedures for making the plaster mix apply regardless of what type of container is used. Remember to keep the bag of loose plaster dry during the entire handling process.

1. Fill the mixing bowl half-full with cold tap water.

2. Open the plaster bag to allow wide access at the top, and place the bag close to the bowl.

3. Dip your dry hand into the bag and transfer full handfuls of plaster to the bowl by sifting the plaster quickly through your fingers. Work close to the bowl but without touching the water. Do not dump the plaster; instead, spread it around, sifting and spreading it in continuous motions.

4. Continue this transfer, distributing the plaster across the bowl. Work quickly but do not jar the bowl.

5. When a mound forms and stays without sinking for several seconds (this usually takes more time than you think it will, at first), let the bowl stand for a few seconds, and then stir. Stir without splashing with a flat hand, squeezing out lumps as you feel them until the mix is creamy smooth. Take care not to stir vigorously or air bubbles will form, creating small holes in your solid form. The setting process begins when stirring begins, so work efficiently; the stirring should take no more than a minute or two.

Setting

You will have five minutes or so before the plaster begins to set; this will vary according to the amount of plaster used, the atmosphere, and your own time spent pouring and stirring the mix. Immediately pour the mix into your rigid container, tap it gently, and move it to a safe place for setting. If you poured into a plastic bag, you have time to manipulate the plastic bag into shape. Do not move the container once setting begins.

Setting takes about 30 to 40 minutes, after which the bag will become quite warm. When it cools, the wrapping can be removed, and you are ready to carve. Containers will take longer to set than plastic wraps. If the plaster seems loose or wet as you start to carve, then let it dry out overnight before you begin. There is no harm in waiting to unwrap your piece and there is something to be said for delaying this.

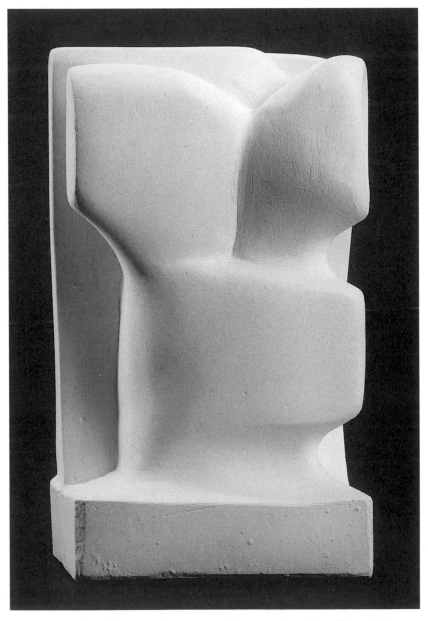

Figure 10-6. This plaster carving emerged from a rectangular milk container. Notice how highlights and shadows add dramatic impact to the sculpture. "Couple," Stephen Issler. Photo by Unhjem/Cavallo.

PREPARING THE CEMENT & VERMICULITE BLOCKS

Choose a container. Remember that the shape of the container will be the shape of your starting block, so give the choice careful consideration. Solid rectangular containers used for juice and milk products are easiest to use and a good starting shape. If you are using cardboard, such as a shoe box, for example, line the box with plastic to prevent the wet cardboard from collapsing.

The procedure for making the cement & vermiculite mix is as follows:

1. Use a cup, jar or coffee can as a measure, and mix the dry ingredients in a large waterproof container using a sturdy stick or your gloved hand. The more cement in the proportion, the heavier the piece. To start, try mixing the first proportions given:

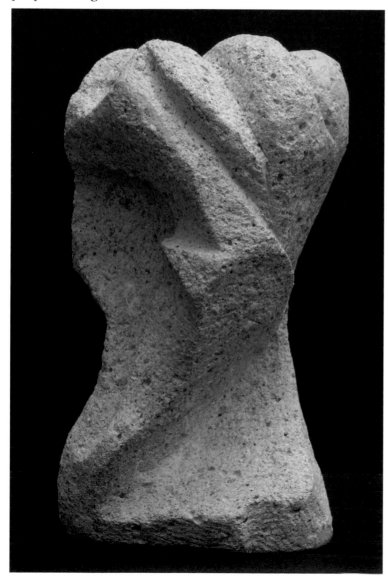

Figure 10-7. This cement & vermiculite carving emerged from a half-gallon juice carton. Planes are emphasized, and it was filed, not sanded, to bring out the vermiculite sparkle. Allison Mital. Photo by Hernandez.

- 2 parts vermiculite to 1 part cement
- 3 parts vermiculite to 2 parts cement
- 1 part vermiculite to 2 parts cement

The total amount used in any of these proportions will depend on the container size to be filled and how many containers are to be filled. If you have not mixed enough, it is all right to mix more and add it.

2. Mix the dry ingredients well.

3. When well mixed, add cold water in a slow steady stream while continuing to stir with the stick. Ask a helper to stir while you add water if the quantity is large, as the wet ingredients can get heavy to manipulate. Do not pour bucketfuls of water at once because the vermiculite is lighter than the cement and will rise unmixed to the top.

4. When the mix is reasonably smooth throughout and is about the consistency of sour cream, pour it into the containers. It's a good idea to have an empty container handy in case too much is mixed. You have plenty of time. Setting time for this mix is considerably longer than that for plaster — overnight or even days.

5. Tap the containers gently when full, as you did when filling plaster containers, to bring trapped air bubbles to the surface. Place the cartons where they will not be disturbed for two or three days.

6. When you are ready to unwrap the mixture, use utility knives or saws. Be careful and take your time; this can be tricky.

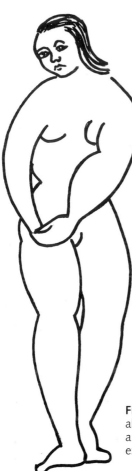

Figure 10-11. An expansive form with large hollows and broad surfaces "decorated" with intricate patterns creates a totality that is inconsistent in style.

Figure 10-10. A figure carved in abstract planes but crowned with a realistic, detailed head is another example of inconsistency in style.

An example of beautifully integrated sculptural forms in plaster is illustrated in **figure 10-12**. As you carve your own piece, look critically to see how small forms can blend into one stronger form through carving or filing. The next section addresses the creation of two forms in relationship.

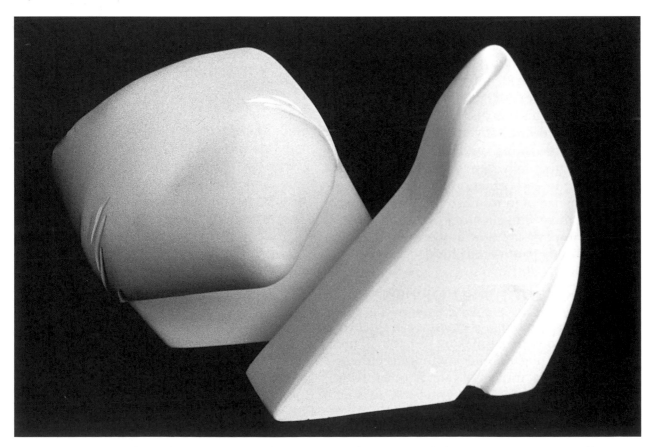

Figure 10-12. The two forms that meet and separate in this beautifully integrated plaster sculpture are quite different yet consistent in their organic style. "Lovers," Karen Sherman. Photo by Vold.

Designing Two Separate Forms in Relationship

A good way to go about the study of relating forms, particularly in plaster carving, is to design two completely separate forms in relationship to one another. You can either pour two separate containers or pour one container and divide it into two parts. To do the latter, incise the block all around the separation you want by cutting into it lightly with your chisel. Then hit in a few places with the mallet and chisel and it will slice into two parts.

Your final sculpture will consist of two forms on one base. The techniques and guidelines for carving and finishing are the same as those described throughout this chapter. The goal of integrating forms remains essential, but you are manipulating two separate masses instead of one. You may unintentionally wind up with two or even more forms if something breaks while you are carving. Don't despair if this happens; use the mishap to create the forms in an intriguing relationship, as seen in **figure 10-12**. And if more pieces break, you have more opportunities (**figure 10-13**).

Shadows: Lights and Darks

In carving, the element of shadow (lights and darks) is significant. The shadows created as a result of carving your forms can add strength or accentuate weaknesses in line and design. Note the influence of light and shadow on the sculptures illustrated in **figures 10-5 and 10-6**.

If you are carving properly, you are turning the sculpture frequently to look, select, modify and fully establish your forms. As you do this, observe the highlights that are created. Highlights can be smooth and clear or rough and irregular. In whatever way highlights and shadows develop in your sculpture, make sure that you recognize their impact on your piece.

- **Accentuate highlights where they can add dramatic depth and interest by cutting more sharply and filing to create crisp edges.**
- **Remove sharp highlights that interfere with the contours you want. To do this, round the edges that cause them, or blend one form into another.**

Light and shadow created by the high points and depressions of your carving should be a strong consideration as you work. Later, external lighting and placement of your piece will influence light and shadow, but try now to direct that influence through critical observation and careful carving. The results can be dramatic.

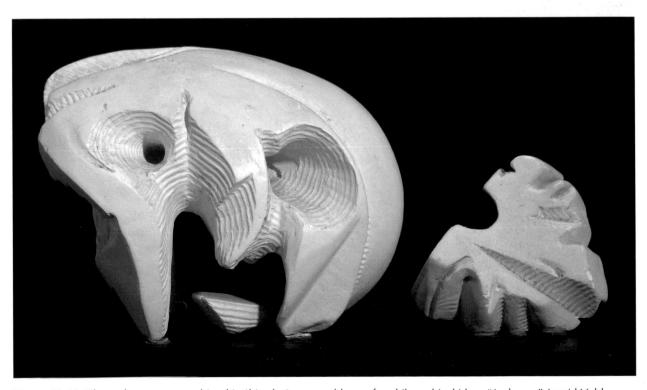

Figure 10-13. Three shapes are combined in this plaster assemblage of a philosophical idea. "Jealousy," Ingrid Vold. Photo by Hernandez.

FINISHING

Let's say that your forms have been reasonably established and you have achieved an overall result that you can live with. It is not perfect, not a pure manifestation of the images floating in your head and it is not the best you can do. But that's what makes artistic motivation so tantalizing: the never-to-be-quite-realized achievement of making the perfect work. Sometimes you might come close to reaching those images — perhaps not often — yet still there will be progress. For every time you explore your creative imagery and produce something of its remarkable originality, something that can be looked upon and touched, you have progressed. You have done something most people never consciously do in their entire lives.

The interplay that has been made between your mind's eye and what appears in the carving is the artistic experience. It is that experience that forms the artistic process, a process that may be the clearest connection it is possible to make between what you do and who you are.

Aesthetic Finishing

Now comes the final refining of your forms. Lumps, scratches, indentations and hollows must be regarded with a brutally critical eye. Do you want them? Are they to remain a part of your finished sculpture? If the answer is "no," or if you regard them as imperfections that detract from your design, you should change them. There are two ways to approach this:

- **File the form, reducing it somewhat in size but keeping the general shape as it is (**figure 10-14**)**
- **Re-carve the form, using the hollows as an impetus for visualizing other, perhaps more exciting forms (**figure 10-15**).**

Frequently, solving finishing problems helps you make aesthetic discoveries. Having to define or crystallize a single form often results in having to change the surrounding forms as well. Then as fresh contrasts emerge in depth, mass, line, texture and shadows you begin to see their impact on the total sculpture and enhance your forms accordingly.

Filing and Sanding the Plaster Carving

Look carefully at your sculpture and decide what is to be filed and sanded and what is not. You may desire a contrast in texture. You might then smooth some areas but allow others to retain the texture of the carving tools, the files or the plaster as it emerged from the container.

For the finishing work on your plaster carving, you will need a metal file and wet/dry Carborundum papers. Use the metal file first. The curved end will allow you to file across both convex and concave forms. All contours of a good metal file are abrasive, not merely the flat ends, so use the tips and edges for hard-to-reach areas.

Understand that you are not smoothing but continuing to model the forms that have been carved with the knife or the mallet and chisel. You may be concerned that the forms will be unnecessarily scratched with the file if you want the final surface to be smooth. But remember that a smooth surface laid over a rough roadbed results in just that: a rough road with a smooth coat. You want clearly defined, solid forms, all chosen by you, not simply settled for. You do not want waves and bumps unless waves and bumps are an integral part of your sculpture. You do not want interference with form, only the form itself. When you use the file, think of form, not surface. A final surface smoothness, if desired, will be accomplished with the wet/dry papers.

Figure 10-14. To remove imperfections such as indentations and hollows, you might file the form (as indicated by the dotted line). This will reduce it in size but retain the essential form.

Figure 10-15. "Imperfections" can also help you to imagine further cuts that may be more effective and stimulate you to carve even more deeply, as indicated by the dotted line.

See **figures 10-6 and 10-12** for examples of well-finished sculptures.

After filing your plaster carving, you are ready to use the black Carborundum papers. Use the coarse grit first and proceed to progressively finer grits as scratches are removed. Wet the paper as you sand; the water keeps the paper from becoming coated with sediment. Tear the paper into manageable-size pieces as you work, bending and folding them as needed to reach all the surfaces. The plaster smooths easily because it is soft; therefore, if you are having difficulty, it is probably because you are using too fine a paper at that particular stage.

When the sculpture is finished and completely dry, you can consider spraying it to protect against fingerprints and dust. Use a clear polyurethane.

Study **figure 10-1** as an example of a finished plaster carving with no abrasions to interfere with the flow of forms.

Filing the Cement & Vermiculite Carving

For finishing the cement & vermiculite carving, you will need a flat chisel and a file that is moderately coarse. Sanding is not recommended since a very smooth texture tends to obliterate the vitality provided by the vermiculite particles and can give the finished piece the appearance of dull and dusty cement. That does not mean the forms should not be fully developed in terms of shape. You will find as you work in the cement & vermiculite medium that modeling the forms with various shaped files often works better than the mallet and chisel to deepen, round and more fully develop the forms emerging from the block. **Figure 10-2** is an example of clearly defined forms obtained by filing the broad shapes made by mallet and chisel.

If negative forms, meaning holes and open spaces, have been carved into the block, be sure to file the inner as well as the outer contours, as in **figure 10-16**.

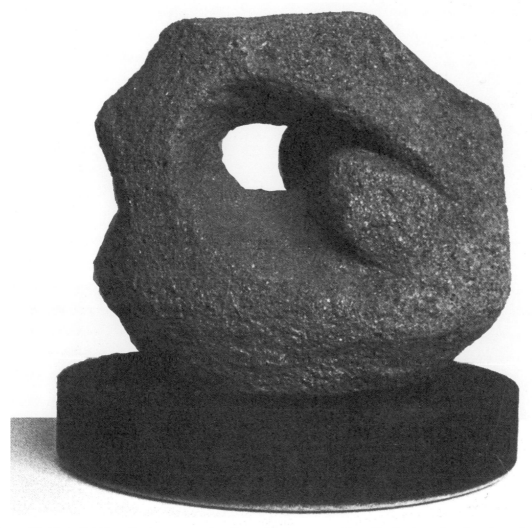

Figure 10-16. In finishing, the inner as well as the outer shapes must be critically viewed and contoured. Michele Nolin, cement & vermiculite. Photo by Vold. Digital enhancement by Csokasi.

The Final Decisions

Whether you work predominately with mallet and chisel or with knife, whether you leave rough cuts in the finished piece or tailor your forms with the file, how much you use the distinctive characteristics of the poured block and how much of it you change, are all a matter of style. Your decisions should be based on what you are striving for and not what you have settled for. Ask yourself this question as you slowly turn your sculpture to critically regard each view of it: *"Is this something I settled for or something I selected?"*

Mounting

Your final decisions in carving, as in every project, will involve mounting your finished piece (or pieces, if you have made two forms in relationship). Both the plaster and the cement & vermiculite sculptures can be drilled with masonry bits. Both materials are soft and not at all brittle; therefore, there is little danger of your sculptures shattering when drilled. A list of materials needed for mounting with suggestions for positioning your piece is found in Chapter 13.

EXTENDING THE PROJECT

Plaster is easy to obtain, transport, prepare and clean up, so it is a good sculptural medium to use in places not particularly designed for art workshops. The projects suggested can be modified to suit the special interests of participants.

Art in Human Service: Shapes, Jewelry, Carving Cups

Shapes

The object of this project is to pour plaster to make shapes, then to see something in the shapes, refine by sanding, paint the shapes, and finally, to mount the shapes on wood or Plexiglas. Materials required are:

- Waxed paper.
- Plaster.
- Coffee stirrers.
- 3-ounce paper cups.
- Sandpaper (medium grit).
- Watercolors and small paintbrush.
- Shellac and alcohol (optional).
- A nail for making holes.
- Wooden base (optional).
- A plastic bowl (3-quart size or smaller, depending on the number of participants).
- Five-minute quick-setting epoxy resin (or white glue, if resin presents a problem).

Process

The process for creating shapes, jewelry and carving cups is essentially the same.

1. Spread sheets of waxed paper on a smooth table surface, one for each participant.

2. Mix plaster in a plastic bowl according to instructions provided previously.

3. After stirring, pour quickly into paper cups. Each participant is given a cup containing the liquid plaster.

4. Squeeze the cup slightly to form a spout. Wait a few minutes for plaster to thicken slightly.

5. Pour shapes onto the waxed paper. Avoid very thin shapes or "tails," as these will break off. Instead, manipulate the plaster into shapes with substantial body. Use the coffee stirrers to push the plaster around. This will be easier as the plaster begins to set but do not manipulate after the plaster sets (approximately five minutes).

6. When hard (approximately twenty minutes), select the plaster shapes you like. Peel them off the waxed paper and refine them with sandpaper.

7. Paint the shapes for further definition. For example, a simple circle can become a face, a plate of food, an animal or anything else with circular form.

8. Mixing shellac and alcohol in equal parts makes a slightly glossy antique finish, which also provides protection against dust if you want to leave the pieces unpainted.

9. Glue the shapes onto a piece of wood prepared with wire and screw eyes for hanging.

Jewelry

The materials are the same as for "Shapes." Add pin backs or leather cord.

The procedure: When the plaster shape is almost set, bore a nail hole. After finishing, string a leather cord through the hole to serve as a chain or glue a pin back on the shape.

Carving Cups

The materials are the same as for "Shapes." Add a paring knife.

Procedure: Prepare the project for "Shapes." Have extra cups to fill in case there is leftover plaster. Pour the plaster into cups and let it harden. When it has set (about twenty minutes) and you are ready to carve, peel the cup back and carve the block with a paring knife. While carving, always keep your hands behind the knife, not in front of it, even when you are tempted to do so in the throes of creativity. Use your sand bag or a clump of rags to keep the cup steady or hold it with only one hand and carve away from that hand with the other.

For variation, fill only the bottom of the cups to form round shapes, then combine these to make relief compositions; or bore a nail hole, then incise the sculpture decoratively with any pointed instrument to make hanging pendants.

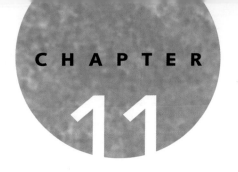

CHAPTER

11

1 DAY

SAND SCULPTURE

THE sand sculpture project is a trip in both the literal and colloquial sense of the word. It is a fun-filled excursion out of the classroom or studio to a location where sand resides. That could be on a vast natural beach bordering a lake or ocean, or at a man-made community pool with seasonally-imported sand. For a school group, the project is best done just before the community beach opens to the public — usually Memorial Day weekend in May — or just after it closes on Labor Day, as long as sand and water are still there.

Another benefit of learning the project may come long after the sculptures are made. Most students will vacation on a beach at some time, and familiarity with creating sand sculptures can provide life-long pleasure, plus a unique way to meet new people as on-lookers ask to pitch in.

Figure 11-1. A student group project nears completion beside a community pool. Melissa Bartley, Andrea Ortega, Jackie Condura. Photo by Peck.

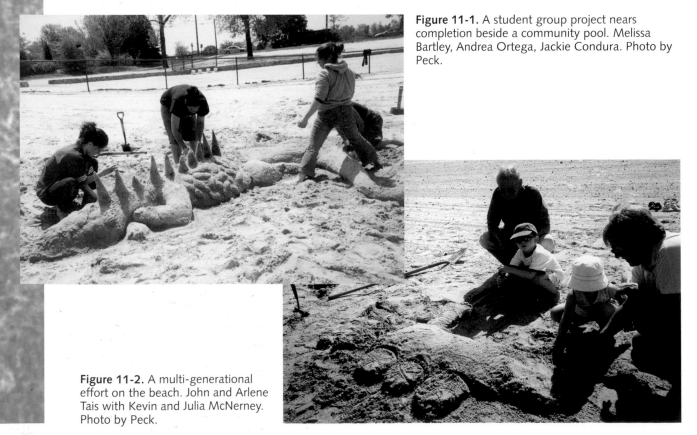

Figure 11-2. A multi-generational effort on the beach. John and Arlene Tais with Kevin and Julia McNerney. Photo by Peck.

THE NATURE OF THE PROJECT

The best rationale for a sand sculpture excursion is the limitless amount of material available for creative use. This fact alone might make the effort of arrangements and transportation worthwhile. While both material and space limit the creation of large sculptures in a school or studio, the sand sculpture project enjoys an expanse of both. Sand is plentiful, pliable and ready for use. All it needs is water to keep it moist. Of course, the end-product will be washed away unceremoniously by the tide or meet the fate of a bulldozer if not trampled upon first by scurrying feet. But photographing the work is part of the process to retain the end product of the experience and the memories (**figure 11-3**).

Although sand sculptures can be created individually, there are advantages to working in a small group. Three or four people working together makes the process of collecting the sand for a large work easier, and since there are usually time limitations, it's a good idea to have multiple hands to work all sides of a large piece. In addition, the act of sharing ideas and aesthetic concepts is a good thing. In visual arts, as opposed to the performing arts of theatre, dance and music, artists and students rarely get the opportunity to work collegially for a single creative outcome.

Recently, sand sculpture has become a major competitive event. In California, Florida, Hawaii and in other parts of the world, major sand sculpture competitions are held and artists travel from place to place to compete for prizes. Knowing that their creations will be smashed — sometimes blown up purposefully as part of the excitement — one has to give credit to the artists for putting so much hard physical and aesthetic work into the project. To view some spectacular sand sculptures created in these competitions, search "sand sculpture competitions" on the Internet. The artists competing are often professional sand sculptors who enter such competitions for a living, but seeing the work produced offers you the range of possibility.

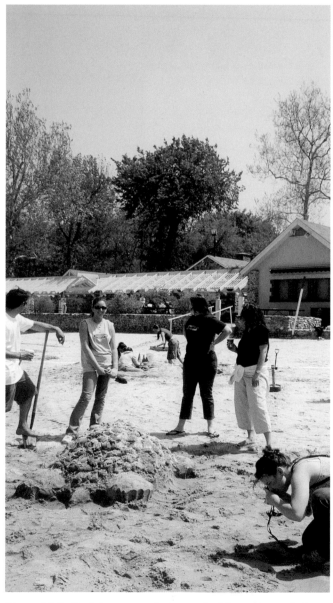

Figure 11-3. Sculptures are photographed from above, below or sideways for the best view. Ana Oliveira taking photo. Photo by Peck.

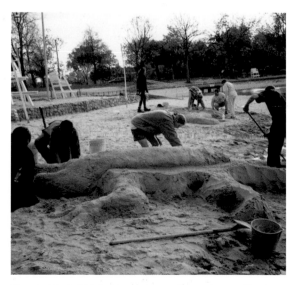

Figure 11-4. Students work as a team, some digging and some applying water, each working different parts of the sculpture. Photo by Peck.

CHECKLIST OF TOOLS AND MATERIALS

The Basic Medium

Sand, either available year-round on a beach or imported for seasonal use, is the basic medium. Because water is needed to make the sand pliable, it must be situated nearby; thus the location you choose for building the sculptures must not only be close to water but accessible, meaning no walls or rocky terrain interfering.

Pails and shovels comprise the essential tools, but there are several variations of each. You will need:

- A pail with handle for carrying water or sand; a pail can also be used to shovel sand onto your emerging form (not shown).

- A common digging shovel or spade for piling up sand.
- A gardening spade or similar hand tool to shape the sculptures.
- A watering can or spray bottle for wetting parts of the sculpture that are drying and flaking.
- A hoe for edging the completed sculpture.
- A flat paddle or small wood plank to solidify forms (not shown).
- A camera for photographing finished work (not shown).
- A folding 4-foot ladder to photograph the sculpture from a height, if desired (optional, not shown).

Figure 11-5. Tools and Materials for sand sculpture. Photo by Hernandez.

PREPARATION

Find a suitable location to build the sculptures according to these elements:

- Sand should be relatively free of debris such as pebbles, seaweed or man-made litter. Test the sand depth with a shovel; if it is too shallow for digging, you will need to pile up more sand as you form the sculpture.
- The water source should be reasonably close. Don't position the sculpture too near the water's edge where waves could demolish it before its time or make the sand too wet. Your site should be close enough to transport water easily, unimpeded by rocks, walls or steps.
- In a large group project, sites for each sculpture should be distant enough from others to provide room to work, to expand the size of the pieces and to walk around them. Sites should still be within one general area, however, so that other sculptures can be visited and tools shared if needed (figure 11-6).
- Create groups of 3 to 5 individuals, depending on the size of the total group and the space available to work.
- Each group selects its specific site.

Figure 11-6. Sculpture sites should be chosen near one another but with plenty of room around each to expand the sculpture. Richard Jacobson and Anthony Giudice. Photo by Peck.

PROCEDURE

1. You may or may not decide on an image to create as your first step. You may get your ideas as you pile up the sand.

2. Using a large shovel, bring sand to the site and build up a substantial mound of sand. You are simply gathering material for use, similar to your initial step of gathering clay or wire or found objects.

3. As the mound rises or spreads out, start to visualize a form. Your sculpture can be either figurative or abstract.

4. The sculpture will be a relief of necessity, but it can be a high relief. Think BIG. Animals of both land and sea come to mind, but figures lying prone or supported by sand-constructed "pillows" could work, as could flowers, bugs, monsters or whatever. Don't be afraid to be bold and adventurous. Sculptures do not have to be realistic; fantasy works just fine.

5. Individuals in the group might want to take on specific tasks — one gathering sand, another hauling water, and another packing the sand down on the form. Then as the sculpture becomes more fully realized, individuals will probably work on specific parts as seen in **figure 11-4**.

6. Keep aesthetics in mind as you work, remembering the formal components of sculpture. The more planes you can establish, the more concrete the form.

7. Keep the elements of light and shadow in mind as the forms emerge. Sand is a dull gray, so the deep carving, shaping and edging of forms is necessary to cast shadows that will dramatize the piece.

8. Crystallize your forms — that is, paddle them down compactly so that each form is fully realized. This must be done often and well.

9. Dampen forms that are drying as you go. Sand will dry at different rates, depending on its nature, the size and height of your sculpture, the time it takes to create it and of course, the weather.

Figure 11-7. Be adventurous. You have all the free material you need to unleash creative fantasy. Photo by Peck.

Fig 11-8. Make each of your forms as compact as you can. You will probably need to do this often. Use your paddle or wood plank as well as your hands. Note also how an edge or platform created around the form increases shadows. Natalie Megaro. Photo by Hernandez.

10. Don't be disheartened if forms collapse. They will build up the second time more rapidly as you increase your proficiency. It's a good idea, however, to take a picture of the piece at a point of near completion, just in case a collapse occurs when time has run out to reconstruct it.

11. Work all around your piece, seeing it and modeling it from all sides.

12. When you are near to finishing, make a sharp edge all around your image with the hoe. This will create the shadows that set your sculpture off from the surrounding sand and allow it to photograph dramatically (**figure 11-9**).

13. Sometimes, the sculpture will be set off well if a frame is cut out around it, as illustrated in **figure 11-12**. You can use the hoe to do this. Your object is to use the effects of light and shadow to counter the rather dull visual effects of light gray sand.

14. Photograph the piece. Depending on the image, you may want to take several photos with various views. A picture from a high perch looking down is a good idea if you can manage it. You might use a ladder or the shoulders of a strong and willing volunteer.

15. Make time to view all the other sculptures, either individually or in a group critique.

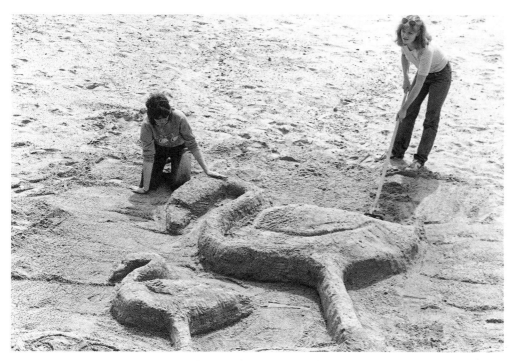

Figure 11-9. One student cuts and shapes a strong edge around the sculpture to set it off from the surrounding sand as another student compacts the shapes. Photo by Peck.

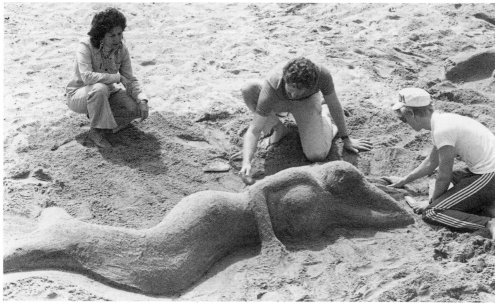

Figure 11-10. "Mermaid," Judith Peck, Paul Barbier, Rick Jerothe. Photo by Vold.

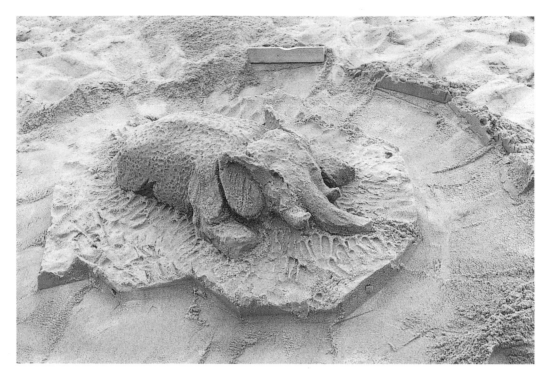

Figure 11-11.

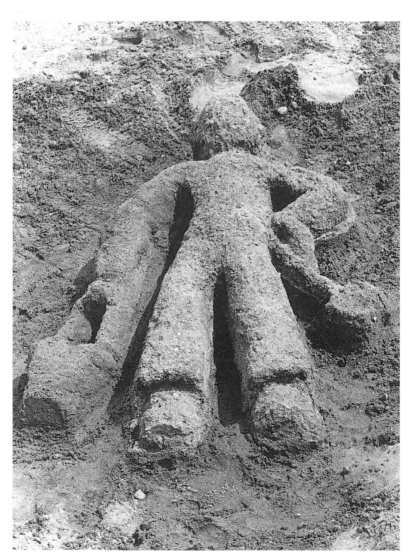

Figure 11-12.

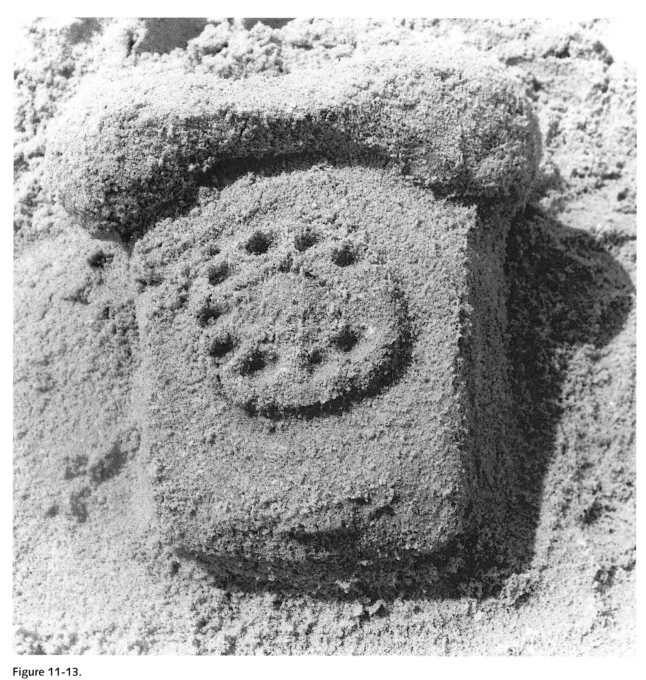

Figure 11-13.

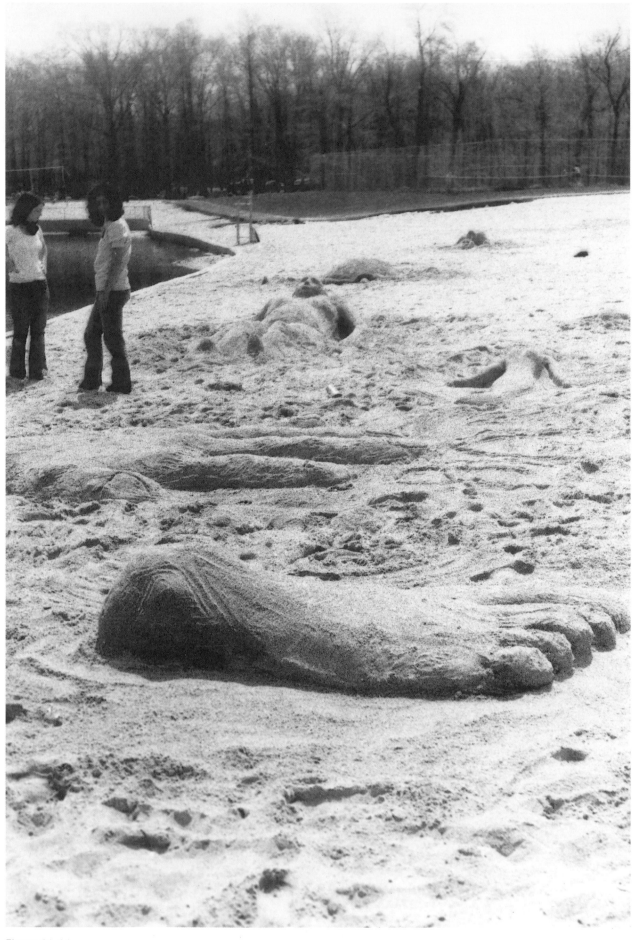

Figure 11-14.

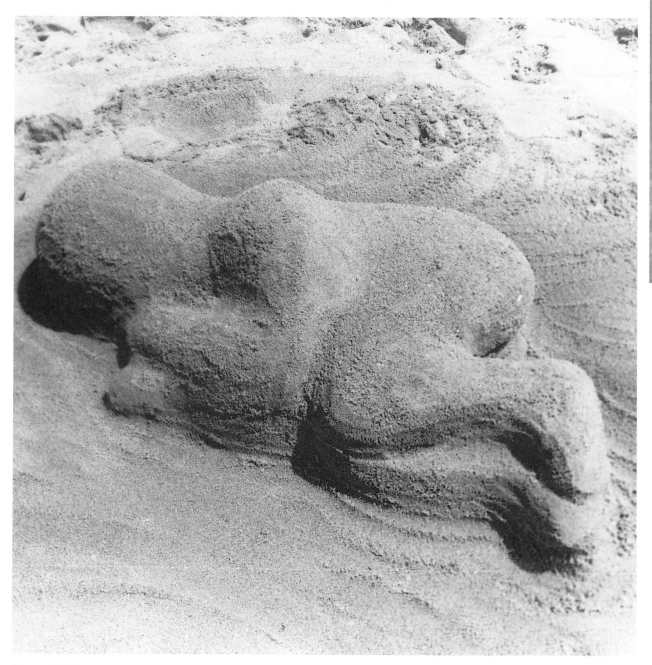

Figure 11-15.

Figures 11-11 — 16. The theme and style of your conception for a sculpture in sand is limited only by your vision and your energy. Photos by Peck.

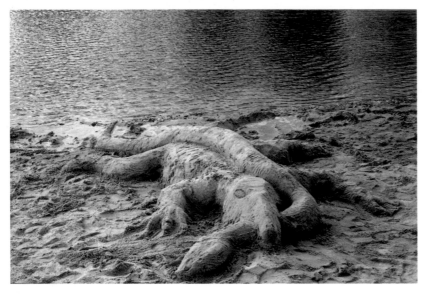

Figure 11-16.

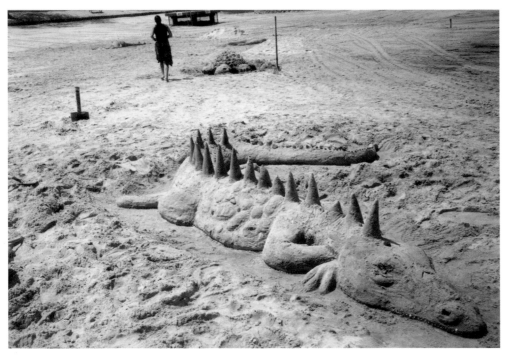

Figure 11-17. Sharp edges around the finished sculpture will catch shadows and set it off from the surrounding sand. Photo by Peck.

Glance at the diverse illustrations of sand sculptures pictured in this chapter to get a sense of the variety of themes, sizes and sculptures to be made out of the vast medium at your fingertips. And, of course, view on the Internet, compositions created for competitions. Still, don't think such creations can be made under your same circumstances. Just enjoy!

EXTENDING THE PROJECT
Sand Casting

Sand casting can be done in the classroom or home studio. The finished piece is most often a sculpture in high relief, although it could be free-standing with extra work. The process takes some getting used to, as you are working by visualizing negative space (what is carved out) rather than positive space (what you see on the surface). In this project, sand is not the finished material; it is used as a mold for a plaster of Paris cast.

Preparation

Pour play sand into a rectangular plastic container or cardboard box lined with plastic material. Play sand comes in bags and can be purchased from a lumber yard or home improvement store.

- The length and width of the container will determine the approximate size of the finished sculpture.
- The amount of sand in the container will depend on how thick you want the finished sculpture to be. You might start with a depth of anywhere from 4" to 8" for a first piece.
- Dampen and flatten the sand.

Process

Using the wooden blade of a clay tool, carve into the surface of your flat, wet container to create various grooves, hollows and negative shapes.

- You are working in the negative, meaning that what is carved into the sand is what will emerge as the sculpture after plaster is poured and hardened.
- Make sure the negative carvings connect in some way, so that plaster can run between them.
- Compact your forms as they are carved. Use a flat wooden tool or paddle to press the forms tightly.
- When all the spaces and grooves are carved to your liking and planes and edges are firmly compacted, mix plaster using the technique described in Chapter 10, Carving in Plaster and Cement & Vermiculite.
- Pour plaster, filling all the hollows, grooves and negative shapes.
- Let the plaster run over the top of the sand for an inch or two, as this will provide a base for the relief.
- Allow the plaster to harden overnight.
- Remove the plaster cast. You will see that some sand has stuck to the plaster. Although you will remove loose sand, some will remain embedded. This adds texture and color to the sculpture and is to be expected.

Figure 11-18. A sand-cast relief sculpture. Photo by Peck.

Sand Sculpture on the Beach

If you are lucky enough to vacation on the beach, you might try rising earlier than usual one morning when the tide has made the sand on the shore line perfect for modeling. You might begin creating a figure all alone or with a friend, but chances are one or two people will start to watch, and don't be surprised if someone asks to help. Sand sculpture in public is a lovely way to meet people who enjoy watching art emerge right before their eyes. You may even be introducing them to sculptural media for the first time.

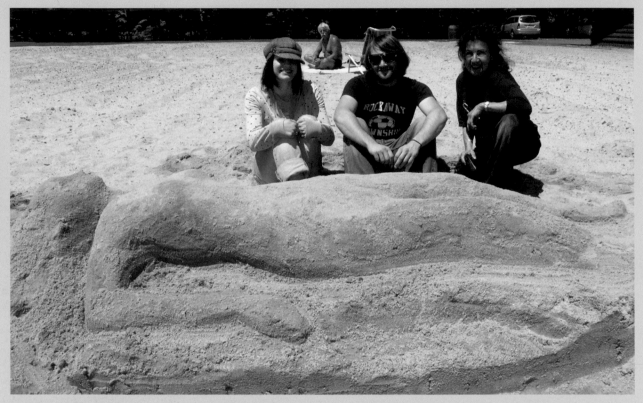

Figure 11-19. A sun bather observes a finished figure in the sand... Natalie Megaro, Dan Rosol and Judith Peck; sunbather, Philip Schauer.

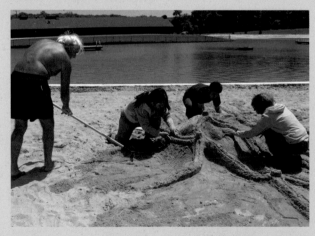

Figure 11-20. ... and can't resist helping another group create the Great Wall of China. Philip Schauer, Elaine Zhang, Xiang Ye, Carole Finklestein. Photos by Hernandez.

The sharing of work and ideas in any setting and situation provides an added plus to the project.

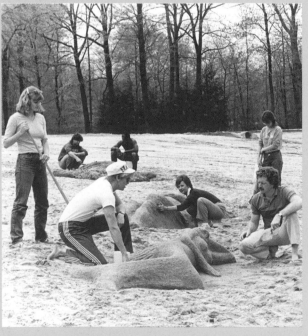

Figure 11-21. Combining talents and energy by forming sculptures in the sand seems more like play than work. Rick Jereothe, Judith Lafiura, Paul Barbier.

PROJECT PRESERVATION AND PATINA

VARIOUS ways to put a protective coat on unfired clay when no kiln is available and on sculptures formed of clay or wax that are not to be cast are offered in this chapter. Specific materials for coating sculptures are described, including Pariscraft, a trade name for gauze impregnated with plaster, and various plastic resins. None, it should be noted, are as satisfactory as firing or casting for providing permanence while maintaining the surface integrity of the work, but each might serve as an alternative to leaving your sculpture in its vulnerable state. (See Appendices to find product accessibility.)

Later in the chapter, methods are suggested for coloring or applying patina to finished pieces. Patina usually connotes a kind of naturally-occurring coloration, as in the green color produced by oxidation in bronze.

PRESERVING UNFIRED CLAY AND WAX

An Overview

Earth clay (water based) is essentially dried mud. Water-based clay must be kiln fired to be preserved. Plastiline (also called plasticine) is an oil-based clay that remains forever soft. It must be cast to be preserved (see Appendices for resources on casting).

All products described, except when covering oil-based clay, must be applied to bone dry work. This means your piece should have no moisture. Since you will not be firing the clay, your piece need not be hollowed. The products work well if bisque firing is an option (a first firing before glazing), so keep that in mind as well.

Wax sculptures are equally vulnerable to collapse. The customary method of preservation is casting in metal, particularly bronze, but also in other materials such as various plastics. Casts in clear Plexiglas have become popular, enhancing the flat, smooth nature of wax sheets. However, because casting in any material is labor intensive and generally expensive laminating might be considered.

Wax, like dry earthenware clay or oil-based clay, can take lamination with Pariscraft or resins if applied properly.

Materials

Materials for coating clay and wax will vary according to what you plan to do. **Figure 12-1** illustrates some basic tools and supplies but you are advised to read all the information supplied before you plunge in. Make sure everything is on hand at the start because setting time does not wait while you run for a forgotten necessity — especially if you are wearing gloves covered with resin and have no way to grab the handle of a door to the room where your forgotten scissors or wood sticks are.

Laminating Choices:

- **Pariscraft, or gauze impregnated with plaster**
- **Resins: Epoxy or polyester**
- **Metals in powder form (aluminum, bronze, iron, etc.)**
- **Autobody filler**
- **Polyurethane**

If you are using Pariscraft and over that applying acrylic paint, you are preserving the sculpture adequately because acrylic paint hardens and waterproofs. The Pariscraft strips are flexible when wet and will adhere to many materials. It is non-toxic, easily applied and easily cleaned up, so it is recommended for group situations.

Similarly, polyurethane, which comes ready-to-go in a can, is easy to apply and affords some protection. Although intended for wood surfaces, it can also be applied to dry clay and even to wax. After dry, it will not prevent your wax from bending, but it will help the sculpture survive. Polyurethane should be applied in a well-ventilated area and the sculpture set aside to dry where no one will breathe in the vapors.

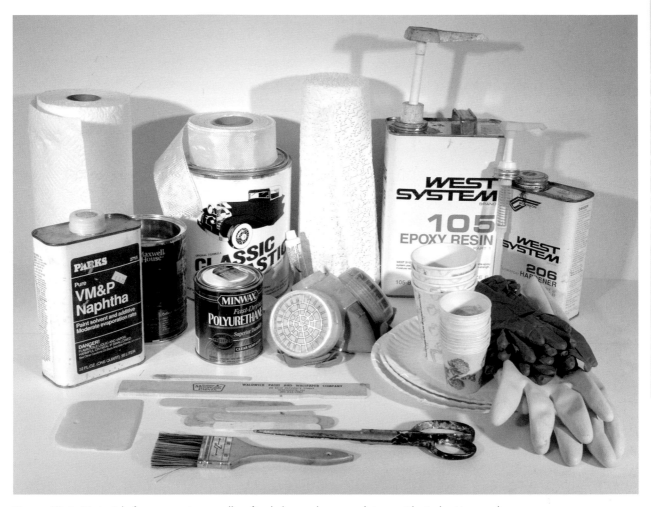

Figure 12-1. Materials for preserving small unfired clay and wax sculptures. Photo by Hernandez.

Here is an overall list of materials from which to choose for coating your sculptures:

- Resin: epoxy resin is preferable to polyester resin.
- Hardener for selected resin.
- Scissors.
- Craft mixing sticks, at least 12 per project.
- Paint stirring sticks, at least four.
- Paper mixing cups: 3-ounce plus 8- or 9-ounce, and paper plates (not plastic or plastic-coated).
- Newspapers (not shown).
- Box of disposable gloves, or 12 at minimum (not shown).
- Rubber household gloves, two pairs.
- Folding table or work table.
- Epoxy resin and hardener dispensers (optional, not shown).
- Autobody filler and hardener.
- Pariscraft rolls.
- Container for dipping Pariscraft strips in water.
- Polyurethane.
- Fiberglass rolls if needed, 1" or 2".
- Respirator mask.
- Protective eyewear (not shown).

PARISCRAFT

Pariscraft is dry, plaster-saturated gauze, packaged in rolls to be cut into strips as needed. You are familiar with Pariscraft from your work in Chapter 7, The Figure in Foil and Pariscraft.

Process

1. Apply the material to well-constructed, fairly smooth wax or bone-dry clay, unless you are using it on plastiline, which is oil-based and does not dry. Pariscraft adheres to many surfaces. You can experiment and apply it to cardboard or various found objects as well.

2. For covering small clay sculptures use strips about ¾" wide by 10" long.

3. Dip the strips lightly in a can of water and apply one at a time around the form.

4. Cover the whole sculpture. One layer is usually sufficient to create a firm surface. You can add more layers but this adds bulk and will alter the forms.

5. Control the application of strips so that unintentional lumps do not appear.

6. As in your earlier work, you might try using Pariscraft directly in various places to create artifacts or costuming and hair. You may need some support for forms without an existing structure.

7. Pariscraft begins to dry in about twenty minutes. Wait at least a few hours until it is completely dry before painting or adding resin.

PLASTIC RESINS

There are various types of plastic resins. Referred to in this text are:

- **Epoxy resin and polyester resin; both are liquid resins mixed with hardeners according to specific directions on the containers. Resins can be thickened with fillers.**
- **Autobody filler, a paste to which hardener is applied (trade name, "Bondo" sometimes used); a thicker resin which sets very quickly.**

All resins must be applied in a well-ventilated room. In addition, wear rubber or disposable plastic gloves. Even better, wear disposable plastic gloves over rubber gloves, discarding the plastic gloves after each application of resin. Protective eyeware should be used. If extensive work is planned, you will also need a respirator mask. See Appendices for locations for these products and safety materials connected with resins.

Benefits and Risks of Using Resins

The resins are remarkable additions to the armamentarium of sculpture making. In situations where firing and/or casting are not easily available, there is nothing quite like them for making impermanent materials more durable than they would be standing exposed to time and the elements. But there are several restrictions to note.

The main restriction regarding all resins is that resins mixed with hardener have an element of toxicity, especially while they are hardening. There are three ways toxic systems can enter one's system: through the inhalation of vapor, through contact with the skin, and through imbibing (drinking or eating). Of course, you don't plan on tasting the brew, but food or drink around your work station could accidentally make this contact as you touch your hands or glove to a glass, cup or utensil. So make sure you do not have food or drink around until you are away from your work station and completely washed up.

To avoid harmful vapor you should not sit or stand over your work or resin containers while the resin is setting. To avoid skin contact at any time, wear long sleeves, long pants and plastic gloves while setting up, working and cleaning up.

Finally, you should recognize that simple coating with resins, although better than nothing, is not as durable alone as when fiberglass is used in addition. Using fiberglass requires a special set-up for safety reasons and should not be done in a classroom or in a room at home used in daily residence. See the latter section of this chapter for using fiberglass.

Resins must be used with concern for potential health risks and thus precautions in preparation, application and clean-up must be strictly applied. Lamination with liquid resins is therefore not recommended for the regular classroom situation where the number of students involved might not allow for such control. Most schools, in any case, do have kilns, so firing clay sculptures will not be a problem.

Pariscraft, on the other hand, is non-toxic and can provide a protective coating, particularly when covered with clear acrylic or acrylic paint. Autobody filler (described below), though still toxic, is easier to work with and control than the liquid resins.

Preparation

Make sure you prepare yourself and your working station before using resins.

- **Keep outer working clothes separated from other clothes when working with plastics to avoid transporting vapors, liquids or glass strands either through the air or in a washing machine.**
- **Prepare your working table outdoors or in a room with excellent ventilation.**
- **Cover your working table with paper; newspaper is fine.**
- **Have a dozen or so pairs of plastic gloves ready. Do not touch any of the resins without wearing gloves and long sleeves that reach to the gloves. This precaution applies throughout the preparation, application and clean-up processes.**
- **Have all your materials on hand and situated on the side of your work table: scissors, mixing sticks, paper mixing cups, paper plates, fiberglass, etc. as needed for the project.**

METAL FILLERS

Some metals in powder form, such as aluminum, bronze and iron, are pre-mixed in resins and available in sculpture supply stores. They are applied directly from the container and do not require hardener. Apply the product in a thin layer with a thin-bladed tool. Allow this to air dry before adding other layers. This will change the texture of your sculpture but will produce a hard, waterproof surface.

Metal powders and fillers can be added to resins directly, with hardener added after mixing, and the process for this is described below. Again, work in a well-ventilated area. You may want to work on another project while laminating, so that you do not become impatient waiting for layers to dry.

Figure 12-2 illustrates a foil figure covered first with Pariscraft, then coated with aluminum powder embedded in epoxy resin. The finish is achieved with black Kiwi paste wax.

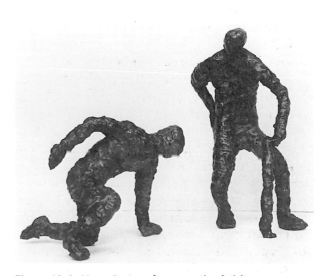

Figure 12-2. Here, Pariscraft covers the foil figure in the method given in Chapter 7, but aluminum powder embedded in resin has been applied over the Pariscraft, giving the figures more solidity. Theodora Zacker. Photo by Vold. Digital enhancement by Csokasi.

141

EPOXY AND POLYESTER RESINS

Epoxy resin mixed with hardener will create a coating that is hard, waterproof and reasonably durable. The mix is one part hardener to five parts epoxy, but if you plan to use epoxy for more than one or two pieces, it is advisable to buy the two dispensers which, when inserted into separate cans of resin and hardener, will dispense exactly the right proportions. All of these materials and related products can be purchased in quart or ½ gallon containers at boat supply stores. A good type of epoxy to use for sculpture is Epoxy 105 B from West Products with 206 hardener, which is slower curing than 205. It is best used at temperatures from 60 to 75 degrees.

Polyester resin is similar to epoxy in its effectiveness, but it has some severe drawbacks for studio use. For one, it has a sharp and disturbing odor. Epoxy has an odor, but it is significantly less intrusive. For another, the hardener used for polyester resin is methyl ethyl ketone peroxide, a particularly bad skin and eye irritant if such contact is made. Epoxy has its own skin and eye irritants, in the form of a mixture of polyamines, so the same precautions must be observed when using either resin.

The ratio of hardener to polyester resin is 12 drops per ounce. Using 3-ounce cups gives you a head start on making accurate measurements. Curing should also be done at warm temperatures. Only paper cups, not plastic, should be used for both epoxy and polyester resins, due to the heat generated when curing. Interestingly, mixed polyester resin will eat Styrofoam, whereas the epoxy mix will not. This probably has more to do with the different chemical nature of each rather than the degree of toxicity.

Another drawback to using polyester resin is in the clean-up. Before it hardens, epoxy resin can be cleaned with warm water (with the protection of gloves, of course); polyester resin clean-up requires acetone, a rather harsh solvent (also, or course, with gloves).

Epoxy resin has a slightly amber color when dry, whereas polyester resin dries clear. Left outdoors, however, depending on the climate, polyester resin may gradually yellow.

Except for mixing proportions and clean-up methods, the application procedures for both types of resin are largely the same.

Process

1. Triple-check to see that all your preparations are made, as above.

2. Thoroughly read the directions on the container.

3. Pour the resin into a disposable paper container.

4. Add the hardener according to directions. If you use a store-bought 3-ounce cup while using polyester resin, you will know how many hardener drops to use because the measure is 12 drops per ounce. For epoxy resin, the amount of hardener is 5 parts resin to 1 part hardener if not using automatic dispensers (highly recommended).

5. Apply only one side at a time because the resin is fluid and will run. You are working with the law of gravity, so wait until one side has set before doing another or you will have a mess to deal with.

6. If you wish, bronze or other metals in powder form can be added to resin to create a natural patina in the finished piece. Mix the powder into the resin, then add the prescribed amount of hardener, stirring well but quickly.

7. There is limited time (which you will find out only when working) for using the material before it becomes hard; therefore, mix only a small batch at a time. Remember to move away from the container and your sculpture during the few minutes that setting is occurring to avoid inhalation of fumes.

8. After material is applied and dry, try creating a contrast between the metallic surface and the darker crevices. On an aluminum finish, mix black Kiwi shoe paste with a bit of turpentine and brush on; on bronze, use brown. When the wax dries, buff with the flat of a spoon.

AUTOBODY FILLER

Another type of plastic resin which is thicker and requires neither added filler nor fiberglass cloth is autobody filler. In **figures 12-3 and 12-4**, wax is coated with autobody filler.

Autobody filler is a plastic resin used to repair dents in automobiles. It is available in auto supply stores and body shops. It is not as pleasant to use as Pariscraft, for example, because it emits strong vapors (though less so than polyester or epoxy resin). It is thick and doesn't drip as much as the liquid resins. You must still work in a well-ventilated area and wear disposable gloves. Autobody filler contains benzoyl peroxide, and it is also a skin and eye irritant on contact. The product is used with a cream hardener rather than liquid, and it produces a hard, durable finish that can be ground smooth with hand files or left roughly textured.

The hardener determines the color of the resin; at present, there are two choices: blue and red. The signature problem with autobody filler is its quick drying properties. Mix a very small amount at a time (a mound no bigger than a doughnut), and be precise in the application of hardener. One thin line of hardener spread from the tube across the center of the mound is just about right. This must be mixed through the autobody filler completely, but be quick! You might have no more than two minutes to apply the mix before it hardens. To use autobody filler, follow these procedures:

Process

1. Prepare your clothes, space and materials as for working with the other resins described above. Wear your disposable gloves.

2. Work on a clean, flat, portable, disposable board; any material will do. Over that, place the paper plate on which you will mix the product.

3. Remove one wooden paint stirrer-full of filler from the can (a mound approximately 3" wide), and place it on your paper plate. You can also use a spatula. Close the lid of the can.

4. Scrape the filler off the spatula or stick, and place the stick on the can for dispensing the next batch. Make sure it does not have any hardener on it.

5. Squeeze a thin ribbon of cream hardener across the diameter of your mound. Mix well but quickly by folding the hardener into the resin and dissolving it.

6. Using a flat blade, a small flexible applicator, a plastic knife or a wooden craft stick, apply the mix, swirling or daubing to obtain the texture you want as you apply it. Plastic knives have serrated edges which may present a problem unless you use the flat side.

7. You must experiment to see how much time you have to work before the mix hardens, sometimes one or two minutes only, depending on the size of the mound, the amount of hardener and the temperature. Use small amounts until you determine this.

8. Repeat the processes until the sculpture is laminated. One layer of resin is sufficient.

Working with Resins: Important Notes

- Hardener is added to resin, not vice versa.
- If filler of any kind is used, mix it well into the resin before adding hardener. You may need time to add more metal or filler for your desired texture, so adding hardener last gives you more time.
- Do not increase the ratio of hardener to resin.
- You can no longer apply a mix that begins to set. This is both ineffective and dangerous, as you want to stand clear of both the fumes and the touch of setting resin.
- Do not use plastic cups with resins because they will melt and disintegrate whole hardening. Use only paper cups and paper plates.
- 3-ounce paper cups are good for mixing polyurethane; use 8- or 9-ounce paper or cardboard cups for epoxy and dinner-size paper plates for autobody filler.
- Never place a tool that has the slightest bit of hardener on it back in the main container, as it will eventually cause the whole container to harden. Keep lots of wooden craft sticks at your work station, and discard each after using it to stir and apply the mix. The filler without hardener won't set, so you can reuse the tool that dispenses filler from the main container.
- Avoid buildups that will make the underlying forms cumbersome or unclear.
- Avoid drips and use a well-made brush when applying liquid resin, as falling bristles are a nuisance.
- Always wear gloves from preparation through application to clean-up; discard and change often.

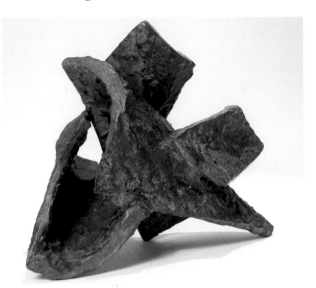

Figure 12-3. Karen Sherman. Photo by Vold. Digital enhancement by Csokasi.

Figures 12-3 and 12-4. These sculptures were created in wax and then coated with autobody filler.

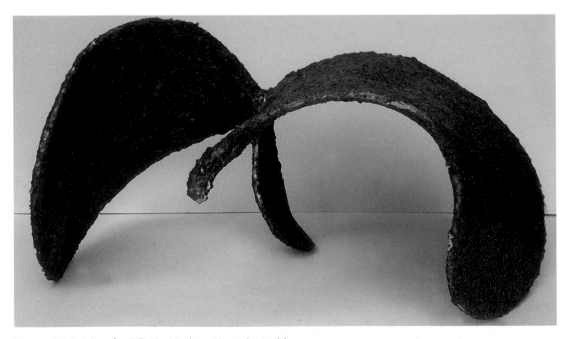

Figure 12-4. "Condor," Peter Nirchio. Photo by Vold.

USING FIBERGLASS WITH RESINS

Coating Sculptures with Fiberglass and Resin

For additional strength or if a larger project is underway, particularly one destined for outdoors, you can apply plastic resins to cut strips of fiberglass. Fiberglass is a cloth; it comes in many different textures. You are probably familiar with the most common form, a white, tightly netted material.

Rolls of fiberglass can be bought from 1" to 12" in width. Fiberglass can also be purchased by the yard in varying sizes. The yard goods, however, tend to ravel in cutting; therefore, rolls are suggested for coating sculptures.

Use fiberglass and resin to coat clay, wax or other suitable sculptures. The texture of finished wax pieces should be relatively smooth for coated fiberglass to adhere.

Follow the preparations and processes offered below for coating and finishing your sculptures.

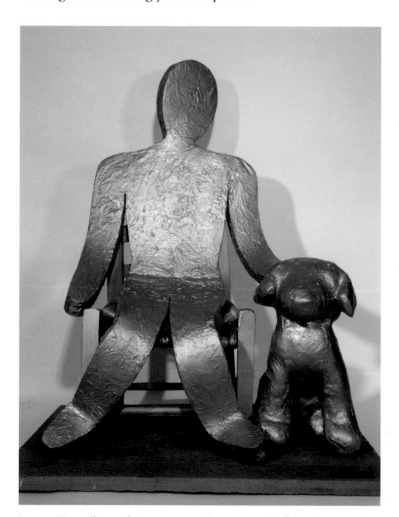

Figure 12-5. This sculpture composition was created with modified found objects using fiberglass and epoxy resin embedded with bronze powders, then sprayed with bronze-colored enamel. "Boy with Dog," 30" x 23.5" x 17" Judith Peck. Photo by Hernandez.

Process

1. Prepare your work space and don plastic gloves as described previously.

2. Use scissors to cut as many lengths of the fiberglass as you think you will need before mixing the resin. Lay them out on the table.

3. After mixing the resin as described previously, layer it with a craft stick onto the fiberglass strips. You can lay one strip over the other to absorb the resin.

4. Wrap the resin-coated fiberglass over the clay or wax form in a single layer.

5. When dry (wait at least overnight) or when the surface is hard, not tacky, file rough edges with a metal rasp.

Cleanup

- If you use epoxy resin and if you clean up immediately after working, your tools and your hands, still covered with gloves, can be washed in warm water. Otherwise, use acetone.
- Polyester resin requires acetone for cleanup.
- Always continue to use the rubber or disposable gloves during cleanup if either product is used.
- Wash your hands thoroughly with soap and warm water after working and during work if your skin comes in contact with the chemicals. Wash again with soap and water after your gloves have been removed.
- Always read the labels on the containers and observe full protective procedures.

PATINATION (COLORING)

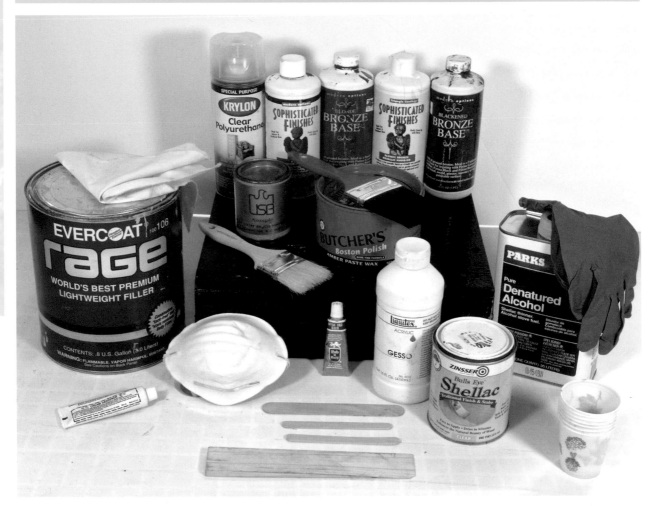

Figure 12-6. Selected product and material choices for patina. Photo by Hernandez.

Patina is different than painting to acquire color. Patina usually refers to the oxidizing process in bronze, a natural aging that adds tones of green to the metal. But the term applied to sculpture goes further; it applies to enhancing a fired clay sculpture, for example, by simulating wood or bronze or iron or even marble by creating tones with pigments, solvents and waxes. Patination is a creative process.

If your sculpture has been fired conventionally, it will emerge from the kiln a different color than before, due to the chemical changes that took place during the extreme heat of firing. That color will depend on the kind of clay used. You can then leave it or apply a patina.

Sealing the Sculpture

The first step in applying a patina is to seal the sculpture. This is done so that the very porous clay does not absorb the patina when it is applied. A mix of shellac and alcohol in equal parts seals the clay sculpture nicely and gives white sculpture an amber tone, which you might like as is. If you are planning to simulate bronze as your patina, you might add some dark green pigment in powder form to the shellac and alcohol mix. It will stay in the crevices when you add the bronze coloration. All sculptures should be sealed first before adding coloration. Other types of sealants are available in art supply stores.

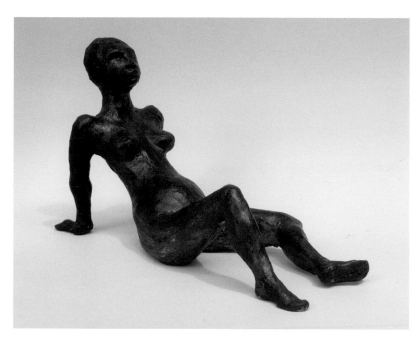

Figure 12-7. This reclining figure was first sealed with a mix of shellac and alcohol into which green powder was mixed to give the effect of bronze oxidation. Bronze mixed into a solvent was then added, followed by daubs of bronze powder mixed with paste wax for highlights. Natalie Megaro. Photo by Hernandez.

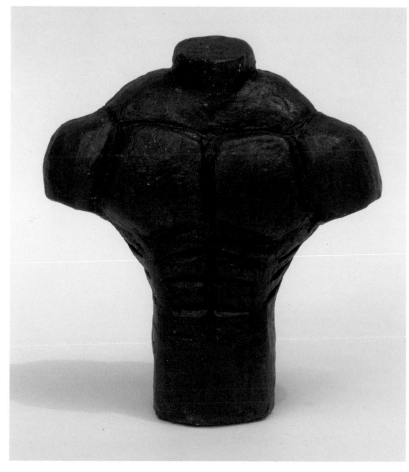

Figure 12-8. This half torso made of fired clay has a dark bronze patina. Michael Kinon. Photo by Hernandez.

Patina in Bronze and Other Metals

When the sculpture is dry after sealing, several approaches are possible. Recently, metallic products have become available, making the simulation of metals less challenging than it used to be. There are ready-made solvents in light and dark bronze, iron, steel, and marbleized mixes having various trade names. Any of these can be applied over the dried shellac and alcohol mix or over a corresponding sealant sold with the patina product. Light touches of bronze in powder form can be added as highlights while the mix is still wet.

When everything is completely dry, paste wax might or might not be added, depending on what surface sheen is desired. Use amber Butcher's paste wax rather than white. Bronze powder can also be imbedded in the wax, if desired.

In **figure 12-7**, a bronze patina was created by first mixing shellac and alcohol together in even amounts and adding green powder to the mix, giving the effect of oxidation. This primary coat also served the purpose of sealing the fired clay sculpture

Carefully look at your finished form to determine what kind of patina would enhance both the forms and the subject matter. **Figures 12-8 and 12-9** are illustrations of simulated bronze patinas, one dark bronze, the other green. **Figure 12-10** simulates aluminum.

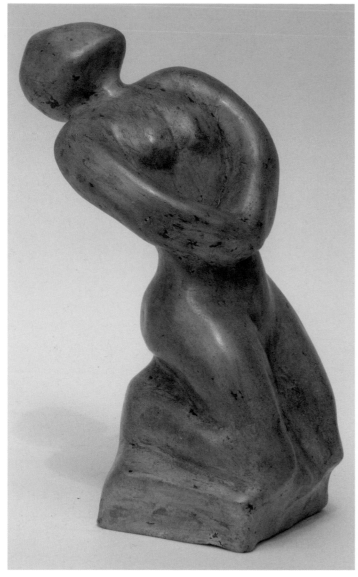

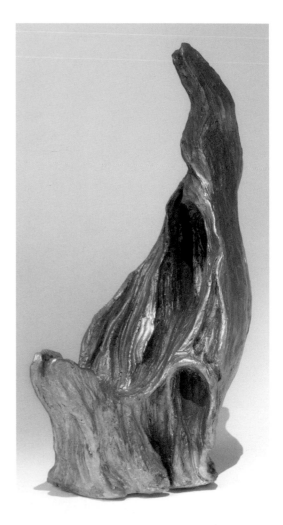

Figure 12-9. This female figure required a golden-green bronze patina according to the artist. Ilana Houten. Photo by Hernandez.

Figure 12-10. This student simulated aluminum in her abstract clay sculpture. She applied a base of shellac and alcohol without pigment to seal the piece, then a liquid metallic solution, and when dry, black wax to darken the crevices. Afterwards it was buffed to a soft sheen. Alison Mital. Photo by Hernandez.

Other metals can be simulated, such as steel, iron or aluminum.

Patina need not simulate any specific product to work. Think of patina as a color enhancement of your sculpture. By all means think of natural materials that exist, such as bronze, marble, granite, iron, steel or wood to get ideas, but then go forward with courage to experiment because often you cannot know what you will like until it begins to appear.

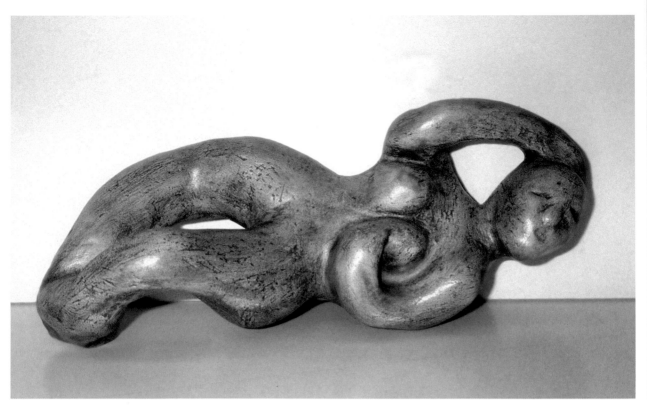

Figure 12-11. This lovely abstraction could simulate bronze or tropical wood. It hardly matters. The patina is beautiful and works with the sculptural concept. Unidentified student sculpture. Photo by Peck.

Wood Patina

To produce a simple patina, one that gives a natural wood tone to fired clay sculptures over the white, buff, red or gray of standard clay bodies, simply apply shoe polish. Kiwi shoe polish in paste form is suggested.

Thin the paste with turpentine just enough to allow it to flow and apply it to the fired piece with a brush, taking care to get into all of the crevices. Dark brown is the most useful color, although that seems to be hard to find; tones of brown, beige and tan can be added over the base color as desired. You can use more than one tone on the same piece.

Figures 12-12 and 12-13 illustrate finishes using dark brown Kiwi shoe wax. On the Pear, **figure 12-12**, only enough turpentine was added to allow the wax to penetrate the cracks; extra coats of wax were applied as each coat dried to create a hard, shiny finish. When dry, the sculpture was buffed so that a light sheen appeared.

On the Duck, **figure 12-13**, the Kiwi wax was diluted with more turpentine to create a duller finish.

Figure 12-12. Dark brown Kiwi shoe polish mixed with a small amount of turpentine was applied to the fired clay sculpture as a patina and later buffed. "Pear," William Francisco. Photo by Vold.

Figure 12-13. Kiwi paste wax was diluted with turpentine on this fired clay piece to create a wood grain with a less glossy finish. "Duck," Paul Barbier. Photo by Vold.

Figure 12-14. Michael Kinon.

Figure 12-15. Kate Ferguson.

A mix of tan and brown shoe paste wax was used on the abstractions in **Figures 12-14, 12-15 and 12-16**, transforming clay sculptures to resemble wood.

Remember that patina is a process, not a paint. Many obscure things have been known to enhance a patina — even tea from a cup and dust from the floor.

Figure 12-16. Jill Chiorazzo. Photo by Hernandez.

Painting

Sometimes the addition of color, because of its associations with familiar things in the personal and natural environment, can extend the expressive potential of clay modeling. Use either watercolors or acrylics for coloring.

You might spray the finished painted sculpture with a clear satin polyurethane as a preservative. Try to avoid gloss finishes, which will exaggerate imperfections and tend to dominate the forms; shiny textures, nevertheless, are often enjoyed by individuals doing clay sculptures for the first time.

Acrylic colors should be mixed experimentally to obtain interesting and personal colors. Colors might also be thinned with water to lessen their tendency to obliterate nuances in modeling.

Figure 12-17. A charming sculpture painted with acrylics after firing. Age, wear and tear rubbed off this composition but added character nonetheless. Unidentified student sculpture. Photo by Hernandez.

Other Finishings

Your sculpture is not finished until it is determined to be finished by you, the artist. Look long and carefully at your piece and consider all the options. None are ordained. All options will be limited, some by availability of time, others by products, still others by work space. But think about those options that are at your disposal and then imagine in your mind's eye what might work well, even if it markedly changes your original conception.

You are not limited to the options suggested in this chapter. The artist whose work is illustrated in **figure 12-18** paid no attention to the products others were using. She simply spray-painted her Pariscraft-covered foil sculpture with a glitzy silver. It worked because she carefully prepared a solid black base on which to mount the figures before sending them dancing on out.

Figure 12-18. This couple, out for an evening's entertainment, was created in foil and Pariscraft, and then given a silver coating, using spray enamel to both enliven the movement and compliment the theme of fancy dress. Edna Dagan. Photo by Vold.

MOUNTING

MOUNTING not only supports your sculpture, but also separates it from other objects in the surrounding area. Together with placement, this final step in the art-making process affords your piece its own immediate, custom-made environment. A sculpture is ready for presentation when positioned at a good height and location, and lit so that its highlights and shadows are revealed to advantage.

Of course, no sculpture created in this program need be given this special send-off. As long as the process was engaged in and a sculpture was produced, it need not ever see the recognition of mounting and placement described in these pages. The information is given in case you need it, either now or in the future.

In this chapter, guidelines are offered for mounting most of the sculptural media described in the book. You will have discovered that some procedures particular to each project were also provided in each relevant chapter.

THE APPROACH TO MOUNTING SCULPTURE

Just as you continually selected and judged relationships between forms and shapes during the evolution of your sculpture, you should now establish a relationship between sculpture and base by means of the same critical judgment.

It is important to keep in mind that the larger the base, the smaller your sculpture may appear. The more elaborate the base, the more diminished the sculpture may be in contrast. The idea is to enhance the sculpture, not the base; to show off the sculpture, not compete with it. So think in those terms when deciding what material to use as a base and what finish to apply. Then, carefully evaluate how the sculpture is to stand (stance); and what width, length and thickness (size) of base is most desirable.

Choosing Materials and Finish

The choice of which material to use as a base and how to finish it will ultimately depend on the sculpture itself in each specific instance. Wooden bases are the most practical. They can be painted, waxed, oiled, varnished, laminated or charred to a dark brown with a propane torch. Other suitable materials for bases, though less simple for mounting, are Plexiglas, concrete, slate and various kinds of marble.

154

The Stance of the Sculpture

You may decide to mount your sculpture differently than the way in which you created it, for example, as a wall hanging piece instead of standing upright on a base.

Figures 13-1 and 13-2 show an abstract plaster form in two different positions. This requires a thoughtful choice by the artist as to which presentation is more dynamic.

If the sculpture is carved all around and does not have a flat bottom, it may work best mounted off the base with a portion of steel rod exposed, as in **figure 13-3**.

If the sculpture is representational, it will no doubt have a defined presentation position. If abstract, it will also, in most cases, be conceived as standing in a particular way. But the fact that the sculpture physically balances in one position as it is being created does not mean that it has to be mounted that way. It may be dramatic, for example, mounted horizontally instead of vertically (**figure 13-4**).

Or, the sculpture may be dramatic tilted on end, even though it was not carved with that intention (**figure 13-5**).

There are many ways to prop the sculpture as you explore these various positions. Use sandbags, rocks or pieces of wood as props — anything that will allow you to step back and make a well-thought-out decision. Finally, if one way seems to work particularly well, meaning that (a) you like it; (b) it has good internal dynamics in balance, tension and rhythm; and (c) there seems to be a good relationship between the sculptural forms and base, go with it.

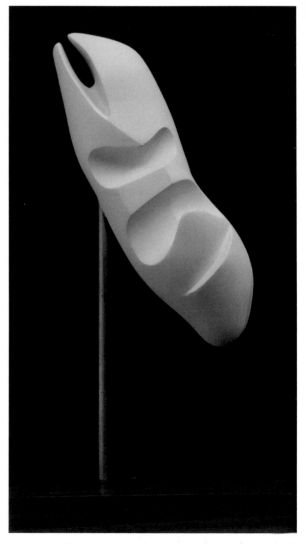

Figures 13-1 and 13-2. The same sculpture held upright and inverted presents two very different choices in mounting. John Reda. Photos by Hernandez.

Figure 13-3. A plaster carving mounted on an exposed stainless steel rod. John Reda. Photo by Hernandez.

Selecting the Base Size

Once you have determined the stance of the sculpture, the size of the supporting base — its width, length and thickness — comes next. One way to determine size is to place your piece on a sheet of black construction paper near the corner edge of a table so that you can see it from the front and sides (**figure 13-6**). Fold back or extend the paper on the sides and front to visualize different widths and lengths. Next, let the paper extend below the table a few inches; then fold it under or extend it to visualize how different thicknesses of dark wood will look. See how these varying sizes enhance or detract from your sculpture. The base should be neither too big nor too thick, as this will dwarf the sculpture; on the other hand, it should not appear visually or structurally inadequate.

Figure 13-5. The sculpture might be dramatically mounted tilted on end, although it may not have been modeled or carved with that intention.

Figure 13-4. Although you created your piece to stand vertically, it may look better mounted horizontally, so be open to surprises.

Figure 13-6. Selecting the size of the base: fold a piece of black construction paper to see how various widths, lengths and thicknesses of base detract from or enhance the sculpture.

Considerations in Judging Base Width and Length

Generally speaking, about 1" of base exposed beyond the sculpture on all sides is a sufficient amount of base, yet other conditions might intervene. For example, in the mounting illustrated in **figure 13-11**, an exposed base of only 1" all around does not take into consideration the wide mass above, so that in this case, more width would be desirable. Your sculpture may not have a base circumference that lends itself to measurement; it may not be a central mass at all, but protrude markedly in one or more directions as in **figure 13-5**. This can be effective, but you must visually assess all of these projections to balance the sculpture on the base.

You may determine that the piece should overhang the base. This can be very effective, but be sure that the overhang visually balances with other forms on all sides.

Considerations in Judging Base Thickness

The mass of your sculpture — its delicateness or thickness — may call for a thin base, or a thick base, or a cube which is even on all sides. The thickness of the base will vary depending on all of these factors, but there are some general considerations to keep in mind:

A thick base, as in **figure 13-7** might overwhelm a slender form, whereas a cube might work well.

It is usually not aesthetically interesting to duplicate thicknesses. For example, if the sculpture is predominantly one or two thicknesses in its walls or height or width, the base should not be the same (**figure 13-9**).

Figure 13-7. A thick base might prove overwhelming for a slender sculptural form.

Figure 13-8. A thin base might appear flimsy for a sculpture with large forms.

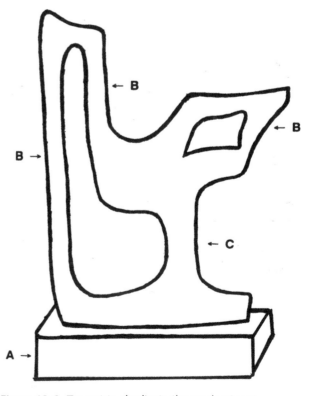

Figure 13-9. Try not to duplicate the predominant thicknesses of the sculpture in the base. Here, the thickness of the base (A) is different from the predominant thicknesses of the sculpture walls (B and C).

For a portrait head, or a mostly solid square, rectangular or circular form, you might consider using a cube base as in **figure 13-10**.

Although approximately 1" of base showing beyond the sculpture is a good general concept, you must also consider other factors, such as the linear or massive quality of an overhang. The base illustrated in **figure 13-11**, although good in terms of height, is too meager for the sculpture it displays because of the massiveness of the overhang.

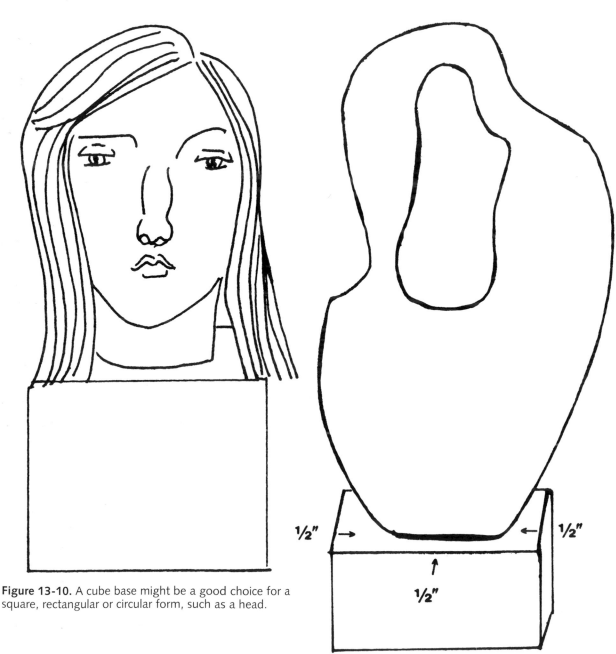

Figure 13-10. A cube base might be a good choice for a square, rectangular or circular form, such as a head.

Figure 13-11. Although the base height works well, the 1" width and depth of space beyond the bottom of the sculpture is too slight to visually carry the overhang.

158

CHECKLIST OF TOOLS AND MATERIALS FOR WOOD BASES

Not all of the items listed below, or shown in **figure 13-12** are necessary for mounting any given sculpture. The checklist is inclusive so that you can scan it and prepare for what you might need. Your own sculpture will be unique, and you will have to decide in each instance which specific materials and method of mounting to use.

- Black construction paper used to determine base size.
- Wood for bases, kiln-dried hardwood, plywood or chipboard.
- Rocks, sandbags, wooden sticks, etc. to prop sculpture to determine stance.
- Ruler and pencil for making accurate measurements before cutting.
- T-square for accurate squaring of bases.
- Saw for cutting bases to size.
- Sandpaper for smoothing bases.
- Kiwi shoe paste wax in your choice of tones for finishing a wood base.
- Propane torch, a choice for finishing a wood base by charring to a dark brown color.
- Steel wool for cleaning wood after burning.
- Linseed oil for rubbing over charred wood or used alone as a final finish.
- Black spray enamel, flat, satin or gloss, a choice for finishing a wood base.
- Varnish, a choice for finishing a wood base.
- Rags and brush for applying wax, linseed oil or varnish.

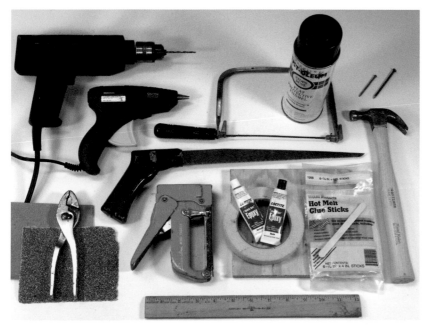

Figure 13-12. Tools and materials for mounting sculptures on wooden bases. Photo by Hernandez.

- ¼" or ⅜" drill with ¼" steel bits for boring holes to mount sculptures.
- Sanding attachment for drill for sanding base.
- ¼" masonry bit for mounting plaster and cement & vermiculite sculptures.
- ¼" threaded steel rod with nut to fit and washer ¾" to 1" to connect sculpture to base.
- ¾" counter sink bit drilled on reverse side of base, large enough to enable washer and nut to be affixed.
- Long-nosed pliers or wrench for tightening nuts.
- Plastiline (oil-base clay) for aligning holes between sculpture and base.
- Talcum powder used with plastiline for aligning holes.
- Five-minute quick-setting epoxy resin and hardener for adhering sculpture directly to base (hollow fired clay, found objects, wire sculptures) and for cementing rods into drilled holes; also useful for mounting on plexiglass or marble.
- Glue gun and hot glue as needed.
- Hammer and nails for mounting foil figures, found objects, wire sculptures.
- Staple gun and staples for mounting foil figures, found objects, wire sculptures.
- Felt, brown or black glued to bottom of base to cover drill holes and protect furniture.
- White glue for adhering felt to bottom of base.

159

CONSTRUCTING A WOOD BASE

Let us assume you are using a simple, flat wood base. You can use plywood or chipboard if the base is to be painted and wood grain is not a factor, but use kiln-dried hardwood if the base is to be waxed, stained or burned.

1. Make sure the board or block is flat and not warped.

2. Measure the base with a pencil and T-square to the proper dimensions.

3. Cut the base precisely so that if it is meant to be a square, it is square and if it is to be a rectangle, it is a rectangle. Take care not to splinter the wood at the end of the cut. If the wood is vulnerable to splintering, cut from the opposite direction as you approach the end of your cut.

4. Sand the surface and edges of the wood.

5. Clean dust and debris from all surfaces.

Finishing the Wood Base

The wood base can be finished in a number of ways, depending on the color and texture desired and the kind of wood that is used. Below are some alternatives:

- **Waxing, using dark brown or brown Kiwi shoe polish in paste form:** produces a handsome, slightly shiny finish with a visible grain. Apply with a rag.
- **Varnishing and wiping down:** produces a glossy finish with grain visible. Apply the shade you like with a brush and wipe down with a rag.
- **Burning with a propane torch:** produces a brownish-black finish (depending on the wood) with a visible grain. Burning eliminates one step in base preparation because sanding is not required. Work on a nonflammable surface, such as a metal-topped table. Sweep the flame over all surfaces of the wood so that it chars evenly. Clean excess char with steel wool, and then wipe the charred wood with a rag dipped in linseed oil.
- **Spraying with black flat, semi-gloss or gloss enamel:** produces an opaque black finish with no grain visible. Before beginning, protect the surrounding area from overspray and support the base off the table with a board so that the edges will coat and dry evenly. Follow the directions on the can for obtaining a smooth application.
- **Laminate with Micarta or Formica (trade names):** produces a semi-gloss or gloss sheet finish. Chipboard can be used as the base. Consult a dealer for the proper materials to use for adhesion. This is a more elaborate method, requiring other tools and materials than those listed and illustrated.

ATTACHING SCULPTURE TO BASE

Adhesion, for the purposes of the projects described in this text, will involve nailing, stapling, gluing or drilling, sometimes in combination. To give the sculpture the stability it requires, it is usually sufficient to drill a hole of adequate depth, turn it over and drill a portion to countersink the nut; you would then insert a threaded steel rod of appropriate proportion, add a washer to fit, and fasten and tighten a nut. The process is described in detail below. However, if the work has been fired, it will be hollow, and there may be insufficient solid areas through which to drill. In that case, gluing may be a better choice. Many of the objects used in found-object sculpture may also lend themselves to gluing rather than drilling. The procedures offered in this section will have to be adapted to the specific requirements of your sculpture.

Procedures for Gluing

1. Place the sculpture on a level surface and locate two or three reasonably well-balanced points where the sculpture makes solid contact.

2. Mark these touching spots with a pencil on the bottom of the sculpture.

3. Carefully position the sculpture on the base where you want it (if the base is easily marred, tape cardboard onto it temporarily and trace the sculpture's form on the cardboard).

4. Place small wads of plastiline on the bottom of the sculpture at each of the pencil marks; then, press the sculpture down at the appropriate place on the base. The clay will adhere to the cardboard or base, or at the very least, leave a stain. Before removing the cardboard, tap a small nail in and out to mark the spots.

5. Use steel wool or sandpaper to roughen the specific area of the base to receive glue so that the surface wax, paint, oil or varnish on the base will not interfere with good adhesion.

6. Thoroughly mix equal parts of five-minute quick-setting epoxy resin and hardener with a nail or craft stick on a piece of cardboard.

7. Then carefully apply the resin to bond the sculpture to the base, making sure that no glue oozes beyond the sculpture.

8. When dry, cut a piece of felt to size. Spread white glue over the felt and affix this to the bottom of the sculpture, smoothing it out flat. This will prevent marring furniture.

Drilling the Sculpture and Base

The procedures given are for moderate-size table sculptures or relatively lightweight wall reliefs. Begin as above by determining the stance of the sculpture on the base and selecting the point or points of contact.

1. Turn the sculpture upside-down by supporting it with sandbags and rocks. If the piece is cumbersome, set it in a trashcan that has been filled with paper or rags for support (**figure 13-13**).

2. Place a drill bit on your drill (diameters will need to be increased for heavy or massive sculptures). A ¼" bit should be okay for small sculptures.

3. Determine the correct drilling angle according to the particular tilt, if any, the sculpture is expected to have on the base. If it is to be perfectly upright, the drilling angle will be perpendicular to the base or surface of the trashcan (**figure 13-13**).

4. Drill as deeply as necessary to support the sculpture. If the sculpture is to be mounted flush to the base (not off the base with rod exposed), it will need more than one mounting point to prevent turning.

5. Cut a ¼" threaded steel rod to the depth of the hole you have drilled, adding to your measurement the thickness of your base (minus about ¼"). It is wise to affix the washer and nut on the rod before cutting, as the threads may become ragged after cutting.

6. Put the rod aside.

7. Carefully set the sculpture on the base and determine precisely where you want to position it.

161

8. When it is in place, tap the sculpture with your hand. A small puddle of material left in the holes from drilling will appear on the base, indicating the precise points for drilling.

9. If there is no puddle of material remaining, put small wads of plastiline on the base in the approximate locations of the intended drilling points. Dust with talc to prevent sticking; then position the sculpture on the base and press hard. The talc-covered clay will be marked with an imprint of the holes in the sculpture, indicating where the holes in the base should be drilled.

10. Drill the holes in the base.

11. Attach a countersink bit on the drill (approximately ¾" diameter should do).

12. Drill the reverse side of the base deep enough to allow a washer and bolt to be affixed to the rod with no hardware extending beyond the bottom of the wood.

13. Invert the sculpture again.

14. Temporarily insert the threaded rod, and place the base on top to make sure everything fits. If there is excess rod, cut it off or drill slightly deeper into the sculpture. Before cutting the rod, be certain that the nut is already threaded on or can be threaded on easily.

15. Remove the rod.

16. Mix equal parts of epoxy resin and hardener, and bond the rod into the sculpture.

17. Repeat the process for each rod.

18. If the rods are to be glued into a hollow form — a modeled head in clay, for example — provide extra support by coating a strip of fiberglass with epoxy resin and hardener and using that to bond the rods to the inner walls. Use plastic gloves to avoid skin contact. As indicated in the previous chapter, resins must never be touched with bare fingers or hands. If skin does contact epoxy resin, wash immediately with warm water and soap.

19. Slip the base onto the rods before setting occurs to make sure they stay in place, but do not proceed further until the epoxy sets.

20. Add the washer and nut, and tighten.

21. Cut a piece of felt to size, and attach it to the bottom of the base with white glue.

Professional Mounting

As you progress, some of your sculptures may be of such stature and complexity that you want them mounted in a more sophisticated way than you can manage by yourself. That is, your accomplishment in creating sculpture may outdistance your skill in making bases. One of the sculpture services offered is professional mounting (see Appendices). If there is a facility not too far away, you might consider bringing your piece to them. Competent carpenters and cabinet makers can also handle the task under your supervision.

Figure 13-13. To drill the sculpture, turn it upside down in a trashcan filled with paper or rags. If the piece is to be perfectly upright, the drilling angle will be perpendicular to the base. More than one mounting point will be needed for good support and to prevent turning.

PLACEMENT

Height

Whether the finished sculpture is to be placed at eye level or above or below eye level is of consequence. For example, a lovely work placed too low may have little impact and become lost in a room. Sculpture will be seen in the manner in which it is displayed; that is, parts will be hidden from view at various heights and in various positions, and other aspects of the sculpture will be emphasized, largely according to placement. Experiment with placement just as you did in choosing a base and in all of the other formal decisions that you have been making all along.

Background

Background is also of consequence. Your base was necessary not only to secure your piece, but also to set it off from its surroundings. So too, placement is designed to set the sculpture off from its surroundings while it acts in concert with them. For example, high placement of a large sculpture might so unbalance other things in the room that although the piece itself might be majestic, adjacent furnishings might be dwarfed. Similarly, a grandiose, highly decorated object close to your sculpture might compete with the eloquent forms you have so carefully established. Competing colors and textures and other such conflicts should also be considered. Of course, you will probably have limited choices in the placement of your pieces with competition from the furniture, lamps and bric-a-brac that occupy the usual household, let alone the people: where they choose to sit and what they choose to look at. Still, it might be useful to go through the motions of choice as an aesthetic exercise for ideal sculpture placement.

Support

Simple pedestals enhance sculpture; they can be made of wood and painted or laminated in black Micarta or Formica. It is sometimes necessary to weight the base of the pedestal with lead to increase its sturdiness (see Appendices for pedestal manufacturers). Tables, mantles and shelves all provide good placement locations for sculpture.

Lighting

Finally, the sculpture must have appropriate light. Lighting need not be elaborate, but it must be sufficient. Both day and night illumination must be considered. Sometimes unexpected effects can occur with a change in lighting; for example, when light beams from behind to illuminate the contours of negative forms in the sculpture or from underneath to give the sculpture a dramatic, monumental quality. Natural light from a window is effective too.

CONCLUSION

The finishing, mounting, placement and lighting of the sculpture should not overemphasize the importance of the work you have made, but rather demonstrate that sculpture is seen in relationship to space around it.

Sculpture is an integration of forms, and those forms must integrate with the base and the environment. Sculpture is not a daub of this and a splash of that; it is the substantial interrelationship of form, mass, line and shape. Well-conceived, fabricated, finished and mounted, sculpture is dynamic movement — a gesture, a statement, a monumental moment caught in time and in place.

SUPPLIERS

Many supplies referred to, such as those listed below, can be found in hardware and household supply stores:

- Acrylic paints
- Aluminum foil
- Chisels
- Enamel spray paint
- Epoxy (five-minute quick-setting epoxy resin, sold in twin tubes of resin and hardener).
- Files and rasps
- Gloves (plastic)

- Hardware and tools
- Knives
- Masks (for dust)
- Mixing bowls
- Pariscraft or other plaster-impregnated gauze
- Plaster of Paris
- Sandpaper
- Shoe polish
- Wire

Arts and Crafts

Blick Art Materials
P.O. Box 1267
Galesburg, IL 61402
1-800-447-8192 to order
1-800-933-2542 product information
www.dickblick.com
E-Mail: info@dickblick.com

Flax Arts and Design
1699 Market St.
San Francisco, CA 94103
415-552-2355
www.flaxarts.com
E-Mail: info@flaxarts.com

Nasco Fort Atkinson
901 Janesville Ave.
Fort Atkinson, WI 53538
1-800-558-9595
www.enasco.com
E-Mail: infor@enasco.com

Nasco Modesto
4825 Stoddard Rd.
Modesto, CA 95456
209-545-1600
E-Mail: modesto@enasco.com

Pearl Paint
(several stores nationwide)
308 Canal St.
New York, NY 10013
212-431-7932

776 Rte 17 N.
Paramus, NJ 07652
www.pearlpaint.com

Sam Flax Stores
(Two NYC locations)
12 W. 20th St.
New York, NY 10011
212-620-3038

900 Third Ave.
New York, NY 10022
800-628-9512
www.samflaxny.com
E-Mail: onlinesales@samflax.com

Sax Arts and Crafts
2725 S. Mooreland Rd.
New Berlin, WI 53151
1-800-558-6696
www.saxarts.com
E-Mail: info@saxarts.com

Triarco
2600 Fernbrook Lane
Suite 100
Plymouth, MI 55447
1-800-328-3360
www.triarcoarts.com
E-Mail: info@triarcoarts.com

Bronze (Metallic) Powder

U.S. Bronze Powders, Inc.
408 Route 202 N.
Flemington, NJ 08822
908-782-5454
www.usbronzepowders.com
E-Mail: garry.bily@usbronzepowders.com

Clay, Plaster, Wax, Sculpture Tools

(see also Arts and Crafts)

Chavant Inc.
Plasteline clay, in particular
5043 Industrial Rd.
Farmingdale, NJ 07727
1-800-242-8268
www.chavant.com
E-Mail: info@chavant.com

The Compleat Sculptor
(everything for the sculptor)
90 Van Dam St.
New York, NY 10013
1-800-972-8578
www.sculpt.com
E-Mail: TCS@sculpt.com

Montoya Sculpture & Supply
(sculpture tools and workshops)
502 Palm St. # 21
West Palm Beach, FL 33401
www.montoyasculpture.com
E-Mail: info@montoyasculpture.com

Perma-Flex Mold Co.
(mold making materials)
1919-T Livingston St.
Columbus, OH 43209
614-252-8034
www.perma-flex.com

Sculpture House
(tools, pedestals, bases and casting)
155 W. 26th St..
New York, NY 10001
1-888-374-8665
www.sculptshop.com
E-Mail: info@sculptshop.com

Kiln Suppliers

Ceramic Supply
7 Route 46 West
Lodi, NJ 07644
1-800-723-7264
www.7ceramic.com

Paragon Industries, L.P.
(contact for local area distributors)
2011 Town East Blvd.
Mesquite, TX 75149
972-288-7557
www.paragonweb.com
E-Mail: info@paragonweb.com

Plastics, Fiberglass, and Resin

(see also your neighborhood boat/marine supply)

Defender Industries, Inc.
(marine outfitter)
42 Great Neck Rd.
Waterford, CT 06385
1-800-628-8225
www.defender.com

Casting, Mounting, Pedestals

Johnson Atelier

(apprenticeships, casting, fabrication,

enlarging, technical services)
60 Sculptors Way
Mercerville, NJ 08619
609-890-7777
www.atelier.org
E-Mail:info@atelier.org

Montoya Art Studios

(cold casting, mounting, carving stones)
502 Palm St. # 21
West Palm Beach, FL 33401
www.montoyasculpture.com
E-Mail: info@montoyasculpture.com

Sculpture House Casting

(cold casting, mounting, pedestals & bases)
155 W. 26th St..
New York, NY 10001
1-888-374-8665
www.sculptshop.com
E-Mail: info@sculptshop.com

Wax Suppliers

M. Argueso and Co.

(brown and black microcrystalline slabs)
441 Waverly Ave.
Mamaroneck, NY 10543
Or:
2817 McCracken
P.O. Box 126
Muskegon, MI 49443
231-759-7304
www.argueso.com

Kindt-Collins Co.

(sprue waxes, also called extrusion waxes —
many shapes and diameters).
For types referred to in text, order: 1-inch square cored red #9; -inch round solid green #16; soft brown sculpture wax; 4-inch wax sheets
12651 Elmwood Ave.
Cleveland, OH 44111
www.kindt-collins.com
E-Mail: info@kindt-collins.com

Bronze Casting Foundries

American Bronze Foundry
1650 E. Lake Mary Blvd.
Sanford, FL 32773
1-800-881-8090

Excalibur Bronze Foundry, Inc.
309 Starr St.
Brooklyn, NY 11237
718-366-3444

Johnson Atelier
60 Sculptors Way
Mercerville, NJ 08619
609-890-7777

Modern Art Foundry
18-79 41st St.
Astoria, NY 11105
718-728-2030
www.modernartfoundry.com

Polich/Tallix
453 Route 17K
Rock Tavern, NY 12575
845-567-9464
www.polich.com

P.S.H. Industries, Inc.
(laminating in sprayed metal)
5346 East Ave.
La Grange, IL 60525
708-354-0969

Shidoni Foundry
Bishop's Lodge Road
5 miles north of Santa Fe Plaza
P.O. Box 250, Tesuque, NM 87574
505-988-8001 voice
505-984-8115 fax
www.shodoni.com
E-Mail: shidoni@shidoni.com

Morris Singer Art Founders
9 Swinborn Drive
Springwood Industrial Estate
BRAINTREE
Essex CM7 2YP
01256 475 301 voice, sales
01376 343 222 voice, production
01376 341 793 fax
www.msaf.co.uk
E-Mail: info@msaf.co.uk

REFERENCES AND RESOURCES

The references and resources listed in this section are provided for readers who want to expand their creative work in a method described or referred to in the text, or to broaden their knowledge of contemporary sculpture techniques and resources. The list is by no means complete and is intended only as an introductory reference source.

Carving (Wood and Stone)

Andrews, Oliver. Living Materials. Berkeley: U. of California Press, 1988.

Beecroft, Glynis. Carving Techniques. New York: Watson Guptill, 1982.

Langland, Tuck. Practical Sculpture. Englewood Cliffs: Prentice-Hall, 1988.

Meilach, Donna Z. Contemporary Stone Sculpture. West Chester, PA: Schiffer, 1987.

Casting: Mold Making and Fabrication

Auerbach, Arnold. Modeled Sculpture and Plaster Casting. San Diego, CA: A.S. Barnes, 1977.

Barrie, Bruner F. Mold Making, Casting and Patina. ABFS Publishing, 1992

Chaney, Charles, and Skee, Stanley. Plaster Mold and Model Making. New York: Simon & Schuster, 1973.

Farnworth, Warren. Creative Work with Plaster. London & Sydney: B.T. Batsford Ltd., 1975.

Meilach, D.Z. Creating with Plaster. London: Blandford Press and U.S.A.: Reilly & Lee Co., 1968.

Wagner, Victor H. Plaster Casting for the Student Sculptor. London: Alec Tiranti, 1970.

Clay

Padovano, Anthony. The Process of Sculpture. Garden City: Doubleday and Co., 1981.

Lucchesi, Bruno and Malmstrom, Margit. Terra Cotta: The Technique of Fired Clay Sculpture. New York: Watson-Guptil, 1977.

Plastics and Fiberglass

Newman, Thelma R. Plastics as Sculpture, Radnor, Philadelphia: Chilton. Book Co., 1974.

Padovano, Anthony. The Process of Sculpture. New York: DeCapo Press, 1986.

Panting, John. Sculpture in Fiberglass. New York: Watson Guptill, 1972.

Roukes, Nicholas. Sculpture in Plastics. New York: Watson Guptill, 1968.

Portrait Sculpture

Lucchesi, Bruno and Malmstrom, Margit. Modeling the Head in Clay. New York: Watson-Guptil, 1979.

Sand Casting

Siebert, Ted. The Art of Sandcasting (and) Wierenga, Lucinda and McDonald, Walter. Sand Castles. Step-by-step. http://dalesdesigns.net/sandsculpt4c.htm

Villiard, Paul. The Art and Craft of Sand Casting. New York: Funk & Wagnalls, 1975.

Also search internet sites: "sand sculpture"

Sculpture Techniques (general)

Note: Most books are available through The Compleat Sculptor, www.sculpt.com

Coleman, Ronald L. Sculpture: A Basic Handbook for Students. Dubuque, IA: Brown and Benchmark, 1990.

Langland, Harold. Practical Sculpture. Englewood Cliffs, NJ: Prentice-Hall, 1988.

Peck, Judith. Art Activities for Mind and Imagination. Mahwah, NJ: Imagination Arts Publications, 2004. www.iapbooks.com

Peck, Judith. Artistic Crafts. Mahwah, NJ: Imagination Arts Publications, 2004. www.iapbooks.com

Verhelst, Wilbert. Sculpture: Tools, Materials and Techniques. Englewood Cliffs, NJ: Prentice-Hall, 1973.

Williams, Arthur. Sculpture: Technique, Form and Content. Worchester, MA: Davis Publications, 1995.

Wax

Miller, Richard M. ed. Figure Sculpture in Wax and Plaster. New York: Dover, 1987.

Welding

Balwin, John. Continuing Sculpture Techniques: Direct Metal and Fiberglass. New York: Feinhold, 1967.

Irving, Donald. Sculpture: Materials and Process. New York: Simon & Schuster, 1970.

Griffin, I.H., Roden, E.M., and Briggs, C.W. Basic Oxyacetylene Welding, 3rd ed. Albany: Delmar, 1977.

Wire

Brommer, Gerald F., Wire Sculpture. Worcester: Davis, 1968.

Padovano, Anthony. The Process of Sculpture. Garden City: Doubleday and Co., 1981.

Art in Human Service

American Art Therapy Association, Inc. (AATA)
Information, publications, education, conferences
5999 Stevenson Ave.
Alexandria, VA 22304
www.arttherapy.org
E-Mail: info@arttherapy.org
Publishes: *Art Therapy: Journal of the American Art Therapy Association*
Vermont College of Norwich University
Montpelier, VT 05602

Sculpture Print and On-line Information Sources

International Sculpture Center
Information, publications, education, conferences
14 Fairgrounds Rd. Suite B
Hamilton, NJ 08619
609-689-1051
www.sculpture.org
E-Mail: isc@sculpture.org
Publishes: *Sculpture*, a magazine on contemporary sculpture
1528 18th St. NW
Washington, DC 20036
202-234-0555

Sculpture Review
56 Ludlow St. 5th Floor
New York, NY 10002
212-529-1763
www.sculpturereview.com
E-Mail: GP@sculpturereview.com

INDEX

MORE REFERENCES TO HELP SHAPE YOUR SKILLS

The Sculptor's Bible
The All-Media Reference to Surface Effects and How to Achieve Them

Covers everything from selecting a surface to adding finishing effects in comprehensive outline instructions, while more than 400 color photos demonstrate various treatment. Extensively introduces specific materials.

Comb-bound
6-¾" x 8" • 256 pages
400+ color photos
Item# SCPB • $29.99

The Kiln Book
Materials, Specifications & Construction
Third Edition

This definitive guide on kiln design and construction offers complete plans and instructions for building kilns of all sizes and for all purposes.

Hardcover
8-¾" x 11-¼" • 288 pages
600 b&w photos & illus.
16-page color section
Item# KILN3 • $44.95

Tile Artist's Motif Bible
200 Decorative Designs with Step-by-Step Instructions and Charts

Transform hand-made or store-bought tiles from dècor to dynamite decoration with color and creativity. A collection of 200 designs, coupled with a photo, diagram, instructions and advice aid you in your art.

Softcover
5-¾" x 8-¾ • 256 pages
400+ color photos, illus.
Item# Z0414 • $29.99

The Potter's Encyclopedia of Color, Form and Decoration

This comprehensive reference is a roadmap for the limitless shapes and forms, with over 600 illustrated inside. More than 700 colors and decorations of pottery are vividly displayed with recipes.

Hardcover w/ vinyl jacket
7-½" x 9-¾" • 160 pages
color throughout
Item# PECF • $24.99

Robin Hopper Ceramics
A Lifetime of Works, Ideas and Teachings

Journey with this master ceramist and teacher through his more than 50-year exploration of ceramics, and learn the "hows" and "whys" behind his ceramic artistry.

Softcover
8-¼" x 10-⅞" • 256 pages
300+ color photos and illus.
Item# RHCM • $44.99